REPRESENTING BLACKNESS

REPRESENTING BLACKNESS

The Marcus Mosiah Garvey Multimedia Museum

BY

Donna Elaine McFarlane-Nembhard, PhD
2016

The University of the West Indies Press
Jamaica • Barbados • Trinidad and Tobago

The University of the West Indies Press
7A Gibraltar Hall Road, Mona
Kingston 7, Jamaica

www.uwipress.com

A catalogue record of this book is available from the National
Library of Jamaica.

ISBN: 978-976-640-919-7 (print)
978-976-640-920-3 (ePub)

Cover design by Robert Harris

Printed in the United States of America

Contents

Figures

Tables

Abbreviations

GRRL	Garvey Research/Reference Library
HEART	Human Employment and Resource Training
IOJ	Institute of Jamaica
LH	Liberty Hall
MMGMM	Marcus Mosiah Garvey Multimedia Museum
UNIA-ACL	Universal Negro Improvement Association and African Communities League

Prologue

Representing Blackness came into being long before Donna McFarlane wrote the book and before she became the consummate director and curator of the Marcus Mosiah Garvey Multimedia Museum. The genesis accompanied her back home to Jamaica in 1978. Armed with the knowledge learned from undergraduate study and the soon-to-be-earned advanced degree in development economics, Donna McFarlane came back to Jamaica with more than formal education under her belt. She came home with a mission to contribute to the country of her birth that was in transition from being part of the British Empire to one coming on stream in a new world order, led by Prime Minister Michael Manley and the promises of Democratic Socialism. It was a heady time to be young, gifted and black. Those attributes came with Donna McFarlane as she re-entered a society that she knew as a seven-year-old child when she migrated to New York, actually to Brooklyn's Jamaican immigrant community and over time became reacquainted with through the visits she made over the following sixteen years. Nonetheless, her return to Jamaica in 1978 was not just a visit but a total relocation and repurposing of her body, mind, spirit, talent and energy.

During the summer of 1978, I too came to Jamaica excited to witness the social, political and cultural happenings during the second term of the Manley-led government. I came as a doctoral student of anthropology whose research focused on women factory workers and their households in Kingston. I do not remember how I gained entry, probably via a personal introduction, into the National Planning Agency where I encountered some of the main economic architects of the Manley administration. Somehow, I was there and was introduced to Dr Patricia Anderson, a sociologist/demographer who was also interested in research on women, work and family. After a great meeting with Pat, she said something like, oh I need you to meet a new member of staff who is working on her masters at the New School in econ. So, we walked down the hall to a cubicle where a young woman focused on reading data in a binder looked up and smiled. After a quick introduction, Pat left to go back to her office while Donna and I engaged in ice-breaker-type conversation. I recalled that during the previous year in New York, I met her New School advisor, Dr Gita Sen who was one of the

leading scholars on women and development issues. Quite envious of the relationship, Donna reminded me that she was studying for her upcoming exams and that Dr Sen was great but a taskmaster, nonetheless. I shared some tips on prepping for those academic hurdles, as a few months earlier I had passed my qualifying doctoral exams. I relayed the current status of my fieldwork just underway, and how I was desperately trying quickly to learn in-depth Jamaican cultural cues and ways of being. This was essential if I was to bridge the national and class differences between me and the women whom I encountered in my research. Donna explained that she too was learning the ropes of navigating this society. At that time, Donna was doing data analysis at work, preparing for her exams back in New York, and being a dutiful daughter by paying the mortgage of her soon-to-be retired mother's Kingston home prior to her own relocation back home to Jamaica. Donna moved into the house and kept it up for a number of months until her mother finally arrived. In the meantime, as two young women on our own, we formed a bond of friendship that will forevermore endure. Back in the day, on many a night the two of us, when Donna was not studying and I was not writing up my fieldnotes, ventured up towards Aylsham to imbibe in low-cost bubbly Rosemount red wine, eat sliced "pear" (avocado) or Anchor cheese on hard dough bread, and commiserate on the Jamaican economy, global politics, our love lives or the precariousness of our social lives, and above all to laugh. Needless to say, Donna McFarlane passed her exams and Mrs Edna McFarlane "Miz Mac" became one of my Jamaican mothers who fed me and schooled me in that house about life and the meaning of hard work through her own experiences.

Donna McFarlane immersed herself in the social and cultural life of Jamaica and specifically in Kingston. She would make other life-long friends, take African dance classes, shop in Coronation market at the crack of dawn on Saturdays and relish in her own heritage of being the granddaughter of a higgler (agricultural producer and market woman) from Ulster Spring. Her sense of personal style and grace was accompanied by her energy, talent and intellectual drive. A voracious reader, Donna McFarlane, used these pursuits as she carved out a life as a regional economist with one enduring penchant to the arts, cultural production, Caribbean life, Jamaican social history and culture and to Africa. Her personal style of wearing African adornments and clothing became her signature motif. Donna McFarlane the economist was drawn to Jamaican poets, musicians, artists and artisans, dancers of all genres, and gallery spaces. She also was enamoured with traditional Jamaican folk life and appreciative of Rastafarian ideology and

anti-colonial heroes, such as the Rte Honourable Marcus Mosiah Garvey, visionary, pan-Africanist, publisher and founder of the Universal Negro Improvement Association and African Communities League (UNIA-ACL). All of these things would soon come together as a whole.

Marcus Mosiah Garvey, National Hero of Jamaica and of the Black World

Marcus Garvey proclaimed his understanding of the African Diaspora in his famous quote "Africa, home and aboard". Donna McFarlane, educated in the 1960s–1970s during the black power struggles in the Diaspora, embraced the connection of home and aboard as she had two homes. In addition, McFarlane was a student of African affairs. She understood the heritage of enslavement and the challenge to undo the legacy of the British colonial mentality that denigrated Blackness. Through 307 years of colonial rule, black skin and black (signifying Africa) cultural practices were belittled and denigrated despite being the essence of all things Jamaican. In order to unmask these anti-black sentiments required a person, a group and a society at large to comprehend the ill effects that such ideologies have on one's psyche, body and soul. Further, it was imperative to discern how this was played out structurally on all aspects of society. Understanding one's Blackness was about valuing this self-identification on all levels. Donna McFarlane came to Jamaica with this in hand. She was dismayed by the inconsequential way that the legacy of Marcus Garvey was downplayed in public and private schools and in popular discourse. When Burning Spear sang about "old Marcus Garvey" did Jamaicans know just how monumental their national hero was and in fact was an international hero and visionary across the diaspora not only for his time period but for all times? When listening to Bob Marley sing "Redemption Song" (1980) did Jamaicans know the lyrics came from a speech Garvey gave in 1937 in Nova Scotia where he challenged the audience to "emancipate yourselves from mental slavery; None but ourselves can free our minds?" Nonetheless, fifty years later after that speech was given, the Government of Jamaica bought the property that housed Garvey's headquarters in Kingston. However, it would take additional funding, opportunity and vision to bring back to life Jamaica's Liberty Hall. Moreover, it would take a cadre of people whose activism adhered to Garvey's prophetic challenge and who garnered the political will to oversee the next step of redemption. It came to pass that the consummate-talented economist who loved culture, and cultural

producers and her people came together in the reclamation, renovation and revitalization of Liberty Hall, 76 Kings Street, Kingston Jamaica, established in the 1920s as the UNIA headquarters.

"We meet in Liberty Hall, not as cringing sycophants, but as men and women standing erect and demanding our rights from all quarters".
Garvey speaking at Liberty Hall, Harlem, 1920

The Redemption of Jamaica's Liberty Hall

Throughout the UNIA world of the 1920s onwards into the mid-twentieth century, there were seven hundred branches of the organization and each were required to have their own Liberty Hall that provided meeting rooms, offices and space to meet the social, cultural and economic needs of the black communities in which they were located. Noteworthy of the UNIA Liberty Halls was the organization's headquarters situated in Harlem, New York. However, Jamaica's Liberty Hall was significant because its location – the home country of the UNIA founder, Marcus Garvey. McFarlane states in "The Story of Liberty Hall" "it was one of ten divisions formed in Jamaica during Garvey's time. Like the others, Liberty Hall, Kingston housed UNIA offices, was the venue of UNIA meetings, operated small businesses, and hosted spectacular cultural and intellectual programs".

When Liberty Hall (LH) was purchased as an office site in 1923 by the Kingston branch of the UNIA-ACL, it was nestled in an "upscale" community of Kingston. For the sake of brevity here, there are three critical points to consider about Kingston's Liberty Hall. First, it was the home base of not only the local UNIA community, but also Liberty Hall housed a variety of educational activities and programs for youth and adults. Secondly, but more importantly, Liberty Hall is where Garvey launched his political campaigns when he returned to Jamaica after his 1927 deportation from the United States. From the balcony of Liberty Hall, Garvey addressed the crowds in an outdoor area, unique to the neighbourhood. Finally, it was the building itself that was used by the British Colonial court system and local anti-Garvey financial forces that in tandem harassed the UNIA and unhinged Garvey's local political ambitions. By 1934, followers agreed that Garvey needed to escape the legal and financial strain he faced in Kingston and to move to London where he could better oversee the international entities of the UNIA with less rankle from the British than what occurred in the colonies.[1] Other properties owned by the UNIA and Liberty Hall were sold in forfeit in this political struggle. Over time, due to Garvey's

departure in 1935 for England and with the decline of the organization, Liberty Hall was resold a number of times and used for a number of events such as office space, a boxing arena and a site for dances and other cultural activities. Even when it was no longer in the hands of the UNIA, Liberty Hall retained its name and always associated with the memory of Marcus Garvey. However, as prime real estate addresses were found further northward into St Andrew, Liberty Hall was now situated in the "inner city" and suffered from urban blight.

In 1964 Marcus Garvey became Jamaica's first national hero and his body was exhumed from a cemetery plot in London and the remains were brought home to Jamaica. Interned in National Hero's Park the Rte. Honourable Marcus Mosiah Garvey rests in a tomb centred in a platform in the shape of a black star, a symbol associated with the UNIA. During the 1987 centennial celebration of Garvey's birth, twenty-three years after the Garvey monument was erected, the Government of Jamaica (Jamaica National Heritage Trust) acquired Liberty Hall. At that time, the Garvey memorial located in National Hero's Park was a significant tribute while close by on Upper King Street Liberty Hall was structurally in shambles. Nonetheless, in 1992 the Jamaica National Heritage Trust declared Liberty Hall as a national monument by reason of its historical significance. After all, forty years before Jamaica's independence, Liberty Hall was the first meeting hall in the country that was fully owned and operated by blacks under the leadership of Garvey. There was still much work to be done.

A dedicated group of UNIA followers, Garvey scholars and concerned citizens formed a group to champion the Garvey movement, particularly in Jamaica, and to restore Liberty Hall. "The Friends of Liberty Hall" planned to rescue the building from further decay with the goals to restore the physical space, to revitalize programs focusing on cultural heritage and African pride, to resurrect the original purpose as a community resource and to return to predominance the legacy of Marcus Mosiah Garvey.[2] Thus, when "The Friends of Liberty Hall" searched for a leader to continue the tradition, to honour the past and to lead towards the future, the name Donna McFarlane was identified as just the person to do the job. Thus, it came to pass that the consummate talented economist who understood the African diaspora, the role of culture, and cultural producers and her people came together in the reclamation, renovation and revitalization of Liberty Hall. Donna McFarlane saw how visual representations were critical in this undertaking of illustrating, educating and demonstrating how Blackness and valuing a black identity was essential to understanding Africa and the diaspora, grounded in traditional Jamaican culture and life. Further, as

director of Liberty Hall, Donna McFarlane followed practice of the curator which is to collect, preserve, interpret and display items of arts, history and culture and society. She would do this by following twentyfirst-century new museum technology by signifying Blackness, self-identity, economic resourcefulness and placing Africa as a positive source of origins, grounded by the words and philosophy of Marcus Mosiah Garvey.

Restoration came through concerted and financial resourcing, the Ministry of Education, Youth and Culture via the Institute of Jamaica, the Jamaican National Heritage Trust, and the Friends of Liberty Hall. On 20 October 2003, National Heroes Day, the restored Liberty Hall was reopened and renamed Liberty Hall: *The Legacy of Marcus Garvey* stands as a cultural and educational institution and a living monument to Marcus Mosiah Garvey. It took an additional six years of construction, additional electronic and museum-related material equipment, instrumental fundraising and the massive efforts of experts and enthusiastic personnel to create the Garvey Multimedia Museum, the Garvey Research Reference Library, the Garvey Multimedia Community and the Garvey Great Hall. How this all came to be is the story of *Representing Blackness*.

Twenty-First Century Telling of Rte. Excellency Marcus Mosiah Garvey

This book, *Representing Blackness*, is an examination of the essential role that museums play in telling a people's history from the perspective of the majority culture, one born in the throes of colonialism, enslavement, post-emancipation, pre-colonial rule, manumission, independence and sovereignty under the heavy hand of globalization. These seven interlocking eras signalled in the way that Liberty Hall plays in telling that particular story of Jamaican society. For Donna McFarlane it was both the restoration of a historical building and a way to instil a corrective ideology that lauded Africa and Africa at home and abroad. Africa, the continent, its people and histories were valued diaspora connections for the majority of Jamaica's population who are black skinned. The legacy of Marcus Mosiah Garvey underscored the philosophical, social and cultural significance for all of Jamaica, and the mechanisms to achieve goals. In Liberty Hall, the museum positions Garvey, the national hero and the UNIA not as artifacts of the past but are emblematic of a set of ideas, perspectives and cultural understandings that can serve to inform and direct the public in the present and as they move forward into the future. Following the refrain of Dr Lonnie Bunch, founding director of

the Smithsonian National Museum of African American History and Culture, "there are few things as powerful and as important as a people, as a nation that is steeped in its history".[3]

Each chapter in *Representing Blackness* stresses the seven historical eras just mentioned that are enmeshed and underscored in at least four reoccurring thematic projects of *The Legacy of Marcus Garvey* and other activities that take place in Liberty Hall. All of these interlocking positions adhere to a decolonizing framework. Using Kenyan playwright and poet Ngugi wa Thiong'o's decolonizing perspective demands that we use a positive vocabulary, value naming practices used by the people, remember that the black intellectual tradition has given so much to the world but usually that knowledge is made invisible, that adverse effects of appropriation of ideas and resources abound, and finally that knowing your history/culture and society is a source for empowerment.[4] As I have argued elsewhere, history and intellectual authority rest with the people in the community, legitimizing those everyday standpoints as valuable outside of that setting.[5]

As groundwork, the first theme in *Representing Blackness* addresses the necessity for a new kind of new museum for Jamaica that centres its mission on national pride and history from the perspective of the majority of the people – black people. The requirement of "a new museum" means that it does not follow Eurocentric ideals but becomes an enactment of decolonizing museum work. A decolonizing museum recognizes the institution as a political space. Decolonizing the museum Wayne Modest, head of the Research Center for Material Culture and professor at Vrij University in Amsterdam, suggests that the museum must contest the very categories that in the past it usually promoted and must include "the idea of what an institution should be, and who the institution serves".[6] For Jamaica, as a post-colonial society requires a "new museum" to recognize the importance of instilling and affirming self-identity as a corrective measure against racism and colourism afforded by centuries of British colonialism. Aligned with understanding the deleterious effects of racism are issues of asserting self-esteem, self-awareness and the necessity of raising consciousness in service to the community it represents. History, culture and social awareness were part and parcel of the UNIA mission. Centred around positive self-identity, pride in history, self-reliance and education were the tenets of the philosophy by Marcus Garvey found in his publications, politics and public lectures. As Donna McFarlane often reminded her audience of one, in a lecture hall full of people, or over the airwaves, Garvey's philosophy holds true for now as it did in the early twentieth century.

Representing Blackness provides a mission statement that was followed by action. Adhering to Garvey's goals, Liberty Hall is the site of latest technological advances in museum curatorial exhibition. The action comes through touchscreens where Marcus Garvey speaks for himself, his history and that of the UNIA. The Marcus Mosiah Garvey Multimedia Centre allows children and adults alike to become immersed in the moment as their own personhood connects with the action on the screen. Then there is the computer centre that brings the whole world to a local poor community that often finds itself without electricity let alone personal access to this kind of technology. The Research and Reference library, the adult literacy program, the Garvey after-school program, the summer art program and many other activities support the efforts of all Jamaicans, but more importantly the poorest and the most downtrodden to see redemptive value of excising what Garvey called "mental enslavement". These programs are designed to promote self-reliance, to heighten self-esteem and to value self-worth through the guidance and support of staff who are generous with their time. As a community-based institution, Liberty Hall services the practical needs of those who live close by. Further, reaching out to all, the Marcus Mosiah Garvey Multimedia Center, the Research and Reference library and the exhibits showed that by January 2018, 60,000 students had visited Liberty Hall.[7] Moreover, there are international visitors who benefit as suggested by the *Lonely Planet Kingston* reports:

> At the end of a tree-lined courtyard, decorated with cheerful mosaics and a mural depicting Marcus Garvey, stands Liberty Hall, the headquarters of Garvey's UNIA (United Negro Improvement Association) in the 1930s. The building now contains a quite excellent multimedia museum about the man and his work, which allows the visitor to appreciate Garvey's impact as a founder of pan-Africanism.

"One Love"

Representing Blackness tells the story of the Rte Honourable, Marcus Mosiah Garvey, *The Legacy of Marcus Garvey: Liberty Hall*, but also the intellectual giant, Donna McFarlane, colleague, scholar, curator and activist. In tandem with the success of Liberty Hall, Donna McFarlane also earned a doctorate in Museum Studies from the University of Leicester (UK). Over the course of less than a dozen years, Donna McFarlane used her talents in securing funding from the Ministry of Education, Ministry of Culture, Gender, Entertainment and Sport, the Jamaican business community, Jamaican

foundations and agencies, technology giants such as Digicel, the Embassy of the United States and other international organizations for construction, redevelopment of facility space, the instillation of technology, children's activities and developing a lectureship among other museum projects. She cajoled and persuaded friends, family and supporters to donate money, goods and services, their time and energy to affect change for the local community in the name of *The Legacy of Marcus Garvey* and Liberty Hall. Special efforts came with Claude Nembhard, Donna's husband/life partner, who as an engineer, provided ideas, expertise, wisdom and comfort when things did not go smooth as anticipated. On 16 October 2017, the Government of Jamaica conferred the *Order of Distinction* on Dr Donna McFarlane as a citizen who "rendered outstanding and important service to Jamaica".

The Sankofa Bird

Housed under the umbrella of The Institute of Jamaica, Liberty Hall excelled in influence and in importance as a premier institution of education and intellectual pursuits in Jamaica

One of the African symbols found in Liberty Hall: *The Legacy of Marcus Garvey* is the Sankofa bird. The Adinkra Sankofa bird symbolizes the need to reflect on the past as to build a success for the future. In addition, as a symbol, Sankofa means taking from the past what is good and bringing it into the present in order to position progress through the beneficial use of knowledge. In this way, *Representing Blackness* serves as both a text and a guide for the decolonizing of museums. The life's work of Dr Donna McFarlane demonstrates that institutions that benefit and serve the people must represent love of country and provide necessary educational and social opportunity for their advancement.

A. Lynn Bolles, PhD Professor Emerita
University of Maryland College Park

Acknowledgements

First, homage is due to my mother Edna McFarlane and all my ancestors both known and unknown for anchoring my self-esteem, guidance, memory and perseverance to accomplish my goal. I thank Ms Elaine Melborne for choosing me to be the first Director/Curator of Liberty Hall and to design the Marcus Mosiah Garvey Multimedia Museum. Her faith in me opened up a world of opportunities to actualize my museological dreams. I thank all of my family and sister/friends who by listening to my ideas and engaging in discussion encouraged me onwards. Finally, I thank my husband Claude for believing in my journey and supporting me every step of the way with enormous love and quiet strength.

Chapter 1

Introduction – Museums at the Crossroads – The Making of the Marcus Mosiah Garvey Multimedia Museum

Everyone remembers their past
Building monuments, museums
Writin books
So that their children children will never forget
We must all learn from de past
So as not to repeat those things
That have kept us back for over 500 years
<div style="text-align:right">Mutabaruka, "Killin", Track 4, Melanin Man, Shanachie 45013, 1994</div>

In celebration of Garvey's centennial birthday in 1987, Liberty Hall (LH) at 76 King Street was declared a National Monument in the name of Jamaica's first national hero, and the Friends of LH set out in 2001 to restore the building with the intent to positively affect the lives of residents of surrounding communities. How all this happened is chronicled here as LH became a cultural educational institution that serves the surrounding communities first and all others. There are several points of interest raised in *Representing Blackness*. First, the book aims to present a modern museological approach utilized in creation of the Marcus Mosiah Garvey Multimedia Museum (MMGMM), the main teaching tool of Liberty Hall: *The Legacy of Marcus Garvey*, a new cultural educational institution where it is demonstrated that culture, identity, education, and community development are integrally linked. That is, the MMGMM and LH's outreach programmes facilitate interconnections between these critical elements that I believe are necessary to produce a transformative epistemology to counter the miseducation of Jamaican people. Secondly, LH's mission was developed to widely disseminate the philosophy and opinions of Jamaica's first national hero, from his perspective, and to use his philosophy and opinions to inspire, excite, educate and positively affect the self-identity of Jamaican people, while creating social and economic wealth. A third part of this story demonstrates the possibility of transforming museum

education to unlock the energies of Jamaican youth and adults for their social transformation is explored. Subsequently, the possibility of creating museums to provide education that is based on Garvey's creed of "African Fundamentalism" is presented. The essence of Garvey's philosophy with respect to politics, literature, history and culture is "Race Independence". That is, people of African origin must create their own heroes, write and criticize their own literature, and build their own strong nation (Martin 1991: 2). Garvey's elucidation of African Fundamentalism is summarized as follows:

> The time has come for the Negro to forget and cast behind him his hero worship and adoration of other races, and to start out immediately, to create and emulate heroes of his own. We must canonize our own saints, create our own martyrs, and elevate to positions of fame and honour black men and women who have made their distinct contributions to our racial history... Africa has produced countless numbers of men and women, in war and peace, whose lustre and bravery outshine that of any other people. Then why not see good and perfection in ourselves? We must inspire a literature and promulgate a doctrine of our own without any apologies to the powers that be. The right is ours and God's... Opposition to race independence is the weapon of the enemy to defeat the hopes of an unfortunate people. We are entitled to our own opinions and not obligated to or bound by the opinions of others (Martin 1991: 4).

Museums at the "Crossroads"

I believe that Jamaica's museums are at a crossroads in their determination of whether the path described above is consciously pursued, or curators continue to refrain from undertaking a critical examination of whose voice is favoured in historical narratives of representation. I believe that a fountain of work has been done (Lynch 1971; Nettleford 1972; Diop 1974; Garvey 1986; Walker 2006) that debunks colonial narratives that overtly reinforce superior/inferior binaries, and encourage negative self-identification, deeply inculcated in the psyches of Jamaican people. My examination of the congruence of the MMGMM with contemporary museum emphases on access, community participation, and relevance utilizes critical museum pedagogy concepts to examine narratives in selected exhibitions to highlight the educational role that Hooper-Greenhill suggests leads museums forward (1999) and which I believe is particularly important in Jamaica's museums. As the Director/Curator of the MMGMM my role here is to demonstrate that because the MMGMM represents the life, work, and philosophy of Marcus Garvey

from the perspective of enlightened scholarship; it is possible to explore the museum's power to instil pride in Blackness and reintroduce into collective memory Garvey's exhortation that people of African descent should

> Be as proud of your race today as our fathers were in the days of yore. We have a beautiful history, and we shall create another in the future that will astonish the world (Garvey 1986).

Conversely, the fact that race and colour stratification in society continues to affect the self-identity of Jamaican children, museums that reinforce positive representation of the people and their communities could be vehicles for its eradication.

The notion of the "crossroads" has the figurative meaning of "dilemma" – a situation in which a difficult choice has to be made between two or more alternatives. In African cosmology the crossroads is a sacred place, a strategic place; where ceremonies are performed; where troubles are buried; where the limitations of ordinary vision become acute (Thompson 1993). In the cosmography of Haitian myth, the crossroad is the most important of ritual figures.

> It is the point of access to the world of the les Invisibles, which is the soul of the cosmos, the source of life force, the cosmic memory, and the cosmic wisdom (Deren 1970: 35).

The book evokes the concept of "crossroads" as being the defining moment in Jamaica's post-colonial decolonization. Crossroads becomes the metaphoric point where we choose to bury the Eurocentric modality through which African-Caribbean history is elaborated and return to a path of Africology that escapes racist binaries and re-embraces African history from the perspective of enlightened scholarship. This is a point of renewal, reinvention and rebirth, which requires a fundamental shift in mindset and world outlook, therefore changes in the material conditions in which we constitute institutions and processes of intellectual, political, economic and cultural governance. The formulation of black self-identity within the boundaries of the cult of monarchy and empire that sought to mould Jamaicans into British colonial subjects will be explored as contributory to roots and origins of contemporary notions of self-identity. The fact that the ideology of colonial education, which was the norm in Jamaica's schools in the late nineteenth century, reinforced black subordination within the white hegemonic sociopolitical system. In other words, this is a decolonizing museum project (Modest 2019).

Through the MMGMM I therefore seek to redefine Jamaica's concept of museum at the crossroads of the twenty-first century to speak to the needs stated above to inspire, excite and raise consciousness and confidence, particularly in African-Jamaican visitors to the museum space. Further, in the spirit of Garvey, the work of LH combines culture with opportunities for economic regeneration, as the two processes are required for achievement of true freedom. The book highlights how the MMGMM constitutes a radical departure from Jamaican museology by analysing how the museum's narrative was constructed, whose interpretation was privileged, and the method chosen to represent the history. In sum, the book provides a critique of the European model museum and shows the transforming power of a decolonizing museum perspective using the life and works of Marcus Mosiah Garvey as a core example.

The emphasis on African fundamentalism is to counter the five centuries of Eurocentric oppression of African-Caribbean history that inculcated in the minds of black and white people the idea that the African is synonymous with "savage". Britain's system of education after 1865 through propaganda and manipulation mandated and supported Jamaicans in their belief that they were British subjects united in their purpose and affinity with British citizens in England. That is, if black Jamaicans, perceived by the British to be absent of self-identity, identify with Britain as their "mother", they would then be imbued with white values and thereby deemed civilized.

The psychoanalytic work required to tackle the unreality of many beliefs that black people hold, that is, hero worship and adoration of other races, cannot be tackled with nuanced approaches to teaching Africa's history (Fanon 1967: 141–210). I argue in support of Garvey's position that black people must first see perfection in themselves through Afrocentric historical perspectives to raise positive self-identity and that museums can be strategic tools in this exercise.

I utilize the term Blackness not to relate to skin colour but to recognition of people of African origin north and south of the Sahara whose history spans some 195,000 years as opposed to the five hundred years, beginning with the European transatlantic trade in Africans, that their descendants in the African Diaspora are taught in schools. It refers to political allegiance, culture, history and a plethora of accomplishments and challenges faced by them that have been systematically devalued and/or erased but which can be retrieved.

In sum, Garvey's demonstration of the power of knowledge led him to create the Universal Negro Improvement Association and African Communities League (UNIA-ACL), the largest black organization ever. The

objective here is to demonstrate that in the processes of representation in Jamaica's post-colonial museums, there is broad paradigmatic utility in the philosophy of Marcus Garvey as demonstrated in the making and operation of the MMGMM. And further, whether the use of such a paradigm could positively affect the social and economic development of communities that surround museums.

Jamaica: Setting the Stage

Like many English-speaking post-colonial societies, Jamaica celebrated its fiftieth birthday in 2012. While contradictions abound in the psyche of the people, there have been demands for changes in the educational structure – curriculum and teaching methodologies – and pronouncements regarding the importance of teaching the philosophy of Marcus Garvey in primary and secondary schools.[1]

Over the past four decades or more, historians have rewritten colonial histories relevant to Jamaica and the Caribbean with the aim of widely disseminating it to people of African descent in schools. However, access to education in the Caribbean is not egalitarian, and these books are mainly written at the tertiary level. It is understood that these rewritten histories will positively affect the self-identity of the majority black population and contribute generously to African regeneration when the material is distilled for children of all ages. Thus, a role for the State is to ensure that deconstructed historical knowledge is taught at the level of primary schools where poor children in rural and urban inner-city areas who may not achieve tertiary level education can get access. As an integral, yet not fully tapped, component of the educational structure, museums have a role in representing deconstructed histories in museum exhibitions.

Jamaica's museums, during colonialism, were understandably the bastions of Eurocentric histories and representation of their geographical and scientific interests for the consumption of the ruling class and their progeny. Yet in 1961, with the imminent arrival of Independence in 1962, colonial authorities set out to create the Folk Museum (later renamed the People's Museum of Craft and Technology in the 1970s) as the first museum to represent, though not clearly stated, Blackness in Jamaica. With this effort, colonial authorities seemed to attempt to recalibrate the self-identity of Jamaicans away from being British (an approach that was energetically pursued for nearly one hundred years after the Morant Bay War in 1865 and the establishment of Crown Colony Rule) towards adaptation of its new identity as "Jamaican". At the outset, the Folk Museum benefitted

tourists who were the museum's main visitors. But as visits of school children overtook tourists in numbers ten years after Independence, the museum's subtle narrative of African Jamaican's underdevelopment did little to instil pride in accomplishment and resilience after emancipation. If the role of a museum is to interpret and preserve of culture of the people, then much work in terms of representation of the majority is to be done as the case of Jamaica's Folk Museum clearly indicates. Following the decolonizing museum model, and as other scholars have called for, is for those institutions to change from being elitist to being more inclusive to remain current, relevant and sustainable. Hooper-Greenhill explains that:

> Looking back in the history of museums, the realities of museums have changed many times. Museums have always had to modify how they worked, and what they did, according to the context, the plays of power, and the social, economic, and political imperatives that surrounded them. Museums, in common with all other social institutions, serve many masters, and must play many tunes accordingly (1992: 1).

The Institute of Jamaica (IOJ), established in 1879 for the encouragement of literature, science and art, is responsible for the development of museums throughout Jamaica. Its early colonial paradigm limited access to the mass of Jamaican people and its subject choices for representation fostered their further alienation. Since the late twentieth century, the IOJ operates small community museums but without the necessary professional and financial resources to ensure widely researched representation; inclusion of communities surrounding museums in the representation process; or to create blockbuster exhibitions that attract new audiences. Further, a limitation of the IOJ's small spaces is that its vast collection of Jamaica's material culture languishes in its storerooms. The IOJ's divisions include:

National Museum Jamaica (formerly Museums of History and Ethnography): People's Museum of Craft and Technology; Taino Museum of the First Jamaicans; Fort Charles Museum; Hanover Museum; and the Museum of St. James

The Programmes and Coordination Division (Junior Centres)

Natural History Museum of Jamaica

The National Gallery of Jamaica

Jamaica Music Museum

African Caribbean Institute of Jamaica/Jamaica Memory Bank; and

Liberty Hall: The Legacy of Marcus Garvey: Marcus Mosiah Garvey Multimedia Museum

The educational role of the museum, which is largely concerned with education, interpretation and communication (Hooper-Greenhill 1999), also seeks answers to questions of what counts as "knowledge" in museums. Specifically, if research proposes that race is a significant factor in "the evolution of hegemony, the way in which society is organized and ruled" (Omi and Winant 1994: 56); then it should be a significant factor in representation in post-colonial societies like Jamaica that has to be challenged and overcome.

Representing Blackness will demonstrate how museum education can contribute to loosening what Marcus Garvey referred to as the bonds of mental enslavement existing in the minds of Jamaican people and form the basis for greater self-understanding, increased consciousness and self-identity (Garvey 1986). The book focuses on the MMGMM in Jamaica as an example of development of a community museum that inspires, excites and educates, while raising the self-esteem and self-identity of its majority viewers.

Chapter 2

Museums in Jamaica

Injecting a Good Dose of English Culture; Restoring Blackness at the Core

Culture is the matrix on which the fragile human animal draws to remain socially healthy. As fish need the sea, culture with its timeless reassurance and its seeming immortality offsets for the frail human spirit the brevity, the careless accidentalness to life. An individual human life is easy to extinguish. Culture is leaned upon as eternal. It flows large and old around its children. And it is very hard to kill. Its murder must be undertaken over hundreds of years and countless generations. Pains must be taken to snuff out every traditional practice, every alien world, every heaven-sent ritual, every pride, every connection of the soul, gone behind and reaching ahead. The carriers of the doomed culture must be ridiculed and debased and humiliated. This must be done to their mothers and their fathers, their children, their children's children, and their children after them. And there will come a time of mortal injury to all their souls, and their culture will breathe no more. But they will not mourn its passing, for they will by then have forgotten that which they might have mourned (Robinson 2000).

The Culture of Museums

One of the objectives of creating a "new museum", that is Liberty Hall: *The Legacy of Marcus Garvey,* was to create a different kind of institution that did not follow a Eurocentric model. For many years the IOJ followed the British colonial relationship constructed between museums and the educational system. Here, the discussion looks at the connection between the Eurocentric model museum and how this relationship impacted Jamaica's students.

As alluded to in the above epigraph speaks to the deliberate, considered, systematic and trans-generational approach taken by colonizers in their making of enslaved/free men and women/or loyal British subjects. It is within the context of this quote that I explore the IOJ, which, for at least

ninety-two years (1879–1971), was true to its creation as the main vehicle whereby all things European were deified as high culture, worthy of collection, research and display, while disregarding the traditional practice, language, religious ritual – in other words, the culture – of the majority African-descended population. According to Rex Nettleford, the old "plantation system" continued "not only in terms of economic dependency but also in terms of an abiding Eurocentrism which puts everything European in a place of eminence and things of indigenous (i.e., native born and native bred) or African origin in a lesser place".[1]

Development of cultural institutions was not considered the responsibility of government. In fact, it was normal in Britain for rich benefactors, and in the case of Jamaica, for members of the elite to undertake efforts to establish museums. In 1846 the Jamaica Society Museum opened in Kingston, and in 1864 two entities the Royal Society of Arts and the Royal Agricultural Society of Jamaica amalgamated[2] to form the Royal Society of Arts and Agriculture. In 1879, forty-one years after Emancipation, and fourteen years after establishment of Crown Colony Government, Sir Anthony Musgrave, a white Antiguan and the then Governor of Jamaica (1877–1883), established the IOJ for the encouragement of literature, science and art along the lines of the South Australian Institute (1856) and vested it with responsibility for public museums.

By Law 22 of 1879 a Board of Governors of the IOJ was created and in it vested responsibilities for establishment and maintenance of:

> an institution comprising a library, reading room and museum, to provide for the reading of papers, the delivery of lectures and the holding of examinations on subjects connected with literature, science and art; to award premiums for the application of scientific and artistic methods to local industries and to provide for the holding of exhibitions illustrating the industries of Jamaica.[3]

In practice, the IOJ was the institutional manifestation of British intellectual and cultural imperialism, which promoted the racial and cultural interests of the dominant white minority whose leadership in every facet of Jamaica's political, economic (mainly agriculture and trade) and cultural life was undisputed.[4] The reality was that white creole Jamaicans lacked the training/exposure of their British-grown counterparts and demonstrated no serious inclinations towards intellectual pursuits.[5] Their main interests were not in social and cultural institutions – such as libraries, theatres, museums, entertainment centres, colleges or universities – that in Europe characterize "civilized" societies but rather centred on activities that

promoted the export of tropical agricultural products from which they garnered considerable wealth.

From the outset, therefore, IOJ was established as a model to demonstrate to white Jamaicans, and those who aspired to be, the mores and institutional trappings of the British cultured elite and to encourage in them replication of that behaviour. The framework was set through its application and membership requirements that necessitated approval by the Board of Governors; subscription fees of five shillings with extra payments for borrowing additional books; and a dress code disguised in the terms "decently clad"; all geared to keep black working-class people out of the reading rooms.[6]

Frank Cundall (1858–1937) was recruited from England by Governor Musgrave to take up the position of secretary and librarian of the IOJ. For forty-six years – from 1891 to 1937 – with minimal support from the government, Cundall set out to gather a collection of books and pamphlets, original manuscripts, and maps and plans on Jamaica and the West Indies which he believed would be a credit to Jamaica. In 1892, through his overseas connections, a collection of twenty-five portraits of British historical notables was presented at the opening of a new IOJ Art (History) Gallery.[7] The collection grew to contain 420 portraits of Jamaican governors and other European notables and 245 paintings and engravings. Cundall's collection choices spoke volumes about the imperial message he intended to foster and portray in Jamaica.

In keeping with the practice of the times, the museum's collection was mostly confined to natural history, consisting of an almost complete representation of the flora and fauna of Jamaica as well as its geology and anthropology, particularly objects connected to Jamaica's indigenous Taíno population – stone implements, perforated shells, broken pottery and beads. There were also a few implements of torture used during enslavement in the collection. Cundall was a prolific writer and was the author of thirty-one publications, of which twenty-one are about Jamaica's social, historical, political and art histories,[8] areas where he perceived deficiencies of knowledge.

Cundall's loyalty to and support for the colonial system of government permeated throughout his writings and served as propaganda tools to under-report the living conditions of the majority black population and ensure concealment of the horrors of the colonial system of government. His views on the black population in 1928 are summarized thusly:

> The negro race has at present gone but a short way on the path of civilisation. The individuals are still as children, childlike in belief and faith ... They too often lack

pride in their work ... Gratitude is, it is to be feared, not a strong point with many of them ... As a race they are certainly not artistic.[9]

Although he disregarded the material culture of African Jamaicans, he assiduously compiled and published their traditional knowledge which he titled "negro" proverbs, although disparaging them as "sententious and quaint, and interesting as illustrative of negro thought and character".[10]

By Cundall's death in 1937, the IOJ's collection consisted of 11,783 items, including books and pamphlets, original manuscripts, newspapers, maps and plans, which became known and revered as the West India Reference Library and eventually formed the basis of the National Library of Jamaica.[11]

The Jamaica International Exhibition 1891

The nineteenth century ushered in an age of international expositions, which, in effect, were public museums, and Britain's Great Exhibition of 1851 at London's Crystal Palace paved the way for exhibitions and world fairs across Europe and the United States. "As a collective phenomenon the industrial exposition celebrated the ascension of civilized power over nature and primitives".[12] The unprecedented scale and extravagance of the expositions and the grand buildings in which they were housed demonstrated the wealth and opulence of the presenting nation and provided opportunities for comparisons between them, as they competed to be the first or the most adept at appropriating peoples and raw materials, and transformation of the world through invention of machines, trade, military might and political and cultural imperialism.

These exhibitions in Paris, Hamburg, Antwerp, Barcelona, London, Milan, Warsaw, Chicago and New York, to name some of the exhibiting cities, usually featured human zoos – popular exhibitions of Africans, Native Americans, Eskimos and others; human beings in cages with animals (i.e., Africans with monkeys to demonstrate social Darwinism), or seemingly going about daily life undisturbed by gawking crowds in replicas of their environment, villages and homes. Human zoos represented non-Europeans as "other" – primitive and "different" in outward appearance and lifestyle, while celebrating the ascension of Europeans as civilized colonial powers.[13] Of the Paris Exhibition of 1889, curator of ethnology at the US National Museum Mr Otis T. Mason reported admiration for the educational value for viewers of "live" exhibitions.

Mason reported enthusiastically on the twelve African villages and the Tonkinese temple with Buddhist priests performing rites. The crowds, he noted, thronged like children to watch exotic peoples in their daily routines.

"It was an exposition," he wrote home, "whose presiding Genius was a teacher, a professor of history, whose scholars were the whole world".[14]

In 1891, Jamaica's colonial government, led by Governor Henry Blake, agreed to organize an international exhibition in Jamaica. The exhibition's organizing committee, including Frank Cundall and others, set out "to make the show in all respects a comprehensive and practical illustration of the various resources of the colony"; to showcase to the world its success in transformation of Jamaica's tropical raw materials with British technological know-how; to demonstrate that Jamaica was also a viable market for imported goods; "to acquire new business ideas and skills to jump-start the chronically ailing colonial economy"; and to provide entertainment, information and education. Further, promotion of Jamaica as a tourism destination was an expected spin-off.[15]

Accounts of the exhibition's planning process relate that committees were formed in England, Scotland, Canada, and the United States (New York), as well as across the island. The planning committee in England resolved to provide the English machines that added value to Jamaica's raw materials, as well as the finished product that was exported back for Jamaica's consumption:

> machines or models showing the latest improvements in the manufacture of sugar and rum, the extraction of coconut and other oils by compression, the preparation of coconut coir or fibre, the extraction of fibres from the leaves and stems of plants, machine and appliances for curing and preparing coffee, cocoa, pimento, annatto, spices, ginger, meals, starches, dyes, essential oils, perfumes and medicinal substances: fruit drying machines, small windmills, turbines and other time and labour saving machines.[16]

Jamaica's parish committees determined what products would represent their industry. Products made from sisal hemp and silk grass plants, plant oils and potter's clays were presented; substitutes for wheat flour such as meals made from banana, yams, breadfruit, cassava and other products; and exhibits of cigars, cigarettes and tobacco solicited high praise. Industries such as beekeeping and dairy, sugar and rum, coffee and cocoa were showcased, while the IOJ presented displays of its maps, mineral products, botanical specimens as well as a working potter.

While the African spiritual practice of Obeah was vilified socially and in Jamaican law by Britain, perhaps to drive home the point of the continued need to "civilize" Jamaica's people of African descent, the parish committees requested that African-Creole curiosities such as "talismans", "charms, and implements and materials" used by Jamaican "obeahmen"

be submitted. African Jamaicans were also encouraged to identify their medicinal plants for inclusion in the exhibition as well as their craftwork: baskets, "jippi-jappa" hats, mats, bamboo pipe stems, napkin rings and flowerpots. African Jamaican peasant cottages made from mud and thatch were also exhibited. A slave collar and slave branding iron were associated with enslaved African Jamaicans,[17] while ironically not exhibited as manufactured products of England's ironworks produced to dehumanize Africans and transform them into property.

In keeping with the popularity of human exhibitions, in addition to replicas of a miniature printing office and a bookbindery where Negroes demonstrated the processes of book production, fishermen making nets and peasants demonstrating operations of small sugar mills and the processing of coffee were included. The "exotic" feature of the exhibition was further fulfilled by six Amerindians from St Vincent exhibited in replicas of their own houses, dressed in their native costumes and surrounded by their own utensils, implements, weapons and the results of their own handiwork.[18]

The Jamaica International Exhibition opened on 27 January 1891. Like its predecessors in Europe and the United States, whose exhibition hall architecture alone demonstrated its achievements, the exposition was housed in a specially constructed 3,716 m² building described as Moorish[19] in style, and named Quebec Lodge. It represented an investment cost of £14,300, provided by three individuals[20] and matched by a public solicitation of funds to bring the total cost to £30,000. It was designed by British architect George Messiter, constructed of imported American wood and built solely by Jamaican labour under the supervision of the Public Works Department. It looked very much like London's and New York's Crystal Palace of 1851 and 1853, respectively.

The exhibition was described as "the most extraordinary commercial event in the history of the Gulf of Mexico and the West Indies".[21] Canada, the United States, Europe (Britain, Italy, Austria, France, Belgium and Germany), and planters from other West Indian territories (Turks and Caicos, Windward Islands, Bahamas, Barbados, St Vincent, St. Lucia, Grenada, Grand Cayman and Suriname) exhibited products.[22] More than three hundred thousand people attended, including rural black Jamaicans who – encouraged by the governor's announcement that entrance would be free on 24 April,[23] and in spite of rumours[24] – attended during the last days of the exhibition.

On the other end of the spectrum of British colonial rule purviews was the rhetoric of Black Power that took flight in the early twentieth century in the United States through the success of Marcus Garvey's UNIA-ACL.

This was the effort to push forward an African-centred economics, history and cultural orientation that affirmed pride in African racial identity. For the next two decades, the UNIA-ACL publications, art and social programs instilled with African pride and confidence was anthesis of the "exotic" exhibitions mounted in 1891.

The suffering of black workers; the need to embark on a process of self-discovery and self-liberation that decried the Euro-African self-rejection that was preached to black people at the pulpit and in the classrooms, and the demand for an increased share of the wealth of the country became the rallying cry at the end of the 1930s. Garvey's influence on the politics of the times was reflected in the work of poets like Una Marson and Claude McKay, who forged Jamaican literature that was inspired by African-Jamaican historical experience,[25] and influenced the perspectives of Jamaica's emerging leaders.

The views of Norman Manley,[26] expressed in 1939 at the height of the labour unrest in Jamaica, called on teachers to help build a new Jamaica with a vision of the future that was based on history that honoured their own experiences. In essence, he struck out against British hegemony, specifically of Jamaican history, and its construction of the cultural annihilation that occurs in schools, which results in increased self-hatred and loathing for one's own race.

Despite the effect that these events had on the black masses and the utterances of Jamaica's political leadership, Britain maintained a stranglehold on the content and emphasis of history taught in schools and that version of history was carried forward by Jamaica's intelligentsia of both races.

For example, in the Minutes of the IOJ's Board of Government meeting on 23 May 1957 with the closure of the St Andrew divisional office of Marcus Garvey's UNIA-ACL, the Board was asked to accept a portrait of Marcus Garvey for display in its museum. The Council conceded acceptance of the portrait but indicated in the minutes that the portrait "could not be considered of artistic merit but that the frame was particularly remarkable". While they concluded "that there was no doubt that the portrait was of considerable historical interest in connection with the UNIA movement in Jamaica ... great care should also be taken that the Board would not be expected to perpetuate a Garvey shrine at the Institute".

Libya, an Italian colony, became the first African country to attain independence in 1947. It demonstrated its achievement with a flag correctly configured in the colours of then UNIA-ACL. 1957 was the year of Ghana's independence and its first President, Kwame Nkrumah, emblazoned

Garvey's Black Star in the middle of Ghana's flag and named its shipping line the Black Star Line in homage to Garvey.

Up to 1961 collecting the material culture of black Jamaicans and representing blackness in museums was never considered the responsibility or interest of the IOJ. As earlier stated, from the outset, funding for museums was not seen as the responsibility of the government, and the IOJ's role was viewed as providing valuable advice to private museum initiatives.

Charles Bernard Lewis was curator of the IOJ from 1939, and its director from 1950. J.E. Clair McFarlane, African Jamaican, poet laureate and chairman of the Board of Governors of the IOJ, appealed to the new governor of Jamaica, Sir Kenneth Blackbourne (1957–1962), to revisit renovation of Kings House in Spanish Town for the purpose of construction of a national museum. Blackbourne agreed to the request and established a committee that decided on a three-tiered approach:[27]

1. The repair of the stables and the establishment of a folk museum.
2. The construction of the main framework of a building behind the existing facade to ensure preservation of the facade.
3. The final restoration of the main building for use as a national museum.

There is little explanation, however, regarding why or whose idea it was to create a folk museum and how it obtained the privileged place of first tier on the committee's approach to restoration of Old King's House. Did the idea emerge out of discussions about Jamaica's impending independence? Why did the Committee believe that the stable was the appropriate venue for the Folk Museum when the main building was considered for the National Museum?

Many of the objects called for by the Governor for inclusion in the Folk Museum were in use on plantations during and after enslavement. These included the branding irons and shackles of the enslaved; sugar mills and boiling coppers, corn mill, coffee huller, and saw pit to name a few, which were the same tools and machines that were provided by the 1891 London Committee as demonstrative of the British Empire's industrial successes in producing machines to process the raw materials of Jamaica and the wider Caribbean. This museum, planned by the Governor, could have, in large part, been named the Plantation Works Museum. With few objects requested of or donated by the folk in question, Jamaica's history of chattel enslavement, post enslavement and colonialism as contributory to the existence, creation or use of the objects by African Jamaican folk, is left unexplored or explained.

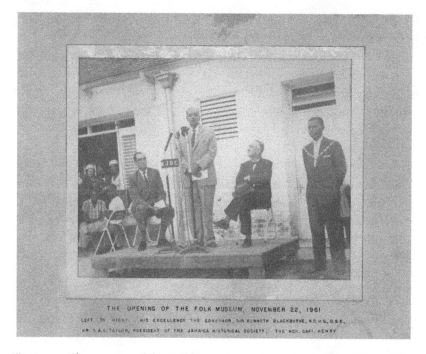

Figure 2.1. The opening of the Folk Museum 22 November 1961 Archives of the Institute of Jamaica, Museum Division p. 30.

Although the British in Jamaica prided themselves on staging official ceremonies usually adorned with decorative banners, flags, flowers and the like, the Folk Museum was opened on 22 November 1961 (see figure 2.1) with little fanfare and with little involvement of African Jamaicans.

Archives of the IOJ, Museum Division
Museum Development After Cundall (1939–1961)

Independence in 1962 increased the pace of the march towards defining a Jamaican culture and personality distinct from Britain for the majority population, even while assessing the meaning of identity after more than four hundred years of enslavement and colonization. In this regard, Rex Nettleford noted that:

> the African presence has not been given its proper place of centrality in that dynamic process of adjustment, adaptation, rejection, renewal, and innovation. For the products of this cultural process are what constitute the mandates for a national cultural expression.

A Shift in Focus: 1971 to Twenty-First Century

With the end of colonialism in the 1960s, people of African descent in Africa and its Diaspora were no longer content with the limited substandard education available to them that fashioned them into the functionaries, "little men and women", office clerks and poorly paid labourers required for the smooth operation of business. The relationship between dominant and subordinate was being renegotiated amidst issues of ambivalent self-identity, deification of Europe and Europeans by the black masses, and denigration of all things African.

The 1970s, with its Black Power movements throughout the African diaspora and notably in Jamaica and Trinidad and Tobago, stirred debates in Parliament over the place of arts and culture in national development, and the challenge that appeared to be the "elephant" in the room was "to restore to the vast majority of its [black] people human dignity through their own cultural growth and development".[28]

For the period 1937 to 1971 successive IOJ directors and curators demonstrated no inclination to challenge or escape the epistemology of colonialism as it relates to representation of Jamaica's black population. In 1971, when Neville Dawes, the IOJ's first Black Executive Director was appointed, he ushered in a marked change in the IOJ's direction, as he declared his mission to use culture as a catalyst for development of all Jamaicans, particularly underprivileged children, whom he observed were being left out of the "national" feeling of being a Jamaican.[29]

This might have been the catalyst for change within the IOJ, as for the first time its administration considered the needs of African-Jamaican communities in programme planning. Dawes was instrumental in defining the role and purpose of the African Caribbean Institute of Jamaica as a research arena for Afro-Caribbean music, dance and speech.

Dawes prepared a cultural policy for Jamaica, commissioned by UNESCO in 1979. In his role as executive director of the IOJ, he acknowledged that Jamaica was at a crossroads in its cultural development and had to choose between remaining within the European cultural paradigm or return to African cosmologies to retrieve and learn from the culture of its majority black ancestors. He wrote:

> Culture and cultural development in Jamaica are on the threshold of transition and transformation from a situation where 'approved' cultural material and a set of activities were the preserve of an elite trained to foreign norms, to a democratic situation in which the materials of culture belong to all the people and draw their strength from authentic folk traditions.[30]

His focus gave full weight to the historically neglected culture of the African Jamaican in development of cultural policy. Dawes points out that even in the 1970s The National Library of Jamaica still showed a film strip to students that stated that Africans on the plantations were only shifted from one vicious form of enslavement (in Africa) to a more pleasant form of enslavement in the Caribbean.[31] He concluded that the Council of the IOJ was critical to the transformation, in that they must make all efforts to "communicate valuable cultural works to all sections of the community".[32] To take the necessary corrective action, Dawes shifted the IOJ's epistemology established by Cundall in the 1890s by raising questions about whose cultural knowledge is valuable and valued by the institution and answering by privileging African Jamaicans in its collection and representation practice. The Folk Museum was restructured and renamed, and on 29 December 1979 Dawes officially launched The People's Museum of Craft and Technology to pay tribute to the spirit of innovation, self-sufficiency and resilience of African Jamaican people.

Dawes demitted the office of the executive director of the IOJ in 1981, shortly after a change of government – the Democratic Socialist People's National Party (PNP) lost to the historically conservative Jamaica Labour Party (JLP). Since then, Directors and Curators with responsibility for the Peoples Museum have added African retentions in the form of traditional religions and more to the exhibition. Many temporary exhibitions have been successfully mounted by the IOJ in the National Museum Jamaica (formally named Museum of History and Ethnography) to represent the history of African Jamaicans. These include, "Of Things Sacred" (2005) (African-inspired religious retentions), "Sly Mongoose" (2002) (Jamaican ska/Mento Music), "Modern Interiors: Jamaican Style 20th Century Furniture in Jamaica" (2007) (Exposition of African Jamaican Furniture Makers), "Materializing Slavery" (Summer 2007) and "Rastafari" in collaboration with the Rastafari mansions in Jamaica in 2013.

However, there was no nod to any concept of "new museum" theory and method as exemplified by one of the exhibitions "Xaymaca: Life in Spanish Jamaica" (2009). This exhibit which commanded a very high profile, was opened in the presence of their Majesties, King Juan Carlos I, King of Spain, and Queen Sophia. Founded on European historical narratives about the Caribbean that accept[s] "it was purely triumphalist, European-centred terms of the displacers",[33] rather than on the work of enlightened African/Caribbean scholarship that debunks those narratives.

Although exhibitions before Xaymaca in 2009 and after seem to chronicle the black Jamaican experience, there remains a need, from a

policy perspective, to ensure that the history exhibited is widely researched; that the material culture collected reflects the evolving nature of Jamaica's culture; and that involving the inner-city communities surrounding National Museum Jamaica is considered. Further thought is the renaming of The Musgrave Medal.

In 1889 to memorialize the 1888 death of the IOJ's founder, Sir Anthony Musgrave, The Musgrave Medals in recognition of notable contributions in literature, science and art in Jamaica and the West Indies were instituted and have since been the highest honours in those fields. The Musgrave name celebrates successful implementation of Britain's imperial plan in Jamaica – associated excellence with Europeans – and to continue its nomenclature extends its influence. However, a change of the name of the Musgrave Award to an African/Jamaican man and woman who are widely considered representative of the best of Jamaica's black intellectual and cultural development would be most culturally reaffirming. Renaming the award after African/Jamaican man and woman then would communicate valuable restorative cultural messages to all sections of the majority African Jamaican community.

In the twenty-first century, the IOJ continues to struggle with the transition and transformation envisioned by Dawes, which, in my estimation, needs to be addressed by deliberate, decisive action that breaks resolutely with the colonial past. Representation of the culture of African Jamaicans requires giving it agency and privilege over and above the culture, and language of the colonizer and in so doing restoring to the people "their traditional practice, every heaven-sent ritual, every pride, and every connection of the soul". Decisive action could be that the IOJ first institutes a policy that ensures that the Director of the IOJ's Museums is of African/Jamaican heritage whose knowledge of Jamaica's history and commitment to pursuing historical transformation for the benefit of Jamaica's majority population is unquestioned.

Chapter 3

Paving the Way for a Museum for the Jamaican People

Agency and identity are important to the analysis of Jamaican people's engagement with museums. Therefore, these two concepts are guiding principles of *Representing Blackness* and the making of Liberty Hall: *The Legacy of Marcus Garvey*. The term agency implies how person(s) make decisions on behalf of the majority of people that support the groups' sense of control over who tells their history. Socially interlocked with agency is the concept of self-identity. Self-identity connotates an understanding that the necessary condition of individual qualities, beliefs, personality, looks and / or expressions is framed by political and historical contexts, characterized by issues of race, class and ethnicity. Jamaican people's participation and access to museums are limited particularly for the majority who constitute the poor for whom possibilities of moving into and belonging to particular sites of activity and power are non-existent (Grossberg 1996). However, all of Jamaica's public museums are within communities occupied by poor people, yet there is little identification with exhibitions. The Folk Museum is a case in point as its intent seemed to be to represent Blackness in pre- and post-plantation life, yet for the black population surrounding the museum there is little identification with, attachment to, involvement with or ownership of the museum. In addition, the National Gallery representing the fine art of Jamaica's predominantly black master artists is surrounded by inner-city communities and yet was for most of its life reserved for Jamaica's elite. Thankfully this has changed.

Identity in Jamaican society is contested space. There are continual debates and calls in the media for re-introduction of civics in the curriculum. This signals recognition of a problem with citizenship. In other words, the need for individuals to define Jamaica for themselves and others as a place to which "we" belong, find our way to, and at the same time acknowledging and respecting the differing ways in which people participate in social life (Grossberg 1996).

The call is also for the teaching of Garvey in schools mainly to attack issues raised by the lack of acknowledgement of Blackness as a source of

pride demonstrated by the increased prevalence of skin bleaching among and across the population. Ambivalence with regard to skin colour, shape of nose and other body-specific traits are tackled by Fanon and Garvey (1963, 1967, 1986) and is elucidated in the course of my work at LH.

I contend that racism created an historical totalitarianism in which world history, chronicled in widely used history books in schools, until the latter part of the twentieth century in the West, Europe and Africa reduces the indigenous peoples of the Americas and Africans to primitive, cannibalistic and uncivilized beings, while presenting images of Europeans as adventurous, technical and scientifically motivated, and their geographical conquest as inevitable and humane.

Scholars (Fanon 1963; Cesaire 1972; Nettleford 1972; Freire 1973; Garvey 1986) have demonstrated that these raced views of the world "help support a legitimating ideology and specific political action" (Tate 1997: 199) which continue to have negative effects on the self-esteem of African-Caribbean youth who imbibe this history and measure themselves against falsely concocted white cultural and intellectual norms and on white youth upon whom are conferred universal superiority simply by virtue of skin colour. There is great value, then, in the examination of the foundations of racialized history in conjunction with the inferiority paradigm which includes evaluation of issues of power and empowerment.

Haney Lopez (1996: 14) provides a legal description of race:

> Race can be understood as the historically contingent social systems of meaning that attach to elements of morphology and ancestry. This definition can be pushed on three interrelated levels, the physical, the social, and the material. First, race turns on physical features and lines of descent, not because features or lineage themselves are a function of racial variation, but because society has invested these with racial meanings. Second, because the meanings given to certain features and ancestries denote race, it is the social processes of ascribing racialized meanings to faces and forbearers that lie at the heart of racial fabrication. Third, these meaning-systems, while originally only ideas, gain force as they are reproduced in the material conditions of society. The distribution of wealth and poverty turns in part on the actions of social and legal actors who have accepted ideas of race, with the resulting material conditions becoming part of and reinforcement for the contingent meanings understood as race.

At issue here is how did race, based on a Eurocentric ideology that references skin colour, deemed "white" with civilization, intelligence and power was inculcated by European colonial forces and perpetrated over centuries. Through European expansionism into Africa from the fourteenth century up until post-Second World War, the valuation of people, cultures and

histories coming from Africa and those descendants who were transported to the Western Hemisphere as enslaved persons were demeaned socially and politically. Clearly, black people were denied their own agency as to who could tell their histories. Subsequently, myths and misrepresentations of blackness prevailed. This chapter looks at how Africa is represented in two popular sources of information. The first are encyclopaedia's that are readily available as educational resources in schools and libraries. Prior to the wide accessibility of the internet, most school-aged children relied on these texts as primary sources. The second are museums that when visited provided material objects for discovery accompanied by supporting explanatory text.

One of the social processes that ascribe racialized meaning is the system of education. Throughout the African Diaspora scholars have recognized that there is a crisis in black education (Fanon 1967; Cesaire 1972; Freire 1973; Garvey 1986; King 2005). Scholars, who are not confident in their academic location seemingly are forced to choose between the so-called objective curriculum which negates or misinforms about the "true" history of African people and that which contests the normative paradigm and offers an enlightened African-oriented perspective.

Those black intellectuals and educators who faced issues related to whose history is privileged from the standpoint of epistemological bias, globalization and hegemony were often silenced.

As late as the 1970s the chronicling of a Eurocentric perspective held sway, despite of the scholarship that showed otherwise (e.g., Davidson 1992; Araújo and Maeso 2011). Although based on myth and misinformation, there is this antiquated view of Africa that still holds dominance in some quarters as it reinforces eurocentrism and racism. The power of this point of view fuels various political agenda now verbalized in alt-right doctrines.

Going back to the 1970s, consider an entry in an established encyclopaedia that begins African history with European conquest and the removal of Africans to the Americas as enslaved. Collins' entry in *The New Age Encyclopaedia* (1977: 111–12) begins the introductory section on Africa with a summary of the continent with opening remarks that refer to Africa as an "ancient Roman province" and Rome's "prosperous granary". He then moves swiftly from the statement that Africa was seized by the Vandals in 429 AD, to the political phenomenon of colonial rule, and mid-twentieth century independence which is illustrated by images of Masai and Kikuyu dancers under a caption that reads: *Africa, the last continent to develop its potential*. Independence was achieved, according to Collins, because of imported nationalist ideas from Europe and the West in the

minds of African students who travelled abroad for education, and by the example set by nationalist movements in Asia and the Middle East. For him, African independence could not have been because of African commitment to reclamation of their land and freedom from colonial powers. Robert Collins was a widely published historian and is known for his unabashed enthusiasm for contributions Britain had made to the lives of colonial people. Clearly, he underscores European privilege in writing in a form that is recognized by them over oral historiography and other African methods of recording unknown to them. It is therefore the observations of explorers, adventurers, botanists, tourists and others that are used to construct what over time became Africa's history.

The *World Book Encyclopaedia* (Bohannan et al. 1976) begins its Africa section with the size of the continent, its rich mineral and agricultural wealth, and the statistic that only 10 percent of all adult Africans can read and write (Bohannan et al. 1976). Thanks to new research methodologies, however, allows Appiah and Gates (2005: 502) to challenge the statement concerning literacy. They write that in 1970, 27 percent of Africa's adults were literate, by European standards, and by 2003 the figure increased to 62.5 percent. According to the editors of the 1976 World Book, information about Africa will of necessity be provided by persons outside of Africa:

> Less than 100 years ago, Africa was called the Dark Continent because much of it was unknown to Europeans. It is still difficult to get information about many parts of Africa. But more becomes known about Africa as educational standards rise there, and as people from other continents visit there. More people go there on business. Thousands of tourists visit Africa to make trips to the world's longest river, the Nile, to cross the world's largest desert, the Sahara, or to go on big-game hunting or picture-taking safaris (Bohannan et al. 1976: 89).

Scholars (Rodney 1972; Diop 1987; VanSertima 1989; Walker 2006) have countered these racist narratives by documenting Africa's rich, ancient and written history before the arrival of Europeans; the African presence in the Americas before Columbus; as well as the technological know-how of the Africans who were brought to the Americas and to Europe as enslaved.

As demonstrated in the two encyclopaedias quoted, perhaps used by most secondary school students in the West at that time, and currently fuel alt-right racist perspectives. African civilization is not treated as ancient and foundational and certainly is not referred to as having a profound developmental impact on Europe. The subtle suggestions of Africa's primitiveness and inherent backwardness are made justifiable by falsification and erasure of Africa's history, and contrasted by the

adventurousness of Europeans who "discovered" waterways, "explored" previously inaccessible terrain, and the missionaries who brought the civilizing influence of Christianity to Africans (Davidson 1992; Hochschild 1999). Where many African monarchs ruled constitutionally and were invested in the development of their people, they were widely portrayed as despotic and demonic (Davidson 1992). Where there was clear evidence of writing systems and oral recording of history dating back thousands of years before Europe's civilization, this information was disregarded, erased and replaced with the myth that Africans did not write, therefore their history, needed to be researched and written by Europeans (Diop 1974; Davidson 1992).

Still contested is where and how Egypt is discussed. Miraculously Egypt exists outside of "Negroid" Africa (which is confined to south of the Sahara) in the Middle East, a place that does not conjure any specific geographic memory space, and where, according to the 1977 edition of the *New Age Encyclopaedia*, the people are considered white:

> In addition to the Negroid people of Africa there are many Caucasoid. These include most of the people of North Africa and Egypt and some in the Sudan. They belong generally to the Mediterranean subgroup of Caucasoid peoples and resemble those of southern Europe and the Near and Middle East. They have brown eyes, straight to wavy brown hair, skin ranging from light olive to dark brown, thin lips, and high-bridged narrow noses (Ottenberg 1977: 137).

Again, only in areas without access to the internet would a counterpoint to this Eurocentric perspective be available. Nonetheless, these four decades-old positions survive. The American Anthropological Association mounted a traveling exhibition, academic scholarship and webinars in its *RACE: Are we so Different* project with headings signalling History, Human Variation and Lived Experience (www.americananthro.org). It is an ongoing discussion as it is the lived experience that is germane as who has power to continue to continually convey racism, sexism and other forms of discriminatory practices worldwide.

This version of history of Africa and particularly of Egypt has become a blueprint for representation of that society's material culture embraced by museums in the United States and in Europe, for example, Brooklyn Museum in NYC, British Museum in London and many others with Egyptian collections. Egypt is separated out from Africa and physically exhibited often on separate floors. In the Brooklyn Museum, the African Gallery is on the first floor while the Egyptian Galleries, Assyrian Reliefs and European Paintings are together on the third floor. Similarly, in the British Museum,

Africa alone is on the lower floor, while Egyptian sculpture and Ancient Egypt are on the ground and upper floors, respectively. Also exhibited on ground and upper floors of the British Museum are the Americas, Ancient Greece and Rome, the Middle East, Asia and Europe.

Peter Vergo's view is critical of traditional history museum displays raising the question of whose story is being represented and from whose perspective. He argues the following:

> Whether we like it or not, every acquisition (and indeed disposal), every juxtaposition or arrangement of an object or work of art, together with other objects or works of art, within the context of a temporary exhibition or museum display means placing a certain construction upon history, be it the history of the distant or more recent past, of our own culture or someone else's, of mankind [sic] in general or a particular aspect of human endeavour. Beyond the captions, the information panels, the accompanying catalogue, the press handout, there is a subtext comprising innumerable diverse, often contradictory strands, woven from the wishes and ambitions and preconceptions, the intellectual or political or social or educational aspirations and preconceptions of the museum director, the curator, the scholar, the designer, the sponsor – to say nothing of the society, the political and social or educational system which nurtured all these people and in so doing left its stamp upon them (Vergo 1989: 2–3).

The non-African-ness of Egypt promulgated by nineteenth-century European historians and anthropologists is explained by Bernal as the "Egyptian problem" as follows:

> If it had been scientifically "proved" that Blacks were biologically incapable of civilization, how could one explain Ancient Egypt – which was inconveniently placed on the African continent? There were two, or rather three solutions. The first was to deny that the Ancient Egyptians were black; the second was to deny that the Ancient Egyptians had created a civilization; and third was to make doubly sure by denying both. The last has been preferred by most 19th and 20th century historians (1987: 241).

The solution to the "problem" was further reinforced by twentieth-century cinema production that presents Egypt's pharaohs and queens as white or near white and blacks solely in the role of slaves. Europe's invention of the "uncivilized and inferior" African was an ideological construct necessary to obfuscate African ingenuity and technical competence; to remove the connection of black people with Egypt to promulgate the Aryan Model of Greek civilization; and to justify centuries of enslavement of black people. Hollywood films such as the *Ten Commandments* (1956) and *The Bible* (1966) erase black people from Egypt's ruling class and present them as slaves,

and *Tarzan* (1932) and *Stanley and Livingstone* (1939) portray Africans as wild, barbaric and in need of the guidance of Europeans.

I believe that museums that serve African origin communities must include opportunities to address the social, educational and recreational needs of the people while building positive self-identity. Misrepresentations of Africa, the peoples on the continent and the histories and cultures endure for centuries. Because of the dominant forces of those who have privilege and power that direct ideological discourses remain and endure, despite counter positions argued for by forward-thinking scholars, politicians and activists like Marcus Garvey. Critical issues then are the importance of agency.

In embarking on this work, I engage in a process of deconstruction of the critical terms – representation and Blackness – as they are utilized in national discourse and influence museum text. This process of deconstruction is to uncover the points of contradiction associated with the critical terms, as well as to highlight the ideas and movements that countered the accepted concepts and re-represented Blackness from the perspective of enlightened black scholarship. In accomplishing the latter, a process of reconstruction of Blackness will take place, the efficacy of which will be demonstrated in the MMGMM that could inform the perspectives of future museum narratives with the goal of educating and inspiring generations of Jamaicans to come.

Chapter 4

Setting the Colonial Identity Stage

Capitalism, Enslavement and Identity

To explore the notion of black self-identity in Jamaica in the twenty-first century, it is important to have knowledge of the institution of enslavement, the struggles for emancipation, and the colonial and post-colonial governments which have manipulated and shaped concepts of identity for over five hundred years. The economic systems of capitalism and enslavement, the role of race and racism, and the manner in which education was introduced to the masses all impacted on the creation of black self-identity. The process of creolization is also an important variable to look at in the identity equation as a prelude to examination of the importance of "shadism" or "colourism" in the nation, which will be analysed later. This chapter explores these interlocking variables to arrive at an understanding of Blackness.

Emancipation (1838), Crown Colony rule (1866) and Independence (1962) represents for Jamaica the transition from one epoch to another – enslavement to post-colonial society. Epochal transition, according to Friere, is froth with contradictions between the way of doing things that held in the past and still perpetuated by some and the demands of a future wherein relationships are based on choice. He suggests that only when the contradictions are perceived critically can objective choices be transformed into reality (Freire [1974] 2008: 3–18).

A Brief Review of Capitalism and Enslavement

The economic system of enslavement in the Americas emerged out of European internationalization of trade through their control of the world's waterways with their superior ships and cannons. Portugal led this activity starting with their capture of the western Mediterranean and the Atlantic coast of North Africa in 1415. Rodney points out that European control of world trade included East African ivory marketed in India and exports of Indian cloth and beads, Dutch linen, Spanish iron, English pewter, Portuguese wines, French brandy, Venetian glass beads and German

muskets to East and West Africa, to exchange for enslaved Africans. With the conquest of the Americas, Europe's insatiable demand for gold coin in their growing capitalist economies, and their growing need for an unlimited supply of labour and technical tropical agricultural expertise, ensured that Africa specialized in exporting captives (Ibid).

Europe's already small population made enslavement of their poor and incarcerated population in the "new" world, as was the norm in most European countries (serfdom) unsustainable. It would have been difficult to maintain white enslavement in a situation where the number of whites was minuscule in relation to the native peoples upon whom war was being waged, and where the argument for enslavement was in part justified based on the absence of Christianity.

Sylvia Wynter's research on Bartolomé Las Casas, whose conversion from "encomendero"[1] to Indian abolitionist, indicates that in the near-final hour of native American annihilation in the islands Columbus named West Indies, he argued to the Spanish King (in 1515), and upon the King's death to two co-regents (1516), that Native West Indians were being abused possibly to their extinction and proposed remedies that included their conversion to free labour and to Christianity. He argued that souls that could be converted to Christianity ultimately made them unfit to be enslaved (Wynter 1984: 46–55). Owners of an allotted number of Tainos (Arawaks) were initially incorporated as a labor force under the traditional Spanish system of encomindo. He advised that the Crown should turn to Africa's peoples for the labour required to recompense the settlers for their Indian labour supply and encourage Spain's peasants to migrate.

The Portuguese and Spaniards, of which the latter's history had been of invasion and occupation by Islamic Africans for seven centuries, were aware of African knowledge of navigational tools, mining, architecture, urban planning, tropical agricultural practices and inventiveness, and labouring under tropical conditions. The obvious identifiable difference of Africans rendered them the logical choice for the great labour demand of their mines, "encomiendas" and plantations established in North and South America, what they coined the "new world". Europeans planned and executed the most atrocious and devastating wars on Africans on a scale until then unimagined.

To fuel the insatiable demand of Europeans, Africans were hired to capture and transport Africans, from locations where, it is said, whites could not survive. However, the seeming fatalism of opposition to the Middle Passage and enslavement, by free and enslaved Africans, did not prevent wars of resistance (Hart 1985; Bailey 2005). According to Chinweizu the

term "slave trade" is a euphemistic Eurocentric misnaming of the war, the killing, and destruction that Africa and Africans suffered for four centuries. He writes:

> Contrary to the conventional portrayal, this was not a system of slavery and slave trading accompanied by violence; it was rather a system of grand violence to produce Black chattel slaves who would produce other commodities for the profit of Europeans. It was a great war making system for profit; it operated in far-flung theatres; it killed or carried off into captivity well over 100 million Blacks; and though the yield from the farms, factories, forests and mines of the system were enormous, and though the profits from these were the ultimate interest of its masterminds, *its principal products were actually death and wholesale destruction* [author's emphasis] (Chinweizu 2010: 14–15).

Racism became a justification for the inhuman conditions Africans were subjected to in enslavement forts after they were hunted down and captured in brutal unprovoked wars, before transportation through the unspeakable "middle passage". Racism fuelled the torture and terror inflicted on Africans once in the Americas to "break" them into the enslaved, to "season" or accustom them to the unimaginable inhuman conditions of work, and the degradation to which they and their offspring were to be subjected to four centuries.

Racism purported a theory of the inferiority of black humanity, the mythicizing of Africa as the "dark continent" (Armstrong 2006), and constructed a European selfhood based on the natural supremacy of whites. Racism then is a social and power construct made to serve the needs of a European bourgeoisie for a large exploitable labour force and was embraced by every European nation that became involved in the exploitation of people who look different, in terms of skin tone.

When the institution of enslavement came to an end and where labour was "free" to negotiate the terms of its employment, capitalism did not cease to require this cadre of workers, it simply changed the terms of its engagement, and those who were the victims of racist ideology continue to accede to its precepts centuries after enslavement ended (Williams 1970). The effects of capitalism forever changed the culture and economic relations of the Native American and the African, for example, but it has not succeeded in forever influencing their worldview. If it was once believed, or people were cajoled into thinking that white skin is the key to white supremacy, they now know that superior weaponry, ownership of and access to natural and financial resources are the keys to white supremacy (Ibid).

With that said, no non-white race has been able to extricate itself from the "caste" like position whites have created in relationship to themselves. That is, white people in the twenty-first century continue to lay claim to the natural resources of Africa, remain in a position of dominance and superiority, and non-whites, too often, seem to behave in an accommodating manner.

Creating Identity through Race and Racism

Race has been used to remarkable effect as a dividing line between people and has amplified intergroup tensions when preferences and privileges are accorded based on race, and when individual choice, particularly in procreation, is made based on race or "shade" of colour. Popular texts such as the *Concise Oxford Dictionary* defines race as:

> Each of the major divisions of humankind with distinct physical characteristics; an ethnic group; a group of people descended from a common ancestor; a group of people or things with a common feature (1999: 1178).

Oxford goes on to include a highlighted note titled *usage* [of the term race] in which the editor explains that the negative associations of race with nineteenth-century theories and ideologies have rendered the term problematic; therefore, race in contemporary usage is often substituted by less emotionally charged words like *people* or *community* (Ibid.).
 Racism is defined by Oxford as:

> the belief that there are characteristics, abilities, or qualities specific to each race; and discrimination against or antagonism towards other races (1999: 1179).

Racism refers to a philosophy of racial antipathy held by one group against another. What constitutes the group may be ethnocentrisms that are not necessarily racially determined but result in binding individuals together to create a "we" as against the "others". The ideology of racism, honed by social Darwinist conceptions of race (Mills 1997: 60, 113), spins on the theory that human abilities are determined by race and, as explained earlier, is particularly useful in a capitalist economic system that requires access to a permanent underclass that is available for exploitation and discrimination to accumulate. From the end of the fifteenth to nineteenth centuries, Europe devastated Africa's industry, trade, housing infrastructure; looted its treasuries, destroyed its monuments and sentenced its peoples to centuries of enslavement at home and on foreign shores; and through the sale of

and the created demand for guns, enmeshed the continent in a spiral of mounting violence that persists into the twenty-first century (Davidson 1992: 185–223).

Banton contends that racial characteristics or differences are employed as signs that subscribe social relationships that differ from place to place. For example, up to the 1960s black people in America's Southern states, no matter the hue of their skin, were made to assume a position of inferiority towards whites and to know and accept their place within the social order (Banton 1967). Enforced by institutionalization of Jim Crow Laws (apartheid conditions) black parents instilled in their children the need to display deference towards white people of any age. This deference was reinforced by the threat or actual events that saw economic hardship, destruction of property, inflicted bodily harm and lynching that terrorized black communities via activities of the Ku Klux Klan up until the middle of the Civil Rights era. The outcome of this "deference" training is aptly described by an African American writer, writing in the early twentieth century:

> When you control a man's thinking you do not have to worry about his actions. You do not have to tell him not to stand here or go yonder. He will find his "proper place" and will stay in it. You do not need to send him to the back door. He will go without being told. In fact, if there is no back door, he will cut one for his special benefit. His education makes it necessary (Woodson 2005: xiii).

Skin colour was an obvious sign of one's race, but the texture of hair, size of nose, and the shape and thickness of lips no matter how fair the complexion were also determinants. The positive evaluation of European physical attributes was part and parcel of the social stratification of former enslaved societies throughout the Western Hemisphere. In the Dominican Republic, for example, official and unofficial policies of the state shape the views of individuals with respect to their identity:

> while skin color and any African heritage are the phenotypical symbol of genealogical and ideological codes for determining racial identity in the United States, for Dominicans the phenotypical symbol is hair, and the ideological code is anti-Haitianism (Candelario 2007: 7) [my emphasis].

Successive governments in the Dominican Republic went to great lengths to de-race blacks from their history in order to present itself as indigenous Indian or as Mestizo who bonded with the Spaniards. Further, Blackness in their ideological construct was synonymous with Haiti with whom they

share a geographical space was synonymous with savagery and poverty (Candelario 2007).

Throughout the history of enslavement in Jamaica, the British set out to convince Africans of the inevitability of their position as the enslaves and the futility of their actions against the system. Persons who uttered or fomented rebellion were indicted as "wicked", and their actions were deemed against God. The corollary teaching was that all whites and most coloureds knew what was good and best for Africans and that the hierarchical positions occupied by both races were ordained by God and enforced by the State.

From Abolition of Enslavement to Crown Colony Rule

Under the reign of Queen Victoria, the Abolition of Slavery Act of 1833 was passed in the British Parliament. With it, the British Government apologized to the enslavers for the loss of their enslaved people by borrowing twenty million pounds from the Rothschild Banking Empire to dole out to owners as compensation (Beckles 2013: 143–55). The Act contained a mandatory "apprenticeship" period, a contradiction in terms, in which the enslaved would become accustomed to being wage labourers for their previous owners for seven years but in reality, the period was required to obtain the additional twenty million pounds demanded of Britain by the enslavers (Ibid). The continued revolt by Africans against dehumanizing treatment on plantations and their demand for total freedom led to Jamaica's full emancipation event taking place on 1 August 1838, two years before "apprenticeship" was to come to an end.

The emancipated people were given nothing – no tools and equipment, no allowances for housing or food, no concern about their medical conditions; nothing but a farewell (Sherlock and Bennett 1998: 229–30). There was no change in the position of white economic power except that labour had now to be negotiated and converted into a proletariat tied to the sugar estates (Johnson and Watson 1998) rather than be set free and left to develop their own national development strategies (Robotham 1987).

A wealth of critical theoretical literature has surveyed the way for centuries, and in their defence of the institution of chattel enslavement, Europeans have held to racist notions that people of African origin were savages, infantile, and required leadership and guidance by whites (Back and Solomos 2000). Livingstone offers a representative example of the literature of the day, when he described newly freed Black Jamaicans as "the inheritor of nothing but ages of barbaric character; ... still raw, primitive

man" (Livingstone 1899: 32). Workers who returned to the plantation for wage work were considered by white Jamaicans to be "of the lower and less governable type" (Livingstone 1899: 37). This quotation is revealing for addressing the way power hierarchies work together with economics and the race theory of the time, discredited today. Friction was bound to occur between plantation owners and wage earners as the former were accustomed to demand and receive the maximum labour from workers without thought to time or condition, while new wage earners were not prepared to continue under enslaved-like conditions without what they deemed to be adequate compensation.

At the same time white landowners decried the movement of people to the hills and away from the plantations, grudging them their power over their labour, and promulgated the notion that they would revert to barbarism as a result of being away from the civilizing force of white people.

From an economic standpoint, Girvan argues that a racially biased labour regime and ideology in the Caribbean and the rest of the Empire were necessary to actualize "export-led" economic growth for Europe, in which the resources both natural and human were violently pressed into service through the brutality of military incursions (Girvan 1987). Further, the hierarchical structure of enslavement and its philosophical and pseudo-scientific underpinnings made Blackness interchangeable with enslavement, savagery and cultural inferiority.

Livingstone, among other colonial writers (Knight 1742; Long 1774), is revealing particularly with respect to Jamaica, and I select his work as representative of the wider body for analysis here. The post-emancipation government was in the hands of the planter and administrative classes and their vengeance against their ex-enslaved people was a primary pursuit. The Legislature operated for its own class, ignored the interest of the greater island, provided no facilities for workers, few highways, and limited infrastructure. Public institutions were inefficient with corrupt administrators, and there was constant controversy with the Home Government, disagreements between the Legislative Council and the House of Assembly, and dissension in all aspects of the public service (Livingstone 1899: 42–43).

The newly freed people who remained on or near to the plantations faced poor and irregular wages, deplorable working conditions, impermanent jobs, added to lack of proper housing, sanitation, education, unjust treatment and conditions akin to enslavement. Those who fled to the hills were doomed to eke out a meagre but independent living from provision grounds.

Taxation of all the necessities of life including bread, salt, clothes, donkeys, houses and a plethora of unavoidable consumption or service items was also used as a weapon. Public flogging and imprisonment met those who were outspoken, stole food or fruit to feed hungry bellies, or who defied the law when repossession of property for those who were lucky to afford to purchase but could not pay or understand property tax, or evictions from squatted land were to take place (Livingstone 1899: 39–57). White Jamaican planters continued to own substantial tracts of land, wield political and economic power as exporters and employers, and enjoyed the backing of government in their abuse of power directed at their labourers. The situation was compounded by floods in 1864 followed by drought.

Although Jamaicans conveyed their plight to their beloved Queen Victoria in signed petitions, it fell on a cold and unfeeling heart. The Queen's response entreated them to continue to work for wages "not uncertainly or capriciously, but steadily and continuously" and to add "prudence to industry, to lay by an ample provision for seasons of drought and dearth" (Sherlock and Bennett 1998: 257). While a self-sustaining black small-farming class was emerging in the hills of Jamaica, their sure footedness was undermined by the upper classes.

Sherlock and Bennett note how the twenty-seven-year period between emancipation and the Morant Bay war was suffused with pain and suffering (1998). The pursuit of justice for black Jamaicans was the reason behind the uprising called the Morant Bay "war" of 1866. A court case that pitted an alleged squatter against a white landowner escalated out of control when the people of Stony Gut, St. Thomas rallied to the squatter's cause led by Native Baptist Deacon Paul Bogle. Although the militia opened fire on unarmed blacks first, for the killing of twenty-nine whites, it is reputed that over fifteen hundred black people were killed in the punitive exercise to put down the war although official statistics count much less (Sherlock and Bennett 1998).

Men and women were hanged, shot, and sentences to floggings were meted out to over six hundred persons (100–500 lashes), while mass graves were dug to receive the dead. Over one thousand houses of perceived and known insurgents were burned to the ground. According to amateur anthropologist, Livingstone:

> the episode is, in fact, one of the most shameful, one of the least excusable, in the whole range of our Colonial history. It was asserted that ruthless measures were necessary in order to check a general rising of the Negroes' (Livingstone 1899: 76).

The then Governor Eyre and his supporters declared:

> Black insurrection could not be treated in the same way as a white one, because the negro in Jamaica [...]is *pestilential*[...] a *dangerous savage* at best (Sherlock and Bennett 1998: 263) [my emphasis].

The shamelessness of the massacre of black people was not lost on Britain who took over governance from the Legislative Council in 1866, making Jamaica a Crown Colony. Appointing British administrators from Britain served to infuse a supposedly objective impartial force for ameliorating the conditions of the poor and ignorant black population while protecting and advancing the interests of the planter oligarchy (Bryan 1991).

This constitutional manoeuvre curtailed the freedom of the planter oligarchy to do what they wanted in Jamaica on the one hand, and on the other, quelled their fears that they were alone, a mere 2.29% of the population in 1891 (Bryan 1998), among a sea of black people who they determined to be barbarous and capable of slaughtering them at a moment's notice. They welcomed the backing of the British Empire; seized the opportunity to reassert their own "Britishness" (it was well known that British whites perceived their Jamaican white counterparts as "creolized" and looked down on them); and revelled in the military show of might that occasioned their official attendance.

Ironically, an assertion of Britishness was deemed by the new governing structure to be the solution to the problem of governing black people in Jamaica. After 1866 it was determined that instead of execution, the whip, and the rack, methods employed in the control of black Jamaicans for centuries, a new approach would be taken. This new approach required that the "civilizing" process, ostensibly begun on the plantation, should be continued in newly established hillside communities occupied by blacks. No longer in the hands of the plantation system, the civilizing process was taken on by government who formed an alliance with churches to manipulate the self-identity of its majority black population. Government facilitated penetration of the church into the cultural realm of black people's lives (Moore and Johnson 2004) and promoted insertion of whites within hillside communities.

Government policy, aided and implemented by the IOJ encouraged importation of white farmers from Scotland and Germany to occupy tracts of Jamaica's hillsides to, at the very least, provide the civilizing radius to counter perceived African barbarism (Bryan 1998: 123–24). It was believed that the superior intellect of these newly arrived white settlers would

result in their production of agricultural surpluses on increasingly greater amounts of land that would make it difficult for blacks to compete with them resulting in their being driven back to the plantations.

Poor, illiterate and unskilled European immigrants, who experienced poverty and social exclusion in Europe, were elevated to the status of equals with their richer white "betters" based on their racial similarities and promulgation of the belief that they could achieve middle-class status by their own effort (Girvan 1987). Their small population required them to band together regardless of class to protect their joint interests – that of the production of sugar, rum, or coffee, for export, and the production of food for domestic consumption. These communities failed miserably in their mandate reverting to unwholesome procreation in failed attempts to preserve their whiteness. Further, although many performed as apprentices on plantations before residing in the hills, they were not as or more productive than black farmers.

Colonial Education for Shaping Identity

Prior to 1866 the church was alone in its mission of building churches and schools but in 1867 government contributed to provision of education to black people through grants-in-aid to the denominations (Moore and Johnson 2004: 206). The school became an extension of the church, and the church became the principal purveyor of civic duties and devotion to empire. Church sermons focussed on the Beatitudes (Mathew 5: 3-11), particularly those that exalted blessings on the poor, the meek and the peacemakers, and drilled into the heads of black people that their rewards for a life of pain and suffering would be abundantly given in heaven. Here on earth, they were required to give their hearts, minds and bodies to the British Empire.

Schooling for the masses concentrated on reading, writing and arithmetic, just enough knowledge to create a literate agricultural proletariat. Jamaican Codes of Regulations (1867, 1900 and 1902) were to be inculcated at school:

> During eight years of schooling the future citizens of the empire learned, among other things, *obedience to persons in authority, love of country, patriotism, the duties* of the citizen, fidelity to official trust, industry, temperance, honesty, and gentleness. Colonial officials seemed to regard these qualities as of greatest benefit to the well-being of the empire. They were able to show eventually how the entire curriculum could be directed to train desirable citizens. The qualities that marked the successful agriculturist were felt to be mainly moral

qualities such as industry, patience, and the realization of responsibility – and conversely, agriculture, manual training, drill, and needlework were regarded as ideal instruments for moral training (Moore and Johnson 2004: 211). [my italic emphasis]

Moore and Johnson offer a full account of how non-sectarian newspapers, bibles and sermons printed in local newspapers abounded and became the means by which the church controlled information and provided religious instruction to the small literate population (2004). They note the way schools offered a British curriculum that trained children to become good and worthy citizens who appreciated and revered the empire to which they belonged, who were able to read the works of Shakespeare, Tennyson, Longfellow and other writers, and learned the history of persons like Alfred the Great, Henry V, Columbus, Queen Elizabeth I, Cromwell, Rodney, Nelson, Wilberforce, Wellington and General Gordon (Moore and Johnson 2004). Teachers were mainly white and were expected to behave as missionaries exhibiting moral leadership and exemplary behaviour.

With low rates of attendance and visibly little impact of schools on students, the question of compulsory schooling was discussed. Most officials agreed that it would be a mistake, as children's labour was regarded by their parents as necessary in times of harvest and planting, thereby making their attendance in school irregular. According to Governor Musgrave, under whose auspices the IOJ was built in 1879 and whose name today is given to the highest honour in literature, science and art:

> To stimulate that [compulsory education] now by artificial pressure can I fear only produce a distorted development, and more of a class of which there are already too many [:] the half educated vagabonds who are too proud of their smattering of knowledge to be able to dig, but to beg are not ashamed (Moore and Johnson 2004: 217).

By 1890 the government determined that the message of Christian Victorian morality and unwavering commitment to the empire was best imbibed by black people coming from their own teachers. Also, Government sought to create a small middle class of educated people, mostly coloured and some black, who would occupy the middle and lower administrative strata of government with the opening of two secondary schools for their instruction.

Religious knowledge formed an essential part of the secondary school curriculum along with "the usual English course" including mental and commercial arithmetic, geometry, British history and British geography, with drawing and music as extras, in addition to Greek, Latin, Hebrew,

French, German, Spanish and Italian (Moore and Johnson 2004). The other important prong of the "civilizing" effort was the reconstruction of former enslaved into loyal British subjects:

> this entailed promoting the British monarchy and empire almost as a cult, fashionable symbols of Britishness and imperial unity that were virtually deified and worshipped for the benefits they bestowed on all who lived under their 'protection'. Indeed, a very close linkage was fostered between loyalty to God and to queen or king, between Christianity and empire (Moore and Johnson 2004: 271).

Already Jamaicans demonstrated great love for Queen Victoria, who they affectionately referred to as "Missus Queen", as she was represented in schools and churches as being their liberator from enslavement. Due to her long life and the fact that she was a wife and mother, it was easy for the authorities through the school curriculum to use these traits as propaganda tools of her deification, while consciously removing all knowledge of the emancipation wars led by enslaved people. Her title of "Empress of India" and the continued spread of the empire in the last quarter of the nineteenth century transformed the monarchy into a grand, national and imperial institution wherein royal births, deaths, birthdays, coronations and especially royal visitations to Jamaica occasioned an orgy of celebration throughout the island. On these occasions, school children were provided with flags and "encouraged", for a reward of bun and lemonade, to march through the towns singing patriotic songs. Churches, town squares, shops and all public buildings were beautifully adorned in the colours of the monarchy using flowers, ribbons and banners.

Sermons were rendered on the importance of her imperial majesty to the existence of her subjects reinforcing the connection between allegiance to God and allegiance to the Empire. Further, the exploits of the empire in Ghana (Ashanti War) and later South Africa (Boar War), and elsewhere, were made to be the concerns of the people who collectively prayed for British success, contributed monetarily from their meagre coffers, and who were honoured to positively respond with vigour to any military calls upon their service. The Royal Jubilees of 1887 and 1897 were thusly celebrated throughout Jamaica to increase the feeling among ordinary black Jamaicans that they were British subjects (Moore and Johnson 2004). Questions of a national identity, although already demonstrated through language and customs, were inextricably linked to, and undermined by, the concept of empire.

Creole and Creolization

According to Wynter in contemporary Jamaican society the "white Jamaican" was only interested in English history and fancied themselves English although born and grown in the island; the mulattoes who did not completely assimilate to white values contend that they are the only true indigenous and nationalist people, and for some black Jamaicans, on the one hand, there is no reality or history for them in Jamaica, they are Ethiopian, and on the other, Jamaica's history is only about black Jamaicans (Wynter). The fact is that over the course of four hundred years amalgamations, transformations and accommodations were made in language, culture, values, and the like creating a creole culture.

The Oxford Dictionary takes a decidedly Eurocentric perspective on the meaning of Creole that suggests that the baseline influence is that provided by the European. Creole is defined as follows:

(1) a person of mixed European and black descent; (2) a descendant of European settlers in the Caribbean or Central or South America; (3) a white descendant of French settlers in Louisiana; (4) a mother tongue formed from the contact of a European language with a local language (especially African languages spoken by slaves in the West Indies) (1999: 336).

In undertaking analysis of the term "Creole", Warner-Lewis' research is cited (Lovejoy 2000: 14) which contends that the term is derived from the Kikongo word *nkuulolo*, "a person excluded, an outsider", *kuulolo*, "excluded", *kuula*, "to be outside, exiled, excluded". Brathwaite's definition of creolization is creation of a distinctive and separate culture in opposition to dominant European culture:

Within the dehumanising institution of slavery...were two cultures of people, having to adapt themselves to a new environment and to each other. The friction created by this confrontation was cruel, but it was also creative. The white population and social institutions...reflect one aspect of this. The slaves' adaptation of their African culture to a new world reflects another (Lovejoy 2000: 15).

Most enslaved Africans adapted to the intensely authoritarian and violent way of life that characterized enslavement, while at the same time learned to overcome the difficulties posed by the colonial policy of scattering people of the same ethnicity and mixing those perceived by them to be of differing ethnicities. Adaptation did not curtail subversive practices (malingering on the job, destruction of tools or stock or crops or buildings) but meant

cultivation of an anti-democratic mentality which, when honed by racism, consistently undermined self-esteem, and unity, while creating loyal informants for the plantocracy. According to Freire:

> the adapted man, neither dialoguing nor participating, accommodates to conditions imposed upon him and thereby acquires an authoritarian and acritical frame of mind (Freire [1974] 2008: 21).

Many demonstrations of adaptation and critical thinking during and after enslavement provide supporting evidence. For example, when persons refused to allow the enslaver's house to be burned during an insurrection; or the case of "Mamby" who refused his freedom when offered as a reward for discovering the Ram's Horn gorge as a source of water during a terrible drought (Senior 2003: 310); or on 13 March 1892 during the siege of Toniatabe in West Africa, when Sergeant William Gordon of the West Indian Regiment threw himself in front of his white Major (G.C. Madden) and took a fatal shot that earned him a Victoria Cross posthumously.[2] The view of these actions by Livingston is instructive:

> This is not an isolated instance of the negro's self-sacrifice, for Jamaica slaves have more than once died for their masters. He [the Negro] is responsive to sympathy and justice, and ready where these are given, to form passionate attachments to the superior race (Livingstone 1899: 230).

Creolization in Jamaica largely meant processes of adaptation, adjustment, hybridization, resourcefulness and re-creation of useful elements of African/European societies in the Caribbean which are not the sole purview of enslaved Africans but are also evident in resident Europeans. Nettleford defines it as:

> The evolution of a native born-and-bred culture pattern with its own inner logic and consistency different from the feeder sources (Nettleford 1998: 10).

The widely used meaning of creole then is the creation of something new in the Americas – language, culture, identity – as a result of interaction between people from the various regions of Africa, and in some cases Tainos, and between people from Western Europe, Africa, India and China under conditions of enslavement and colonialism. The popular use of the term, though, is simply to describe people who were born in Jamaica or who lived in Jamaica for most of their lives and could not "purely" be referred to as English, African, Indian or Chinese.

The Consequences

Enslavement, emancipation, colonial government, religious and other institutional policies frame the constraints endured by black Jamaicans over the centuries. The dominant ideology that underscored this framework was based on racism. The colour of black skin coded were the presumptions of degradation. The civilizing thrust was an exercise in mind control through propaganda and manipulation of black people's perceived absent self-identity. The fact of Blackness and of the control of their lives by minority whites was understated and exchanged for the concept of unity as British subjects. Repetitions in churches and in schools of the patriotic songs and verses, use of symbols and ideology, and particularly for celebrations of Empire Day were meant to confirm this sense of Britishness.

Children were targeted for indoctrination by a catechism adopted by the Board of Education entitled "One King, One Flag, One Fleet, One Empire" that was read at all Empire Day celebrations throughout the island up till 1962. It inured them to identify with the power of the monarchy, the unifying strength of the empire which encompassed a plethora of peoples (races, languages and religions), the power of the British navy and the might of the commerce it ensured, and the undisputed strength and pervasiveness of the empire upon which the sun would never set (Moore and Johnson 2004: 294–97).

While this brainwashing could have been deemed successful among black Jamaicans, particularly those who occupied the small middle classes achieved through shade (colourism), education and position, and land ownership, it had little full effect on the masses. Even where they participated in the staged events and declared themselves members of the various Christian denominations, they cleaved to their African retentions in religion and dance, birth and death rituals, child rearing, and marriage that had served them well for centuries.

Many remembered the Morant Bay war and spoke among themselves in admirable terms of its leaders and victims. Jamaicans demonstrated, in my estimation, their intent on being subversive in that they appeared to "behave" according to the paradigms laid out for them by the church and state, but in reality, they "seemed almost consciously to defy the conventions of 'polite' society and to render them irrelevant to their own lives" (Moore and Johnson 2004: 166).

The civilizing effort did create a chasm between the fledgling middle classes and the majority working class. During enslavement and thereafter the "coloured" population was made to believe that they were better in all

aspects of intellect, culture, beauty and potential than their black brothers and sisters, often of the same family. The privilege of secondary education had afforded them first and they were favoured with any available opportunities in the government's administration or in business.

Contradictions did abound by black Jamaicans, as their self-identity was ruthlessly shaken by the church and schools, and many declared their allegiance to the Empire and their abhorrence of anything African. Wynter frames issues of identity faced by "Jamaicans" succinctly:

> For in our tormented tossing about for an identity, our labelling ourselves Afro-Jamaican, Euro Jamaican, Afro-Saxon, Chinese Jamaican, etc., etc. we have missed a truth because so many of us may have subconsciously wished to evade it, and also because this link, this truth has been obscured by the myth fostered by British historians and sucked in with our mother's milk. It is the myth that Eric Williams in his book "British Historians and the West Indies" tilts an angry lance at when he quotes the great historian Toynbee to this effect:
>
> "The Negro has not indeed brought any ancestral religion of his own from Africa. His primitive social heritage was of so frail a texture, that every shred of it was scattered to the winds at the first impact of our Western civilization. Thus he came to America, spiritually as well as physically naked; and he has met the emergency by covering his nakedness with his enslaver's cast-off clothes" (Wynter: 33).

The importance of the work of African/Caribbean scholarship is here made urgent to question imbibed British versions of history with knowledge not just of the cultural retentions that Africans managed to nurture through the ordeal of enslavement, or their creation and use of new cultural forms rather than "cast-off clothes" to cover our perceived cultural "nakedness", but to restore to African descendants the wealth of their history, the history of mankind, that has been hidden, appropriated, and erased.

During Jamaica's crossroads between colonial and post-colonial epochal transition, racism and "classism" (preferential access to power and privilege based on skin colour) continued to feature in the institutional structure of the society. A small white minority enjoyed immense wealth through provision of entrepreneurial skills, ownership of the majority of resources and disproportional influence on the political process (Reid 1977: 15); they shared the crumbs of that wealth with the "brown" and educated blacks, while the black majority retained the status of a cultural minority accompanied by economic deprivation (Nettleford 1998).

Europeans and Middle Easterners, Jews, East Indians and Chinese in Jamaica, regardless of the moment of their immigration to Jamaica, transform to Western hierarchical relationships which places European civilization at the apex of human development, and all others below.

the concentration of power and control of the [Jamaican] corporate economy lies in the hands of minority ethnic elites and is mainly dispersed through 21 families and their interest groups. The ascendance of these groupings – Jews, local whites, Syrians and Chinese – closely followed and in some ways anticipated the transition of the plantation state to independent nation (Reid 1977: 15).

The majority population dominated the agricultural sector as small and medium farm owners, agricultural workers, agricultural marketers and producers of processed agricultural products. The role of women is pervasive throughout the sector, and like their counterparts in West Africa, even more so in the area of agricultural marketing – higglering. Land is the basis of all wealth, yet in less than three generations, the descendants of emancipated Africans, whose ancestors fought and worked hard to own land, are witnessing its loss. The lure of the tourism sector, the next largest employer of the majority black population in the twentieth century, has sentenced workers to low-wage and semi-skilled areas of the sector with little possibility of upward mobility (Pattullo 1996; Dunn and Dunn 2002).

The twentieth century ended without any appreciable change in the living conditions of the majority of black Jamaicans, although many blacks entered the middle strata of the occupational groups fostering upward mobility in the society and leading to enlargement of the middle classes (Reid 1977). The heretofore rigid patterns of racial stratification were adjusted and slightly blurred, but like mixtures of ethnicities, racially defined questions when intertwined with economic issues, became more complex. Subsequently, in the twenty-first century there is little change from that described in the millennia just described above. Light skin in Jamaica is still equated with wealth, power, beauty, access and competence, while black skin, despite the successes of individuals, is largely considered a hindrance to upward social and economic mobility. Although the numbers of non-white and non-black people are small in Jamaica, the minority white population remains the arbiter of racial prejudices among them. This situation is adequately described:

> The race against whom the whites are least prejudiced tends to become second in rank, while the race that they despise most will ordinarily be at the bottom. Thus more or less directly the superior race controls the pattern of all dependent race prejudices (Baxter and Sansom 1972: 214).

There remains some ambivalence among people in Jamaica to admit outright to their black ancestry especially when they are mixed once or twice removed with "others". While in the United States the "one drop rule", a historical colloquial, prevails, wherein one drop of African ancestry

deemed the individual black, it is not necessarily so in Jamaica, particularly as the equation of black equals poverty is one that all persons of some mixed heritage as well as un-mixed African Jamaicans are earnest to escape. Questions of whom or what is a Jamaican are very relevant to the progress of this book as it brings into sharp contrast the issue of identity.

At the heart of the contradictions faced by Jamaicans at the point of transition between independence and post-colonial society is the notion of identity. For the majority black population, the understanding of self, interpretation and representation of history, participation in institutions, social relations, are all negotiated through the lens of race. The philosophical underpinning of the research is that colonial society inculcated black and white people in Jamaica with racist notions of self-identity. Black Jamaicans carry the contradictions of colour created by centuries of hierarchical difference, whatever their hue. These contradictions are played out by what is described as the "Color Complex":

> a psychological fixation about color and features that leads Blacks to discriminate against each other (Russell et al. 1992: 2).

They are played out in schools where lighter skinned children are favoured by teachers as being innately able to undertake intellectual work or for important roles in plays; while darker skinned children are likely to be considered "dunce" and relegated to secondary roles in public performances, as well as in the workplace where lighter skinned adults are presumed more intelligent than their darker sisters/brothers. Narratives collected in the course of my work are demonstrative of how current these occurrences are and discussed in the corrective programmes conducted in Liberty Hall.

Museums in Jamaica during this period functioned to represent the colonial authorities and the wealth, lifestyle and power of Britain. In post-colonial society, I argue in *Representing Blackness* the role of a "new museum", one based on the experiences of the majority of people, and the ideology of a national hero whose life's work was to dispel the myths, raise consciousness, promote self-esteem and pride in history and in Blackness. These are the roles and functions of the MMGMM.

Chapter 5

Liberty Hall

The Legacy of Marcus Garvey

Building a Cultural Educational Institution that Serves Members of the surrounding inner-City Communities First

"to Inspire, Excite, and Positively Affect the Self-identity of Jamaican People while creating social and economic wealth".
(The Mission of Liberty Hall)

Education is the medium by which a people are prepared for the creation of their own particular civilization, and the advancement and glory of their own race.

Marcus Mosiah Garvey

Why a Museum to Marcus Mosiah Garvey?

Marcus Mosiah Garvey's journey as the leader of the largest black organization ever by the 1920s began humbly in St Ann Jamaica in 1887 where his life was governed by the post 1865 war measures introduced by the British in their assertion of Crown Colony Rule. In this chapter, I try to answer the question posed in the title, why? There are three basic reasons as to why: (1) Garvey was maligned by the Crown Colony Rule through governmental and political measure; (2) despite persistent racist and classist misrepresentation factions in Jamaica and the United States, his social, economic and political message had major impact across the globe during and after his lifetime; and (3) Garvey's philosophy still faces scrutiny based on myth and fabrication requiring a counter discourse to reveal the value of Garvey, and the UNIA. As a body these three reasons give rise to acknowledging that Garvey's philosophy and associated activities that support notions of black Jamaica's agency and self-identity is needed more than ever before. From the 1930s to today, only a segment of the population, particularly the Rastafarian community, revere Garvey, and keeps his name and teachings alive in the music and in instruction of their children. In

spite of Garvey being designated Jamaica's First National Hero in 1964, many Jamaicans today continue to view him with ambivalence, suspicion, reticence and apathy. However, on many occasions – political campaigns, social and political crises, national commemorative celebrations – there are calls echoed in the media for the teaching of Garvey in the schools. In 1988 a Carl Stone Poll published in the Jamaica newspaper, *the Gleaner*, indicated that "89% of the population polled agreed with the teaching of Garvey in schools while 11% disagreed" (Stone 1988). A *Gleaner* article the next year reports that since Garvey's centenary celebration in 1987, Jamaicans consider him in the number one position as the most favoured national hero (Correspondent 1989).

In 1990 a Letter to the Editor chided successive governments for their seeming intent on obliterating the memory of Jamaican people's suffering during enslavement and their public avoidance of acknowledgement of the role African Jamaicans played in achievement of emancipation. The letter made a clear demand of the government from the perspective of Jamaica as a black country:

> It is the duty of an Afro-Jamaican government to allow the teachings of our first African leader and stop this nonsense of using his name merely for political purposes. This year should see the commencement of the teaching of the life and philosophy of Marcus Garvey. Every progressive nation needs a philosophy to make worthwhile advance. Our National Heroes left us noble messages; let us begin to listen, to study them, and to inspire new Jamaicans to rival and surpass the work of our great forefathers (Witter 1990).

Twenty-one years later, Garvey and Garveyism is still not taught in secondary schools as a specific subject. Teachers, if they are so informed, may choose to explore major events in the life of Garvey and of the UNIA-ACL in one (highlighted) out of five core areas set out in the Organization of the Caribbean History Syllabus notably:

1. The causes and consequences of interaction within and among the major groups in the region, namely: Indigenous peoples, Africans, Asians and Europeans
2. Enslavement and emancipation in the Caribbean
3. The responses to challenges in the nineteenth century: new arrivals and the establishment of the peasantry
4. The involvement of the United States in the Caribbean
5. The part played by twentieth-century protest movements and other groups to achieve political independence.

The core areas listed above in chronological order are best fit for teaching Garvey, particularly the following themes: Movements towards independence and Regional Integration up to 1985 and Social Life, 1838–1962. The social and economic conditions of the people from Emancipation to Independence are explored in the curriculum. Strikingly missing is no specific focus on the worldwide impact of Jamaica's first national hero's plea for Africa for Africans at home and abroad.

This chapter provides a brief biography of Marcus Mosiah Garvey that supports the claim that his life's work demands attention because of its global impact and significance for those in the Caribbean. Furthermore, there is a discussion of how Garvey developed his African-based philosophy and established affiliated organizations as well as the bearing in many of the geographical areas of the black world. Finally, the examination turns to Garvey's return to Jamaica in 1927 and the construction of Kingston's LH.

The Garvey Story and the Formation of the UNIA

In 1903, as a youth of modest means Garvey's exit from the school system at fifth standard was normal, access to his father's library unusual and beneficial, and internship with his godfather as a printer, important to his future life work. Not only did he access training, a means to obtaining a living, and ideas about Jamaica's political and economic climate, he also dared to dream of what life was like for black people in other parts of Caribbean and the world. In Kingston in 1906 where he worked with P.A. Benjamins Manufacturing Company as a printer, he sided with the workers in their wage disputes which cost him his job. On 14 January 1907, he witnessed and lived through the natural catastrophe that devastated Kingston in the form of a massive earthquake. According to information from the National Library of Jamaica (NLJ: 2016) the aftermath of destruction of homes, fires, dead bodies, and unimaginable horror and devastation also laid bare the lack of social services for the majority black masses who were sentenced to living in the open for months without the necessities of life and to relying on each other, family in the country, and Caribbean philanthropy.

Between 1910 and 1911 Garvey travelled throughout Central and South America stopping for several months in Port Limon, Costa Rica, where he worked alongside other Caribbean labourers as a timekeeper on a banana plantation and edited a newspaper called *La Nacion*. The plight of these workers encouraged Garvey, then twenty-four years old, to file a formal complaint to the British Consul regarding the harsh treatment

of West Indian labourers. He then travelled to Colon, Panama, where he edited a newspaper called *La Prensa* (The Press) that chronicled protests, the deplorable working conditions in construction of the Panama Canal and particularly against the racist two-tiered system of payment to black and white workers for the same work. Garvey found his way to Honduras, Ecuador, Colombia, and Venezuela and returned to Jamaica at the end of 1911.

Shortly after his arrival, Garvey set his sights on Britain and Europe to continue gathering information about the lives of black people. He landed a job with Duse Muhammed Ali, an Egyptian, whose publication the *African Times and Orient Review* was described as a "monthly devoted to the interest of the coloured races of the world' (Grant, 2008: 40). It was here that it is believed Garvey was politicized as African, African American and Caribbean writers submitted their work for publication, and Ali pushed the boundaries of criticism of British imperialism thus becoming an irritant to British aristocracy. In 1913 Garvey demonstrated his own voice on the pages of the *Review* as his published historical essay heaped criticism on Britain's policy of shadism in his native Jamaica and its influence on access to civil service job opportunities, an approach that had been favoured in place of examinations as the latter had seen too many successful black applicants (Grant, 2008: 43). He ended his essay with the unheard-of notion that people of African heritage in the West Indies "will found an Empire on which the sun shall shine as ceaselessly as it shines on the Empire of the North today" (Ibid: 44).

While in England, Garvey endlessly read everything he could, including the works of Edward Blyden and Booker T. Washington in the British Museum's Reading Room, attended law classes at Birkbeck College, expressed his views at the Speakers Corner in Hyde Park, and travelled throughout Europe. Upon his return voyage to Jamaica in 1914, a fellow passenger regaled him of the deplorable conditions of Africans in Africa, leading him to his resolve to create an organization to which black people could look with pride.

Garvey, along with Amy Ashwood, formed in the summer of 1914 The Universal Negro Improvement Association and African (Imperial) Communities League. It was conceived to mirror Booker T. Washington's Tuskegee Institute, an idea that fuelled Garvey's next excursion, to the United States. Although correspondence with Washington preceded his travels and a plan had been made between them to tour the Southern States of the United States. Washington unfortunately passed away before Garvey's arrival in New York on 24 March 1916, but he nonetheless availed

himself of the tour. What Garvey saw, heard and read about was unheard of even in Jamaica. In the United States, black people were being lynched by white supremacist groups (Klu Klux Klan), apartheid conditions existed under the legal framework of Jim Crow and increased racist conditions that faced blacks particularly returning black soldiers during and following the end of the First World War. From 1916, these events contributed to the Great Migration (1916–1930) of nearly 400,000 African Americans from the South to the North in search of greater freedoms and war industry jobs (Dodson 1999: 115–34).

Garvey set up offices in Harlem, New York, fast becoming one of the desired cities for black people in the North. Here he established LH as the UNIA's headquarters creating a meeting, entertainment and business place for black people to share information, air their grouses and try to interpret why they continued to be in such an inequitable position in society. This time between 1917 and 1921 is referred to as Red Summer that saw black people killed, maimed and property destroyed. In 1917 in East St Louis, Illinois, a riot, one of twenty-six race uprisings during the first years of the Great Migration broke out in cities throughout the North and South. It began when black workers were hired to break a strike at an aluminium plant. The rampage began when it was rumoured that a black man had accidentally shot a white man, which later became told as fact and embellished with inclusion of the insult of a white woman. When the dust cleared, 48 African Americans were dead, hundreds injured and 300 buildings destroyed (Ibid: 129). Again in 1919 in Chicago, the results of the riots killed 23 black people, wounded 839 others and hundreds fled their homes. In 1921, Tulsa Oklahoma, Black Wall Street, a town built by black people boasted its own hospitals, schools, bus company, supermarkets, air strip and more. A black man was accused of sexually assaulting a white woman that escalated into a war zone where white authorities and a mob of over 2,000 whites bombed the black community, murdered 300 and imprisoned 6,000 blacks prompting the migration of 2,500 blacks after the riot.

These midwestern events and the stories of individual blacks in Harlem bolstered Garvey's resolve that he and the organization were needed in the United States. He spoke up passionately and eloquently against white supremacists and advocated the need for blacks to unite, organize and be educated. By the 1920s the UNIA-ACL grew into the largest black organization ever with 1,056 divisions on nearly every continent and 837 divisions in the United States. The organization called on people to stand up for their rights, to get up and do through economic independence

arrived at through business enterprises, education, racial pride and racial consciousness.

Throughout Africa and the African Diaspora, organizations dedicated to achieving change for the oppressed masses in their countries employed the print media as a critical political tool for politicizing their communities. Through newspapers, journals and magazines, readers had access to news from Africa; black businesses had a marketing agent; organizations introduced their development plans and needs and reported on divisional activities throughout the world. The print media was used to solicit support for causes, and to stimulate individuals' interest in the arts, literature and social activities was deemed necessary to uplift the race. Garvey's political life in Jamaica, Central America, Europe, the United States and in Britain (1910–1940) is chronicled in the various newspapers and magazines he worked for, contributed to, and founded (Hill 1983: Vols. I–VII). *The Negro World* was the UNIA's propaganda tool in the United States that reached across the seas to Africa, South, Central, and North America, the Caribbean, Europe and even in Australia.

Throughout Garvey's political life, the US mainstream white media such as the *New York World* and *the New York Tribune* circulated negative propaganda about him personally, and about the UNIA-ACL as an organization. In addition, the Black newspaper *Chicago Defender*, an advocate against racial injustice and the leading African American Crisis Newspaper of the NAACP vilified Garvey and the UNIA by casting aspersions and concocting nefarious stories about the "real aims" of the organization. Garvey was portrayed as a thief, a conman, and a liar, rabble-rouser, and troublemaker. He was hounded by the judicial authorities in New York (Hill 1984: 30) and became the target of US Justice Department's Bureau of Intelligence's Division which later became the Federal Bureau of Investigation (FBI). Headed by J. Edgar Hoover, The Bureau gathered intelligence largely through illegal means on "radical" groups and individuals considered subversive and a threat to the United States and its way of life. These elements joined together in a "Garvey must go campaign" to diminish his credibility and ultimately to imprison and deport him.

Garvey's commercial ventures (Hill 1984: 32), his ability to raise money; his charismatic personality displayed at his "mammoth" conventions; and his defiance regarding the condition of black people in America expressed on banners carried in parades such as "Liberty or Death', "Down with Lynching" endeared him to Caribbean and African American blacks. Federal Bureau agents who infiltrated the UNIA described his influence on the black community in their reports:

He is looked upon by these West Indians, as well as numbers of coloured Americans, as being a second "Moses", and they swear by him as their salvation. Considering the way that feeling is now, it would be very foolish for anyone to go to New York, and particularly in Harlem, and say [anything] against Garvey, he has so many supporters [speaker's brackets and emphasis] (Hill 1984: 31).

Ordinary black people throughout the United States were hungry for his message of self-reliance; black pride, creation of black enterprises (see figures 5:1 and 5:2) and likewise expressed their pleasure in the movement in letters to the Editor of the *Negro World*, a publication of the UNIA-ACL. Mrs Susie Wilder from Chunchula, Alabama did so on 12 October 1920:

Although it has been only a short time that we have been receiving your paper, it seems as one of the family. We look forward to its coming with as much joy as we do to one of us, and there is not much done until it is read through and through. You are doing a good work and I am so glad that you are having much success. Though it has been late, very late for some of us way down here, and especially those of us who are in the "Piney" woods, to hear of it, I think I can say we won't be late in doing our duty towards the uplift of our race. If all of us could see through your efforts, what it will do for us and ours, and every man and woman should stand up to their manhood and womanhood, what a great thing it would be (Hill 1984: 51).

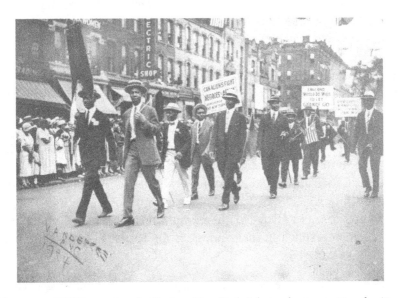

Figure 5.1. UNIA marches in Harlem New York (photos by James Van der Zee, official photographer of the UNIA-ACL).

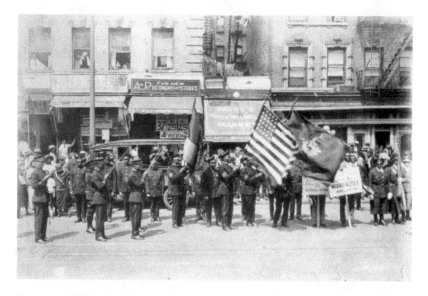

Figure 5.2. UNIA marches in Harlem New York (photos by James Van der Zee, official photographer of the UNIA-ACL).

The reach of the Garvey movement was far and wide. The call of "Africa for the Africans" permeated the consciousness of people of African heritage the world over, who had been economically and mentally downtrodden but were given hope by the many ventures of the UNIA-ACL – The Black Star Line (1919), the Factories Corporation (1920), The Black Cross Navigation and Trading Company (1924). Because of the rapid development of the UNIA-ACL Hoover hired the first black agent, James Wormley Jones (www.fbi.gov) in 1919 to infiltrate the organization and sabotage Garvey's Black Star Line, a shipping company established to ultimately link Africa with the African Diaspora through commerce and transportation, without the intercession of white people. Jones' success as an agent is borne out by the fact that he gained the trust of the UNIA-ACL and was entrusted with registration of all incoming correspondence to the organization and held the position of Adjutant General in the African League. Through Jones's efforts Garvey was sentenced on 21 June 1923 to the Tombs Prison in Atlanta on the trumped-up charge of mail fraud. His incarceration resulted in dismantling of the largest black organization ever, Clarke said:

> The greatest losers were the ordinary Black people who had found a home within the movement, who had been a part of something that had hope and possibly a future for them, and for their children (Clarke and Garvey 1974: 163).

Amy Jacques Garvey diligently compiled the *Philosophy and Opinions of Garvey*, or *Africa for the Africans Volumes I and II* for the practical purpose of raising money for her husband's continued defence, although in the preface to the work she indicated a much wider intent:

> I decided to publish this volume in order to give to the public an opportunity of studying and forming an opinion of him; not from inflated and misleading newspaper and magazine articles, but from expressions of thoughts enunciated by him in defence of his oppressed and struggling race; so that by his own words he may be judged, and Negroes the world over may be informed and inspired, for truth, brought to light, forces conviction, and a state of conviction inspires action (Garvey 1986: Preface).

In 1927 the pleas of Garveyites the world over joined together during the Harlem UNIA-ACL Convention to petition for Garvey's release. These efforts proved fruitful resulting in President Calvin Coolidge to commute Garvey's sentence on 18 November 1927. He was released and immediately deported on 2 December 1927. Although Garvey's home with his wife was in New York, he said "he was rushed to New Orleans, where he was given twenty-four hours in which to leave the country" (Clarke and Garvey 1974: 274). He was not allowed to disembark from the ship. However, he made a rousing speech to the thousands of Garveyites who gathered to bid him goodbye. Garvey left the United States on board the S.S. *Saramaca* that first stopped in Panama, then was bound for Jamaica.

Garvey's Return to Jamaica

While lynching of black people (Allen et al. 2004) and institutionalized racism (Chafe et al. 2001) were commonplace in the United States, in early twentieth century Jamaica racism existed in the form of "shadism" (lighter skin preferred to darker). Fusing light skin colour and class were markers of social inequality whereby black people experienced extremely low wages, continued deplorable working conditions, lack of credit to secure bank loans by shopkeepers while banks favoured Chinese retailers, and general lack of access to land, education and training. These opportunities were available to "lighter brown skinned" middle strata of the society. These realities resulted in mounting frustration among black Jamaicans and the society underwent several localized strikes, labour unrest and anti-Chinese demonstrations (Lewis 1988: 238–40).

One group who were objected to another kind of racism were First World War black soldiers of the British West India Regiment. They experienced

rampant racism in England, Italy and other places they served. On their return to Jamaica, these war veterans were more receptive to the messages of the UNIA-ACL than ever before, particularly in the organization's call for unity among the black people of the world. Garvey's return to Jamaica was a boon for these former soldiers who as black men saw little had changed for them in the society.

By the 1920s, from his LH headquarters in Harlem, Marcus Garvey built the UNIA-ACL into the largest international black organization ever, with over one thousand and fifty-three divisions worldwide; all of which were required to establish a LH. Driven by his first-hand witness of the economic, social and political deprivation of black people in Jamaica, Central America, England, Europe and the United States, he took the forefront in creation of an organization that sought to unite black people in Africa and its Diaspora around their common interests and advocate for an African voice in international fora where the fate of Africans was being addressed. In March 1921 Garvey said:

> We soon found that the condition of the Negro was everywhere the same; his colour was a bar to the advancement. In some sections of the world it was a bar to his economic progress; in other sections a bar to his enjoying the rights and privileges of citizenship. And we desired the world to bestow upon the Negro that liberty and freedom for which he fought and died in Flanders, France, and Mesopotamia (Hill 1984: 240).

Some of the principal goals of the UNIA-ACL were restitution of black people's authenticity through deconstruction of and reacquaintance with Africa's ancient history, promotion of self-help, self-sufficiency, upliftment of the race through economic and commercial activities, racial pride, self-rule, attainment of a Pan African perspective, and establishment of universities, colleges and academies for the purpose of racial education and culture of the people (Hill 1987: 206–11).

Garvey arrived in Jamaica on 10 December 1927 to a huge crowd of supporters. *The Gleaner* reported that "Mr. Garvey's arrival...was perhaps the most historic event that has taken place in the metropolis of the island" and "no denser crowd has ever been witnessed in Kingston" (Lewis 1988: 198). The crowd was so large, the cheers so loud, that the planned welcome event to take place at the Coke Chapel was reduced to a short three-minute address to the thousands of supporters from its steps (Ibid). During the next year (1928) after a series of meetings and speaking engagements in Europe – London, Paris, Brussels, Berlin and Geneva – Garvey travelled to Quebec where he was arrested by immigration authorities, ordered not

to speak publicly, and to return to Jamaica in one week. Nevertheless, he proceeded on to Toronto for meetings with UNIA division heads, then sailed (deported) back to Jamaica.

Back in Jamaica, Garvey's return and his foray into politics stirred the ire of not only the colonial authorities but also of white and coloured Jamaicans who viewed his actions as an affront to their "natural" right to lead. He launched Jamaica's first political party, People's Political Party, during the sixth convention of the UNIA (Hill 1990: lxx). The People's Political Party's platform included land reform, prison and legal reform, labour rights, public health, and housing and educational opportunity measures (Hill 1990: lxxii).

In September 1929 Garvey's presentation and discussion of the People's Political Party's Manifesto particularly plank #10 from a podium at Cross Roads in Kingston landed him in jail on a charge of contempt of court with a fine of £100, and a three-month sentence to St Catherine District Prison, Spanish Town. The plank was critical of the judicial system and read: "If elected, I shall do everything in my power...to make effective the following:...a law to impeach and imprison judges who, with disregard for British justice and constitution rights, dealt unfairly" (Clarke and Garvey 1974: 277–78). In other words, Garvey argued that judges who enter into agreements with lawyers and other persons of influence deprived people of their rights. In spite of being jailed Garvey achieved an unprecedented feat, in that he won his seat as municipal councillor of the Kingston and St Andrew Corporation Council (KSAC). However, other members of the Council refused to grant him leave of absence, and because of his inability to attend three meetings while in jail, his seat was declared vacant. He did regain his seat in the by-election (Hill 1990: lxxii). A copy of Garvey's success in the KSAC elections that was reported in the *Blackman* Newspaper is archived in the National Library of Jamaica.

76 King Street – 1920s

LH at 76 King Street was purchased in 1923 by the Kingston Division of the UNIA-ACL for establishment of its offices. Upper King Street ends at the hub of Downtown Kingston in St William Grant Park so renamed in 1977 in recognition of labour leader, Black Nationalist, and Garveyite St William Grant. Initially called Parade, describing the fact that the British Regiment had a barracks on the north side, used the Park as a drilling ground and as a site for hangings in the nineteenth century. Its name was changed to Victoria Park in 1914 in honour of Queen Victoria, and it became

a popular green space for upper-class Kingston residents. The Park and its surroundings changed dramatically as the upper class moved their homes and business headquarters uptown, and overcrowded ghetto communities mushroomed in Downtown Kingston.

LH on King Street was surrounded in the 1920s by what was termed a "better class" of people living in a "better class" of detached buildings (Clarke 2006: 65), and King Street had several retail stores that were owned in the majority by Syrian-Jamaicans. For LH to be established on King Street was an important accomplishment for the UNIA-ACL and must have redound to their benefit with respect to legitimacy and stature. That is, it is likely that there were few black-owned businesses on King Street in the 1920s as the colour bar dictated, and northeast Kingston was considered of high status, and therefore a white area.

Business activities were largely encompassed and emanated from the port, where African Jamaicans worked as labourers; whites of all nationalities owned wharves and warehouses; and Syrian Jamaicans and Jewish Jamaicans operated retail shops that were later eclipsed by former indentured Indians and Chinese. These groups were classified in the colour and class on the middle strata of the society. Clearly, 76 King Street, the location of the Kingston branch of the UNIA at LH was an anomaly.

Garvey's philosophy regarding Blackness was inimical to what held in Jamaica in the 1920s and 1930s, and is illustrated by his declaration published in the *Daily Gleaner* on 11 December 1927 one day after he landed in Jamaica:

> I am a Jamaican by birth. I am a Negro, and all things black appeal to me with a loving sympathy. I love the black race – I respect every unit of it. I have gladly suffered to win recognition for the people, and I am willing at all times to yield all for them. I respect all, and only those who respect my race, and anyone who thinks he can insult my race and merit my respect is mistaken (Hill 1990: 20).

The next day at the Ward Theatre, with its seating capacity of one thousand, Mr Garvey spoke to a packed audience:

> You shall find no coward in me. You shall find a black man ready and willing to represent the interests of the black people of this country and the black people of the world, without any compromise. We have had this rot long enough and Marcus Garvey is here, as a British subject, to constitutionally see that Negroes living under the British flag receive their constitutional rights (Hill 1990: 22).

In 1928 the UNIA-ACL in Kingston purchased Edelweiss Park on Slipe Road, North of Upper King Street, a larger facility in which to house the international headquarters of the UNIA, the offices of *The Blackman*, a daily newspaper, and, in 1931, the Edelweiss Park Amusement Company to promote cultural and recreational programmes supportive and reflective of the aims of the UNIA-ACL. Through this company, the arts were employed for education and entertainment. This venue provided opportunities to develop and showcase black talent which at the time was non-existent in Jamaica's theatre movement or on its cultural landscape. Garvey's understanding of the need for creation of a black cultural landscape is explained by him:

> To organize Negroes we have got to demonstrate; you cannot tell them anything; you have got to show them; and that is why we have got to spend seven years making noise; we had to beat the drum; we had to do all we did; otherwise there would have been no organization (Hill 1994: 189).

The company hosted plays, vaudeville shows, elocution contests, choral concerts, dance competitions, films, pageants, parades and a non-denominational religious service conducted by Garvey on Sundays. Garvey believed that the creative arts and artists should identify with, and positively contribute to the struggles of black people (Lewis 1988: 250). Furthermore, in this way Garvey ensured himself a place in the collective consciousness of the people. In Stanley Nelson's PBS film, *Look for me in the Whirlwind* several persons interviewed reiterated mainstream newspaper propaganda that purported Garvey's use of performance through pageantry as foonery. His penchant for uniforms and titles for the organization's various quasi-military arms were thought to be inappropriate, or perhaps only the preserve of white people. Garvey's title as Provisional President of Africa was considered pretentious, and he was ridiculed for his choice of uniform which was similar to that of Governors of Jamaica. The uniform and authority of the later however, were never questioned. It was also never considered that Garvey's adoption of a plumed hat, that designated him as "Provisional President of Africa" which bore the brunt of criticism, recalled his African heritage where for centuries African nobility donned distinctive garb and headdress that identified them as such. An example of the symbolic representation of power is seen in photos of Chief Soul Bearer of the king of kings of Ghana, known as Asantehene (Beckwith and Fisher 2000: 93). Ironically, the plumed hat was also part of the uniform of high-ranking British officials at that time (see figure 5.3).

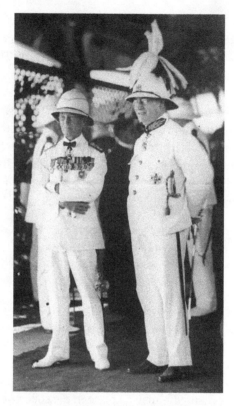

Figure 5.3. A famous photo of Marcus Garvey showed him wearing a plumed hat befitting his title as Provisional President of Africa; Sir Samuel Herbert Wilson (in plumed hat), Governor of Jamaica 1924–1925 (National Library of Jamaica).

Garvey was very aware of the criticisms levelled against his "performance" style but was adamant that Western education demanded criticism of black people who sought to create alternative means of representing themselves from their perspective. He said:

> As far as their society is concerned, if you want to hear about titles, just cross the channel. White folks like titles so much that they pile up millions of dollars for a lifetime so that they can buy a title on the other side of the channel…Why therefore should some folks want to be spectacular and do not want Negroes to be spectacular? We say therefore, that since they have found some virtue in being spectacular we will try out the virtues there are in being spectacular (Hill 1994: 199–200).

Garvey presided over the reconstruction of 76 King Street in 1933 from a small wooden structure into a modern two-story concrete building. At

its dedication on 22 March 1933 Kingston's civic and business leaders laid the foundation stones at the ceremony that was attended by a wide cross-section of Jamaican people and reported on in detail the next day in the 23 March 1933 (p. 18) issue of *The Daily Gleaner*.

A total of nine foundation stones were laid, six of which are still visible. *The Daily Gleaner* 23 March 1933 reported the event. The most prominent is the one laid by Garvey at the front of the building where today it is a point of reverence in recognition of him as an ancestor, and a major point of pause for Jamaicans, tourists and all other visitors to LH. The cornerstone is quite visible and marked by a traditional Jamaican vessel for libations. Set back from the street, the open garden space provided a legal venue for Garvey's public meetings and lectures, and, in keeping with his promotion of black people in business, the new building housed a Laundromat, a canteen, an employment service, a co-operative bank, as well as offices of the UNIA/ACL.

In 1934 Garvey announced to participants of the international UNIA-ACL convention held at Edelweiss Park that he planned to move the organization's headquarters to England (Hill 1987). Garvey's departure for England in 1935, his death in 1940, and the decline and fragmentation of the UNIA-ACL that followed, resulted in the sale and resale of LH. However, for three decades (1950–1970) 76 King Street was a popular venue for boxing, dances and other cultural activities, and during the early 1980s it served as a garage and offices of a mini-bus company.

In recognition of the worldwide celebration of Garvey's centennial in 1987, 76 King Street, which had fallen into a derelict condition, was purchased by the Government of Jamaica under the aegis of the Jamaica National Heritage Trust and declared a national monument. Marcus Garvey adhered to a visionary philosophy and promoted by his political acumen was firmly supported by his stead-fast belief in the resurrection of self-identity by black people for their own benefit. Despite the oppressive powers of colonial authority, colour and class biases, and US dogmatic discourse, Garvey's message still holds forth. This is clear in the work of the Friends of Liberty Hall. The National Library archives hold photos showing the status of LH in the 1920s. In 1987, The Gleaner Company printed photos of the status of LH at that time.

Chapter 6

The Friends of Liberty Hall (Marcus Garvey)
Foundation – 2002

Members of the UNIA-ACL in Kingston launched several unsuccessful attempts to raise money for restoration of 76 King Street. However, the efforts of a consolidated group of individuals, the Friends of Liberty Hall[1] (The Friends), bore fruit. The Friends set out to restore 76 King Street through several avenues. First, in 2000 Ms Elaine Melbourne, then Executive Director of the IOJ, created a home for LH by placing it within the IOJ as a special project of the African Caribbean Institute of Jamaica, a division of the IOJ. The IOJ was an agency of the Ministry of Education and Culture. In 2002 the Ministry earmarked fifteen million Jamaican Dollars (J$15M) for the restoration of LH in the IOJ's budget. The work was planned, supervised and executed in 2003 within budget by Mr Harding, Assets Manager at the IOJ. After the initial funding was secured, the next step for The Friends was to find the next wave of resources.

The Friends embarked on fundraising projects for future programming. In Jamaica fundraising took the form of a performance of Marcus Garvey Speeches in full UNIA regalia by artist/journalist Ron Bobb-Semple; poetry readings by renowned Jamaican poet Lorna Goodison; and silent auctions of art donated by well-established visual Jamaican artists. Later, in Washington DC, a gala luncheon for prospective individual and institutional donors took place at the Ortanique Restaurant which was catered by the internationally celebrated food designer and restauranteur Norma Shirley. This event garnered the bulk of funds made available for programming.

Next, The Friends garnered a commitment of one million Jamaican Dollars (J$1m) from the National Housing Trust, a Government Statutory body, to purchase six computers and accessories, a scanner, printer, a suite of educational software for children ages seven and up, as well as engagement of Vilcomm Services Int'l Ltd., a computer training firm to conduct classes for one year. UNESCO donated one computer, and another was provided by the United States Ambassador's fund. The staff of UNESCO in Paris collected and donated funds enabling the purchase of a table and four chairs to create a lunch area for the staff.

The Friends gave priority to community involvement by mobilizing a group of teenagers ages 14–18 from Love Lane and the surrounding communities in a programme lasting over one year to tease out their vision for themselves and for their communities. The intent of the programme was for the youth of the community to help determine and therefore buy into the concept of LH.

With the help of Caribbean Cultural activists, Ms Carol Laws, and the comedic team of Bella and Blackka, the Liberty Hall Community Youth Club was established. Through their discussions, while on retreat outside of the community, it was determined that LH needed to function as a youth centre offering training in computing, resume writing and small business development. LH was also envisioned as a place that used culture and the teachings of Marcus Garvey to strengthen self-esteem and contribute to conflict resolution. In this manner, the skeletal outlines of LH's community inclusion programmes were loosely constructed. Through consultations among themselves, the Youth Club, and stakeholders within the community, The Friends, resolved that the building should have the following use:

1. House a museum dedicated to the life and work of Marcus Garvey.
2. Establish a multimedia computer centre that would serve the interests of youth in the community.
3. Establish a research/reference library.

Although I joined the team after the foundational work had been completed, it was clear to me that The Friends had a vision of LH as a place that the community would take pride in, be a part of, and as an oasis of safety, caring, knowledge and belonging in a decaying downtown community rife with contradictions and challenges. 76 King Street has the distinction of being built by Marcus Garvey in 1933. The dedication plaque bearing his name remains at the front of the building. As a restored National Monument, 76 King Street is a testimony to Garvey's teachings of self-reliance, confidence, enterprise, racial pride and pursuit of knowledge. Since Garvey's philosophies are not taught in the school's curriculum, I have made it my passion as a museologist to create a cultural educational institution wherein the museum chronicling the life and work of Marcus Mosiah Garvey from his perspective is its primary educational tool. Further, the Multimedia Computer Centre and the Research/Reference Library would incorporate Garvey's teaching during community outreach programmes and in the latter's collection policy which favours Garvey, Africa, and the African Diaspora.

The Skeletal Outlines of the MMGMM

In June 2003, I was offered the opportunity to be LH's first Director/ Curator and to design the skeletal outlines of a museum. Because the time frame between the request and the proposed opening ceremonies in October was very short, I partnered with the Jamaica Information Service to produce a twenty-minute documentary on Marcus Garvey and LH that would inform the public about what was planned in the future for the museum and for LH.

The position of Researcher was undertaken by Ms Nicosia Shakes, whose remuneration for the first year was provided by a United States Embassy, Ambassador's Fund, awarded to Professor Rupert Lewis a well-known Garvey scholar and Chairman of The Friends, and Chairman of the African Caribbean Institute of Jamaica a division of the IOJ. The award was to compile a CD of Garvey's *Blackman* newspapers published in Jamaica 1929–1931. As a past student of Professor Lewis' "Garvey and Garveyism" course at the University of the West Indies, Ms Shakes produced informational storyboards on Garvey's life and achievements that would constitute the skeletal outlines of the museum's exhibition.

Ms Nicole Patrick, also a past student of Professor Lewis' course, was seconded from the African Caribbean Institute of Jamaica, worked with the Friends of LH from the outset, and filled the post of Administrator. She was instrumental in gathering the neighbourhood teens who would evolve into the Liberty Hall Youth Group, and her continued work was integral to building linkages with the surrounding community and establishment of community outreach projects.

The IOJ's graphic designer assisted with determination of the layout of Garvey quotes on the walls and placement of storyboards in the museum space. I collaborated with renowned Jamaican installation artist, Ms Petrona Morrison to create a vitrine (a glass display case) for the exhibition of Marcus Garvey's cane – the only personal artefact of Garvey's owned by the IOJ.[2] The vitrine holding the cane was made a focal point in the museum. It was surrounded by images of Garvey's life and the movement with text under glass offered a learning opportunity for visitors.

The Friends secured, on temporary loan, an iconic oil painting of Garvey by renowned Jamaican artist Barrington Watson, who created it as part of a series of paintings and a book by the same name – *The Pan-Africanists* (Watson 1999); on which it features on the cover.

Donations of three wooden benches and a large carved wooden bench with an ornate back by Master carver/furniture maker Gilbert Nicely helped

set the stage for the theatre area of the museum that was to come. Also, on permanent loan from the IOJ and featured in the Museum is a portrait of Garvey in his wedding clothes. Garvey married his first wife Amy Ashwood Garvey on 25 December 1918 in Harlem. The portrait was gifted to the IOJ by the UNIA-ACL in 1957.

Liberty Hall: *The Legacy of Marcus Garvey* – The Re-Opening

On 20 October 2003, National Heroes Day, the newly refurbished LH reopened to the public with a ceremony befitting its importance as a national monument dedicated to Jamaica's first National Hero, The Right Excellent Marcus Mosiah Garvey. King Street was blocked off to vehicular traffic and hundreds of chairs were laid out facing a large stage and a banner emblazoned with the words "Remember Marcus Garvey" that spanned the width of the street. The day was overcast and windy producing little whirlwinds of paper and dust on the sidewalks eerily reminding us of Garvey's promise: "look for me in the whirlwind, look for me in the storm" Persons were seated as well as lined the sidewalks hours before the proceedings were slated to begin at 4:00pm while Rastafari Nyabinghi Drummers provided the African cultural context for the event. Among the dignitaries were the Mayor of Kingston Desmond McKenzie, Prime Minister the Hon. Percival J. Patterson, Prof. Rupert Lewis (Chairman of Friends), Deacon Wolde Mehdin (member of the UNIA and the Friends), Mr. Delano Franklyn (Advisor to the Prime Minister). Hon Leader of the Opposition and former Prime Minister Edward Seaga and his wife Mrs Seaga, Hon. Burchell Whiteman, Minister of Education and his wife Mrs Whiteman, Professor Rex Nettleford, Vice Chancellor of the University of the West Indies, and Mr Wycliff Benne.

The event was opened by the Liberty Hall Youth Group who recited poems based on their own lives and the life and work of Marcus Garvey. Noted poet Mutabaruka performed several works and Mr Ron Bob Semple, in a reproduction of Garvey's uniform, recited one of Garvey's speeches to thunderous applause. The Prime Minister, Percival Patterson, Leader of the Opposition and past Prime Minister Hon. Edward Seaga, and Hon, Ms. Elaine Melbourne, representing of The Friends, all spoke at the event including Garvey Scholars, and members of The Friends of Liberty Hall Professors Tony Martin and Rupert Lewis.

Re-opening of LH saw a ribbon-cutting ceremony performed by Hon. Prime Minister P.J. Patterson and Leader of the Opposition Hon. Edward Seaga, witnessed by the Minister of Education, Maxine Henry Wilson, and

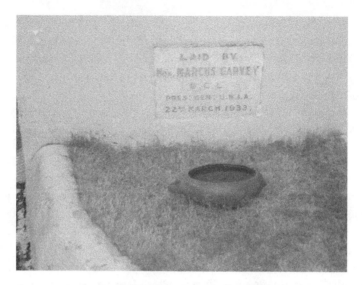

Figure 6.1. Foundation Stone laid by Marcus Garvey 22 March 1993 (photo by author).

Kingston's Mayor Desmond McKenzie. Also in attendance were crowds of people who observed these acts of celebration.

The event culminated in the formal opening of the building, a musical performance by Mystic Revelations of Rastafari, and tours of the museum and the building. The foundation stone laid by Garvey holds an important historical position in LH (see figure 6.1).

Chapter 7

Building a Cultural Educational Institution that Serves Members of the Surrounding Inner-City Communities First

Get Up and Do

In taking the first steps to re-establish LH on Jamaica's cultural landscape, I drew on my Museum Studies training in progressive museology in the UK. There it was reinforced that for the facility to achieve its potential, it must have a sense of purpose, priorities and methodologies. A mission statement makes it possible for staff to focus on the facility's purpose; for the public to be aware of what drives the institution particularly for the purposes of raising funds, marketing and creating networks with like institutions; and the methodological approach to be taken to achieve the purpose (Ames 1994). Sustainability requires that this process be a consultative one with stakeholders who we identified to be as follows:

1. The Friends of Liberty Hall
2. The staff of LH
3. The LH Community Youth Group
4. The UNIA-ACL in Jamaica
5. Members of The Marcus Garvey Movement at the University of the West Indies, Mona

In November 2003, the consultative process yielded a concise mission statement by fine tuning the first three lines of a draft that I crafted and circulated:

> The primary mission of Liberty Hall: The Legacy of Marcus Garvey is to inform the public about the work of Jamaica's first national hero and to use his philosophy and opinions to inspire, excite, and positively affect the self-identity of Jamaican people, while creating social and economic wealth.

The Mission Statement was immediately printed and displayed for the public to see the course charted for LH. The mission of LH is actualized

through the needs of its audience – the immediate community first, the remaining citizens of Jamaica second, followed by all others. The draft mission statement, which was more detailed than intended for the public, serves the staff and volunteers of LH as an indication of the organization's culture (individual commitment to self-reliance, organization, pursuit of knowledge and excellence, racial pride, and reverence for history); of LH's mandate (be a source of pride and learning); and of the areas envisioned for its development (museum, multimedia computer centre and research library).

The staff and I were already aware of the fact that the history of LH and Garvey were in and of itself redemptive of black self-esteem and knowledge. We simply had to create the tools by which this outcome could radiate to all who passed through its gates. The physical conditions of inner-city communities and the cultural and educational needs of community residents directly influenced determination of the goals of LH. Fulfilling these gaps provided opportunities for the institution to be a catalyst for personal and community development by offering relevant programmes that educate and inspire both youth and adult members of the community.

This strategy is in keeping with Sylvia Wynter's culture-systemic theoretical framework in which providing access to transformative education produces "the knowledge and understanding people need to rehumanize the world by dismantling hegemonic structures that impede such knowledge" (King 2005: 5). Using Beer's (1994: 38) typology as a model, I devised the institution's goals which were considered, changed and accepted by all stakeholders previously mentioned as follows:

The Museum's Audience: Communities Surrounding LH

The community surrounding LH is now popularly referred to as "Spanglers". Downtown Kingston today is essentially a business district surrounded by pockets of residential spaces. Many of the facilities and services that are otherwise commonplace in communities designed for residences are absent including playgrounds, adequate living and outdoor spaces, legal access to utilities, and suitable garbage and sewage disposal. St William Grant Park (Parade) is considered unsafe and inhabited by the homeless and persons of unsound mind, although efforts have been initiated by successive municipal authorities to implement a more community friendly vision of the park. Residential pockets still constitute a network of small lanes and streets, but with substandard housing. This includes those that are make-shift rooms of zinc or plyboard traditionally surrounding

Table 7.1. Goals set for Liberty Hall: *The Legacy of Marcus Garvey*, 2003

Goal Type	Definition	Goals for LH
Educational/Interpretive	Goals for exhibits, publications, lectures and other programmes to promote learning by visitors (including knowledge acquisition and changes in attitude, awareness and feeling)	To use state-of-the-art technology to demonstrate the relevance of Garvey's philosophy in relation to contemporary issues and challenges, to bring Africa to Jamaica through film. Its main outreach programmes will consist of a mobile museum to traverse the country with the teachings of Garvey interpreted for all ages and creation of a "Garvey box" of hands-on interactive tools for primary school children.
Social Purpose	Goals to promote positive changes in society	To ensure that the teachings of Garvey remain alive in the minds of the youth; to engender race pride, respect and communication between people; and to be a guide for reducing and solving conflicts.
Curatorial	Goals for acquisition and preservation of collections and for research on collections	To build and interpret the collection of Garvey's teachings that will support short/long-term exhibits and programmes. The museum will not be object driven, but it will collect Garvey/UNIA writings, printed memorabilia and any other available material.

(Continued)

Table 7.1. (Continued) Goals set for Liberty Hall: *The Legacy of Marcus Garvey*, 2003

Goal Type	Definition	Goals for LH
Professional	Goals for contributing to the museum profession (including networking with other museums, historical societies and academia)	The museum at LH will be the first multimedia interactive museum in Jamaica and possibly in the Caribbean. Lessons learned from its establishment will be important to future museum development. To be a centre for Garvey studies, to work with African and African Diaspora institutions worldwide.
Environmental	Goals for contributing to the museum's relationship with the local retail and residential communities (including outreach to non-museum organizations and community groups)	To use the restoration of LH to assist in the urban renewal of the surrounding built environment. To facilitate the development of the surrounding communities.
Organiza-tional/administrative	Goals for the internal affairs of the museum (including staff and volunteer organizations)	To attract the best people on staff; to nurture a core of volunteers; to evaluate progress towards the goals at least twice per year.

Financial	To devise a transparent system wherein a large membership base can be developed; to raise funds to support LH's programmes. To establish a bookstore/gift shop, a coffee/juice bar and an internet café as income generating centres for LH. To charge a modest fee in order to accommodate everyone. To be financially independent with respect to implementing its programmes and projects.
Goals for maintaining and enhancing the museum's endowments with other fiscal supports	
Marketing	To create and develop communication media to inform people of the museum and other LH programmes.
Goals for promoting and advertising the museum (public relations)	
Logistics	To provide adequate space to support programmes and exhibits, community group meetings, lectures, poetry readings and the like that are consistent with the LH mission statement.
Goals for the effective and efficient use of museum property and facilities (including internal and external traffic flow and use of non-exhibit space)	

Figures 7.1 and 7.2. Living conditions on Love Lane, directly behind LH seen from the Garvey Great Hall (photo by author).

a decaying nineteenth century "better" house with nearly non-existent infrastructural services.

Overcrowded conditions and criminality stigmatize the majority of its residents who are law-abiding, poor and suffer from the negative effects of under- and unemployment. Graphic images of urban poverty nearby LH (see figures 7.1 and 7.2). According to the United Nations, poorer households are more at risk to be victims of all violent crimes (Martin and Anstey 2007: 35), a situation that dampens hope for a better life – good.

The report also indicates that in Jamaica, where there are more young males in a community, the homicide rates are higher. Further, where young men are prevalent in households there are higher rates of violent crime victimization than otherwise (Martin and Anstey 2007: 37).

A reformulated principal of Ubunto, proposed by African American philosophers stating "I am, because we are" or "the individual is a harmonious part of society, and there he finds his safety, his strength and identity." Hord, F. L. and J. S. Lee (1995). This was further adapted to conditions in urban garrisons, is evidenced by "authority" figures within inner-city communities. Dons/Area Leaders, who wield tremendous power over residents on the one hand, are on the other required to reciprocate with assistance in satisfaction of economic needs, thus providing protection from molestation within the community. For example, when Dons are brought before the court system, it is mandatory that community members appear inside or outside of the courthouse as a public show of support. The punishment for non-attendance may be forced removal, burning of the home, or even rape of females within the household. Conversely, when unemployed parents need medical care or are unable to pay school fees and provide uniforms and books for school age children, the Don allegedly plays the role of benefactor to adults and children. Public holidays like

Christmas are widely celebrated in the inner-city where Dons lean on the business community to provide funds to finance "treats" as a part of their provision of protection from break-ins, hold-ups and fire. Further, where there are disputes between community members, Dons are reputed to have their own extrajudicial hearings and sentencing systems (Levy 2009).

Levy finds that the link between poverty, crime and drug use leads to persecution of residents, especially males, by the police in entire neighbourhoods where "harassment of the innocent embitters many youth against the police" (Levy 2009: 66). Inner-city youth also experience discrimination in the job market where an inner-city address acts as a deterrent to employers from offering employment to qualified youth.

The UN Report previously referred, indicates that Jamaican female-headed households make up a larger share of the population and are more likely to suffer from murder, shooting and robbery. There are demographic and economic factors at work here, as poor households are constituted in areas where there is a breakdown in social ties that may lead to violent crimes. Productive investment is deterred by violence-plagued neighbourhoods resulting in fewer productive employment opportunities (Martin and Anstey 2007: 52).

Violence is pervasive in many spheres of contemporary Jamaican life, and I contend that its cultural centrality dates to establishment of the island as a colony by Spanish and then British powers. Extreme violence was a way of life for enslaved Africans and continued after emancipation, colonialism, and is part of the tool kit of post-colonial Jamaicans in their problem-solving. However, extreme violence continues to be pitted against the Afro-cultural ethos that also survived enslavement. That ethos includes respect for elders, for education as a means of social and economic advancement, of the importance of the extended family, prevalence of rituals and social networks characteristic of the traditional black church, Creole languages, and art forms anchored in indigenous African legacies (King 2005).

One must also consider the culture of violence in Jamaica's schools. From 1866 when churches established schools, teachers operated under the accepted racist premise that black people can only learn by rote and with the threat of a whip. Corporal punishment was therefore considered an intrinsic tool in the teacher's arsenal. Evans' research (2001) reveals that the wide scale method of teaching in government-run primary and secondary schools continues to use violence as a disciplinary mechanism. She documents that a "seatwork teaching" methodology is employed where a lesson is taught over a period of eighty-five minutes. The teacher "writes on chalkboard without speaking (5 minutes), solicits answers and writes

on chalkboard (32 minutes); and students line up while teacher sits at table correcting (48 minutes)" (Evans 2001: 87). If or when children become bored and misbehave then they were subjected to corporal punishment and verbal abuse by teachers:

> Observers noted that teachers carried the strap or cane everywhere, and the threat of corporal punishment pervaded the atmosphere of classrooms. Students were beaten for a variety of reasons – for not paying attention, for not doing homework, for not having textbooks, for not understanding, for forgetting what had been learned, for making spelling errors, for arriving late (Evans 2001: 88).

Evans does indicate that the behaviour of teachers could be related to the stress of overcrowded classroom conditions, noisy environments in which a blackboard separates a class of fifty from another, the lack of proper teaching resources and materials, and unmotivated students who believe that school is a waste of time. Their dissatisfaction and frustration may be directly related to their resort to corporal punishment. And, if that is so, then it could be surmised that in the learning environments of teacher training schools, students are taught that these methods were acceptable in public schools.

There are eighteen (18) all-age and primary schools that serve as feeder schools for LH's community outreach programmes. Some of the lessons learned from discussions and activities within the Youth Group in 2003 are: that there is a definite stigma connected with living in inner-city communities and attending inner-city schools; young people have little access to new technology in their schools and communities; violence serves to define the parameters of children's future potentials; and the prevalence of lack of self-confidence and low self-esteem among children, particularly, those who are dark in complexion, is rampant.

A sample of the writings of children in LH's 2011 summer art programme (age 7–17) reflect on violence in their communities in their statements and their poems:

> I live in the ghetto part of Kingston called Wilton Garden. I would like to move. Lots of conflict [,] war [, and] crime. When I am coming home from school, war, I have to wait for when they kill someone or beat up someone before I can pass to continue my journey home.

> Justice

> Mi want peace in a the community... too much man a dead and little pickney... .mi want love in a the environment because man a kill man because paliment [parliament]...peace, peace everyone, me want peace.

A nuff things a gwaan wah me don't no [many things are going on that I don't know]
You dah war a man if him step pon your toe
We tired a the violence and the killing
Gun man put down the gun and lets have some fun
We want peace, peace everyone, we want peace

I live in a the Ghetto

I do not like to live in a the Ghetto. I would like to move out a the Ghetto. I would like to live in Montego Bay. I would like the violence to stop and the crime. I would like the man to put down there [their] gun and stop kill people and what I [don't] like about my community is that when we want to have a party we can['t] have party because a everyday gunshot a fire

My Community

My community is a bad community in the ghetto. Well sometimes the community is nice. It's nice sometime because they keep a little treat in the community but I don't like my community at all. I would like to move to Negril with my family. I would like to live near Cool Runnings Water Park and would go there every day.

Admittedly these narratives and the preceding analyses seem to privilege what Chimimanda Adiche has coined "a single story" of violence and lack. From the perspectives of researchers, writers and the children, the narratives are incomplete, truncated and biased. The narratives leave us with the perception that inner-city lives are not nuanced, complex, layered, or that there are no happy fulfilled lives being lived, or that people don't wish to move out of these conditions in search of better accommodations. Further, constituency requirements of the British parliamentary democracy model accepted by Jamaica with Independence makes it convenient for members of parliament to keep large numbers of residents, hence votes, within a constituency no matter how onerous the living conditions. They in turn, seem to turn a blind eye to illegal connections to essential services within the communities and pander to and protect Dons/Area Leaders who ensure turnout of voters.

The importance of the work of LH is that through its involvement of community members in determination of its programmes and through its core educational tool, the MMGMM, housed in LH, provides the historical and cultural bases upon which to reframe attitudes about what is possible and a forum to discuss information needs that are indicative of people who are underserved by available opportunities. LH provides tangible opportunities for adults to gain skills and increase their employability,

as well as a safe place for children to be after school and during summer holidays. LH therefore provides a platform for narrative creation around issues of identity, participation and belonging within a community, and a sense of pride in the children who participate in summer art programmes in leaving physical markers of their ownership on the walls and grounds of the space.

Enabling the Community: The Garvey Multimedia Computer Centre

In the first three years of operation, the two stated goals *to promote positive changes in society and contribute to the museum's relationship with the local retail and residential communities* were particularly relevant to development of the Garvey Multimedia Computer Centre, the Garvey After-School Programme, Garvey Community Outreach, and the Garvey Research/ Reference Library (GRRL).

The Garvey Multimedia Computer Centre's first students were members of the LH Community Youth Club. The programme, devised by Ms Vilma Gregory of Vilcomm Services Int'l Ltd., was entitled "Techno-Garvey Community Multimedia Centre" and aimed to teach computer skills to youth in the community while teaching them about the life and work of Marcus Garvey.

The Multimedia Computer Centre was very popular among the older youth; however, in 2004 when we attempted to accommodate smaller children ages 7–12, older youth began to drop out because they did not want to share the space with younger children, and they believed they had learned what they deemed the important skills – surfing the internet, creating e-mail addresses and basic computing tools. A core group of ten remained for another three years and two of this group became computer teachers at LH.

As more and more children between the ages 7 and 10 came after school, Ms Shakes, Ms Patrick and I provided computer classes for the children in the afternoons that the older youth did not have classes in school. We requested assistance from other computing firms and invited computer teachers to apply, as the contract with Vilcomm came to an end in December 2004. Parents were required to come into LH to register children. On one occasion, a parent asked: "so, we caan learn computa to"? [So, can't we (parents) learn computers also"?] The parent's inquiry was in fact appropriate as the computers were idle during the morning hours while the children were in school.

For a small registration fee of J$300.00 (US$ 4.92) and $200.00 (US$3.28) (In 2004 the exchange rate was J$61: US$1. By 2010 the fee was raised to J$500 registration and J$300 per class. The exchange rate moved to 85:1 such that registration and class fees were US$ 5.80 and 3.52, respectively) per class, adults are enrolled in an eighteen-week programme where they attend classes once per week between the hours of 9:00 a.m. and 1:00 p.m. Adults range in age from 20 to 82 with a larger percentage of women than men, many of them employed or underemployed coming from surrounding communities and the nearest Parishes of St Thomas and St Catherine.

Since 2005, LH has trained over twenty-five hundred adults in basic computing skills that include the Microsoft Suite and Internet access. Students are introduced to Garvey through tours of the museum, lecture and typing assignments from *Marcus Garvey Said: A Collection of Quotations From Statements Made by Marcus Garvey* (Jones 2002) which serves as a text. Students are exposed to the philosophy and opinions of Marcus Garvey, particularly those passages pertinent to increased self-identity and self-esteem.

While there is great demand for classes on Saturday, and for late opening hours, LH cannot satisfy the demand due to the lack of budgetary allocation to cover salaries and utilities. LH did not receive any subventions from government until 2007, and because subventions only cover salaries, utilities and building maintenance costs, funds were raised elsewhere. Through proposals to national and international institutions, and solicitations to private sector companies and individuals, the funds garnered from these sources were used for programming.

We found that many adults and children in high schools in communities surrounding LH, who were desirous of learning computing, were functionally illiterate or read below their age group. Therefore, these youth and adults had trouble accessing the programme. I wrote a successful proposal to the Organisation of American States titled *Downtown Kingston Inner-City Computer Centre & Community Outreach Programme* and obtained funding to introduce opportunities for adults and children to learn to read while learning to use computers. These funds facilitated the acquisition of four computers, literacy and numeracy software, and the opportunity to train teachers to impart literacy and numeracy skills to adults and children. The grant enabled contracting a literacy specialist, Dr Donna Wright-Edwards, whose area of expertise was devising literacy strategies through the methodology of transformative black education which uses culturally based tools to achieve literacy.

Through the project, LH employed four teachers – two computer and two primary school teachers – who were trained in imparting literacy skills to adults and children using computer software and creating simple effective tools and games. Funding enabled the programme to be conducted on Saturdays – morning for adults, and afternoons for children. The project's duration was one year with follow-ups in the second year and attracted over two hundred and fifty students over the period.

With the assistance of the Organisation of American States, LH provided remedial educational interventions to improve the academic performance of children and youth in inner-city schools and adults to obtain literacy and computing skills to improve their marketability in the job market. Dr Donna Wright-Edwards, a literacy consultant undertook the training of teachers.

After the Organisation of American States project, the IOJ agreed to fund two teachers who were recipients of literacy training to teach children at the primary school level as well as continue training of adults within the computer literacy course on a part-time basis. This agreement by the IOJ strengthened the After-School Programme by establishing continuity in instruction and allowed us to track the academic development and achievements of the children in the programme over the years. Unfortunately, the end of the Organisation of American States funding meant an end to Saturday classes which were most beneficial to adult students. We accommodated the children with individual literacy instruction in the regular After-School Programme but were unable to make further provision for literacy training for adults.

Through the Organisation of American States Jamaica office's promotion of "Capoeira" for empowerment and peace to "at risk" youth, LH became a site for teaching this African Brazilian martial art that has roots in Angola and was developed as a method of warfare by African Brazilian maroons. The teaching of Capoeira encompasses music and movement and is very popular among children, especially boys, in the After-School Programme.

Enabling the Youth: Garvey After-School Programme

From the outset, we noted that children enrolled in LH's After-School Programme ages 7–17 demonstrated a lack of preparation for learning. Some do not live within a family structure that teaches and enforces discipline, consistency, respect, manners and courtesy, and often love and care are absent from the home. Where these conditions exist, the children are likely to be unprepared to learn.

In 2004 over 75% of the children attending reading classes were unable to read at their age level. This problem is exacerbated by the fact that the educational system does not sufficiently address illiteracy among students but rather seems to simply advance them in grade. It is therefore LH's challenge to raise the literacy levels of its students and provide a safe environment that dispenses cultural and academic information by providing all students with the required tools to build self-respect and self-esteem.

As LH became known throughout the community the After-School Programme grew in numbers. A formal registration process was introduced that required forms to be filled with the signature of parents or guardians. The daily attendance fee was set at "a Garvey"[1] or J$20.00 (US $.23) and no child was turned away without it. By the start of the school year in 2004, LH registered over sixty children between the ages of 7 and 17 in the after-school programme but without adequate space, were unable to allow every child to attend every day.

By September 2004, LH attracted nine volunteers to the After-School Programme. Their professions and interests coincided with our vision of development of LH as a cultural educational institution. They assisted with the following skills: counselling, karate, reading, art, drama and dance which were utilized as opportunities for infusion with the philosophy and opinions of Garvey.

Over the years, LH strengthened its volunteer programme with students from the University of Technology, The Mico and Shortwood Teacher's Colleges, The Edna Manley School of Visual and Performing Arts, and the Jamaica Theological College that provides counsellors, and other institutions satisfying their teaching practice, community service requirements, as well as giving of their time freely to teach the children at LH.

By 2016 LH registers an average of sixty-five children every school year and through its advocacy has been able to maintain a teaching staff of at least five consisting of two paid part-time teachers and three volunteers. A reading competition has become a staple activity for the children who are exposed to books about Garvey, Africa, African American inventors, poetry, literature and more. The children are grouped by their age and abilities, required to write short compositions about the books and present their understanding of what they read. Parents and guardians are invited to attend the award ceremonies where first to third places were awarded gifts (figure 7.3).

LH's After-School Programme also introduced the children to educational games on and off the computer that encouraged learning while having fun.

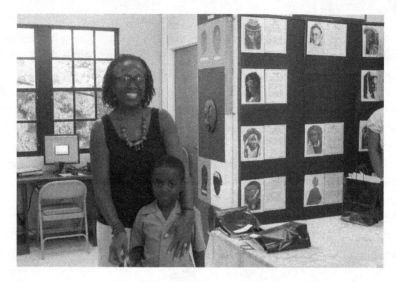

Figure 7.3. Reading Competition awardee, with Dir Dr McFarlane (photo taken by LH Staff).

LH: Community Outreach

In-house lectures, symposia and programmes held at LH include: drug awareness presented by Addiction Alert; issues with respect to hygiene, presented by a representative from the Ministry of Health; the ill effects of skin bleaching presented by a dermatologist; a demonstration on how to get sugar naturally from consumption of fruit presented by a food scientist; story telling; information on the rights of the child presented by a representative of the Jamaica Coalition on the Rights of the Child; proper care of pets by the Jamaica Society for the Prevention of Cruelty to Animals (JSPCA); the environment; and more. LH has hosted many lectures on domestic and international topics; has been the site of several book launches; readings by internationally acclaimed poets; is the site of the airing of contemporary and historical films on Africa, issues of self-identity; and the site of Garvey Birthday Celebrations and Christmas Treats for neighbourhood children.

LH annually hosts the Marcus Mosiah Garvey Lecture whose inaugural lecture was undertaken by Professor Verene Shepherd, Historian, and was followed by all three Garvey scholars: Professors Rupert Lewis, Tony Martin and Robert Hill. Dr Julius Garvey, second son of Marcus Mosiah Garvey, shared the lecture with Mr Howard Dodson, who at that time was the Chief of the Schomburg Center for Research in Black Culture.

Sankofa

This project was the brainchild of Ms Nicosia Shakes, the ACIJ/LH researcher. It was agreed that there was deficiency in the depth of information taught about Africa and African Jamaican history in the schools and that LH needed to design outreach programmes specifically targeting high school students to address this lack. We created a paradigm for this outreach and named it Sankofa – which is one of the Adinkra symbols utilized in 2004 by students in the first summer art programme. The symbol "SankƆfa" is a well-known Adinkra symbol from Ghana, whose most popular representation, one of eight, is a bird looking backwards. It literally means "go back to fetch it" which is the wisdom of learning from the past to build for the future (Willis 1998: 188–89).

SankƆfa is an annual all-day educational symposium catering specifically to secondary school students who are currently engaged with the History and Caribbean Studies syllabi in preparation for the Caribbean Secondary Education Certificate and the Caribbean Advanced Proficiency Examinations. We are partly guided by these syllabi as we identify specific themes within them that are consistent with the areas identified earlier and by UN designations of years. For example, a symposium was held in 2007 to commemorate the UN recognition of the end of the trade in enslaved Africans and, in 2011, as the UN year for recognition of people of African descent.

Scholars, whose work is exemplified in the subject areas, are invited to present a more studied in-depth perspective to students. Presentations are always followed by the fielding of questions and interesting discussions. Students at teacher's colleges, such as Shortwood Teachers College and universities also form a significant part of the audience. SankƆfa features presentations, exhibitions, films, and cultural items relating to themes on Africa and African Caribbean history. Demonstrations of Capeoria and drumming are seen in figures 7.4 and 7.5.

Students were fascinated by the performances as indicated in figures 7.6 and 7.7.

LH has produced and hosted six SankƆfa symposia the first of which was held in February 2005, black History Month, titled "Slavery and its Impact on Contemporary Jamaica". The themes explored for **SANKOFA II – VI** are as follows:

2006 – African Cultural Retentions in Jamaica

2007 – The Trans-Atlantic Trade in Africans

2008 – Our Freedom Journey: Resistance to Slavery and Colonialism in Jamaica

2010 – Garvey, Rastafari, and Africa

2011 – Recognizing our African Connections

The symbol of SankƆfa adorns the building in paint, tile mosaic as well as in metal on the gates that welcome visitors into LH. Symbol of SankƆfa was executed in tile mosaic by children.

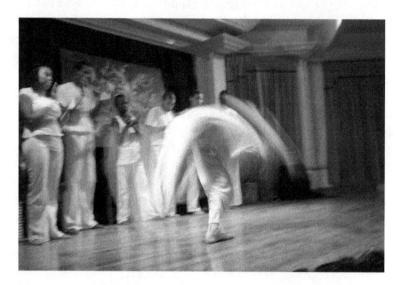

Figure 7.4. Demonstrating Capeoira at Sankofa III at IOJ Lecture Hall 2008 (photo by author).

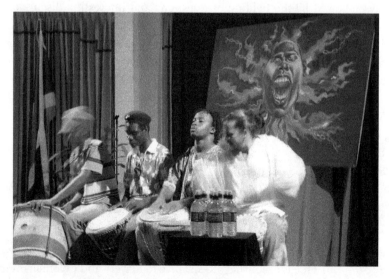

Figure 7.5. Drumming as forms of Resistance at Sankofa III at IOJ Lecture Hall 2008 (photo by author).

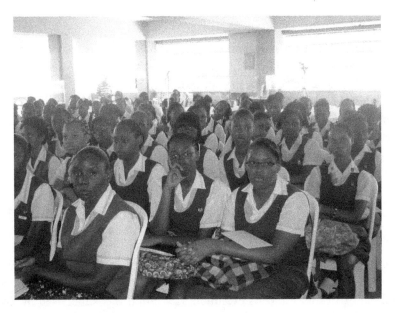

Figure 7.6. Over 300 students listening attentively during Sankofa VI, Garvey Great Hall: LH 2011 (photo by author).

Figure 7.7. Students listening and watching the performance at LH (photo by LH staff).

Summer Art

The first summer art programme began in July 2004 in response to the request of children and parents who live on Love Lane (a street directly behind LH) and those from the surrounding communities who attended the After-School Programme. They urgently requested that we provide something for them to do during their summer holidays, as they were accustomed to playing on the streets with little supervision. There were chess and dance classes held in the Garvey Great Hall in 2003.

The summer art programme consisted of a total of thirty-five children between the ages of 7 and 17 from the immediate communities that surrounded LH. Its duration was six weeks – July to August 17, Marcus Garvey's Birthday; between the hours of 9:00 a.m. and 2:30 p.m. It was held on the top floor of LH named the Garvey Great Hall, from which a panoramic view of the mountains that surround the city and of Downtown Kingston to the sea is offered. The theme arrived at was Garvey, Community, and Pan-Africanists and its execution as a mural was supervised by five student artists from the Edna Manley College of the Visual Arts, and one intuitive artist who was a volunteer in the After-School Programme. Through the IOJ, LH obtained the services of two youth workers through the Government's National Youth Service Programme. At the outset the teachers complained bitterly about the children's behaviour noting that it impeded their execution of the programme. The objectionable behaviour consisted of fighting, calling each other names like "black and ugly, black like pot" etc.; refusal to listen to instruction; running around in an uncontrollable manner despite instruction to the contrary; and inability to concentrate on any one task. Although the majority of the children lived in the community, were enrolled in the After-School Programme during the school year. They were beginning to learn the required conduct of students at LH and the summer holiday programme was an opportunity to further reinforce behavioural requirements with the goal of behavioural change.

To deal with the name calling I took a cultural approach and held a series of morning sessions with the children on the teachings of Marcus Garvey that exemplify his and the UNIA's "Black is beautiful" campaign and made it punishable by demerit if a child reported that another was guilty of the name calling described above. I taught the children to be proud of their skin colour through books, films, magazines and history lessons pitched at their age levels. I invited Ms Althea Laing, Jamaica's very first black supermodel to do a session on grooming with the children and to discuss with them what it meant to her to be black.

The children were introduced to books with historical storylines and illustrations of black people. These included: *Mansa Musa: The Lion of Mali* (Burns 2001); *Mufaro's Beautiful Daughters* (Steptoe 1987); *Book of Black Heroes* (Hudson and Wesley 1997); and *Black Stars: African American Inventors* (Otha Richard Sullivan 1998). These books increased their interest in reading and for many it was their first time learning black history.

In consultation with Dr Wright-Edwards then Chairperson of the Education Department at Medgar Evers College, a predominately black college in the City University New York system. It was suggested that the children be gathered in groups according to their ages and introduced to Adinkra symbols, a Ghanaian philosophical tradition that is usually displayed on funerary clothing.

Adinkra symbols reflect the complexity of traditional Akan social and spiritual existence. These historic Akan symbols depict the panorama of cultural life parables, aphorisms, proverbs, popular sayings, historical events, hairstyles, traits of animal behaviour, or inanimate or man-made objects. Adinkra symbols reflect cultural mores, communal values, philosophical concepts, or the codes of conduct and the social standards of the Akan people...expressions of the Akan world view (Willis 1998: 28).

The children were encouraged to choose the symbols they liked individually and then asked to arrive by consensus at the symbol that would represent their groups. There were four groups of five and two groups of seven students and they chose the following symbols and their meanings:

1. Bi-Nka-Bi (bee- in-ka- bee) – literally: No one should bite another, outrage or provoke another. Symbol of justice, fair play, freedom, peace, forgiveness, unity, harmony and the avoidance of conflicts or strife.
2. Fi-Hankare (fee-han-krah) – literally: An enclosed or secured compound house. Symbol of brotherhood, safety, security, completeness and solidarity.
3. Gye Nyame (jeh N-yah-mee) – literally: "Except God: or "Tis Only God". Symbol of the omnipotence, omnipresence and immortality of God. "Except God, I fear none".
4. Kuntunkantan (koon-toon-kaun-tan) – literally: Inflated pride. Symbol of pride of state and at the same time a warning against an inflated pride or an inflated ego.
5. SankƆfa (sanf-ko-fah) – literally: Go back to fetch it. Symbol of the wisdom of learning from the past to build for the future.

6. Sunsum (soon-soom) – literally: The "Soul". Symbol of spirituality, spiritual purity and the cleanliness of the soul.

The importance and efficiency of this methodology became apparent as the programme progressed. Whenever a child was outside of his/her group they could be asked what group, they belonged to, and they were required to name it as well as to repeat its philosophy. Further, whenever a child within the group misbehaved, the group would consider how inconsistent the behaviour was with their representative symbol, and based on this, decide collectively what the punishment would be. This tied into a system of merits and demerits where three demerits resulted in an audience with a parent or guardian and greater than five demerits resulted in the student being disallowed attendance to the end of summer excursion out of town or suspension from the programme. Merits were given based on helpfulness, cooperation, discipline, insightfulness, ability to listen and setting example, that is, picking up paper without being asked. Merits and demerits would redound to the benefit or not of the student as well as the group.

The methodology was deemed effective by all the teachers and is employed thereafter in subsequent summer art programmes, resulting in Adinkra symbols painted on the walls of the Garvey Great Hall and appearing in mosaics on the garden walls.

The programmes in 2005, 2006, 2008 and 2010 encompassed creation of tile mosaics on the wall of the Kingston Bookshop that borders the garden of LH. The theme of the mosaic is Garvey, Family and Community. Summer Art enrolment went from the initial thirty-five children to over sixty-five, many of whom return year after year to participate. As a result, the children took enormous pride in their achievements and are often seen pointing out sections of the mosaic for which they are responsible (figure 7.8).

Summer Art in 2009 was implemented by students from the Art and Drama School of the Edna Manley School for the Visual and Performing Arts. A play was created by the children and their teachers and the challenges of children in the inner-city were highlighted through the teachings of Garvey. The play entailed acting, set design and videography. This project was very successful.

Garvey Research/Reference Library

The published works of the Garvey scholars were donated by Rupert Lewis, Robert Hill and Tony Martin and became the foundational materials of the

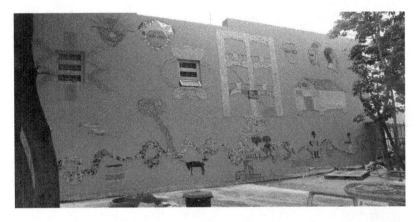

Figure 7.8. Garvey, Family and Community mosaic 2005, 2006, 2008, 2010 (photo by author).

GRRL. The special Garvey collection includes seven volumes of *The Marcus Garvey and Universal Negro Improvement Association Papers* compiled by Robert Hill, and four volumes of the Marcus Garvey Court proceedings– *Marcus Garvey – vs – United States of America.*

In 2005 Mr Cecil Gutzmore, a bibliophile and lecturer at the University of the West Indies, donated over six hundred Pan-African books that he painstakingly collected over a period of twenty years in England to LH. In 2010 he donated his remaining ten thousand books and materials to the library making the GRRL the largest collection of Pan-African books in the English-speaking Caribbean. The children enjoyed these literary treasures.

Over five hundred visitors to the GRRL have been assisted through the digital catalogue CDS/ISIS to access books, and students both local and overseas, undertake research in the GRRL. (http://portal.unesco.org/ci/en/ev.php-RL_ID=5330&URL_DO=DO_TOPIC&URL_SECTION=201.html #do) Individuals of all ages have also taken advantage of the opportunity to simply read about Garvey in quiet comfort. The GRRL is built on Garvey's premises of intelligence, education and universal knowledge.

Children's Library

A wide range of children's books were purchased from book sellers that specialize in African American children's books in New York. Donations of Caribbean-inspired books were solicited from publishers and children's book writers in Jamaica and over the Caribbean region. These efforts resulted in the successful establishment of a rich African-centred

children's library. The underlying intention was to source "books about us" with images and illustrations that look like the children reading these books.

To address the observation of youth in the LH Community Youth Club that there was ambivalence regarding Blackness among children of dark complexion, the Children's Library serves to counter their negative perceptions of themselves by providing positive images of black people in books. Therefore, donations of books with images of white children were rejected with an explanation of our methodology to donors many of whom had not thought about the conundrum caused in our children by such images.

Interaction with the children at LH reveals that there is great need for a specific collection methodology with respect to children's books throughout Africa and the African Diaspora. There was also a presentation of African-centred books by Read Across Jamaica to Garvey Children's Library.

This need is reinforced by renowned Nigerian writer Chinua Achebe who expressed shock when his daughter made the following statement: "I am not black; I am brown". Upon investigation of what prompted her resolve, he concluded that:

> in many of...those expensive and colourful children's books imported from Europe and displayed so seductively in the better supermarkets of Lagos...was not civilization but condescension and even offensiveness...hiding behind the glamorous covers of a children's book (Achebe 2009: 69).

He describes these books as "beautifully packaged poison" for our children and encourages parents to think critically when they purchase children's books and at the very least to read them before presenting them to children. It is reasonable to assume that images in children's books are partly responsible for the crisis of self-identity displayed by African Jamaican children. A lot of the blame could be levelled at the wide availability of white dolls only for black children, and films like Tarzan, whose racial and racist narrative has been recreated and animated for consumption in the Caribbean. Garvey specifically addressed this in the 1920s by advocating construction of black doll factories (figure 7.9).

Attention must be paid even to comic books, which are usually uncritically accepted by parents as a positive form of children's entertainment, particularly as it involves reading. Wilson argues that these books may "not enhance positive ethnic self-love and often work against it by consciously

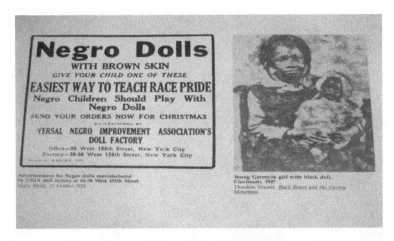

Figure 7.9. Garvey Centenary travelling exhibition devised for the Schomburg Center for Research in Black Culture and donated to LH in 2012.

and unconsciously promulgating 'white' values and perceptions, the [B]lack child may unwittingly assimilate those values and perceptions which are at odds with his own self-interest" (1978: 110).

Following this analysis, the paucity of black comic books with black heroes, and black animated films of the same genre, may lead black children to believe that only whites can be "super" heroes, masters of the universe, fight against evil, and rule and conquer all. In fact, evil is often portrayed in black clothing and or accoutrements subtly reinforcing the binary that black is bad and always loses, while white is good and always wins. In looking at the tendency in children to imitate cartoon characters, Wilson suggests that such "imitations make it more and more difficult for him [her] to separate his [her] own reality and destiny from those of whites and simultaneously lay a foundation for a dependency-ambivalent attitude toward whites and a rejective-ambivalent attitude toward himself" (Wilson 1978: 111).

LH introduced reading competitions for all ages in our programme that include reading comprehension and essay writing. African-centred books afford opportunities for the children to be immersed in the variety of cultures in Africa and its diaspora. Students are awarded trophies and gifts for successful participation and improvement in reading skills. This programme has become very popular among the children and their parents (figure 7.10).

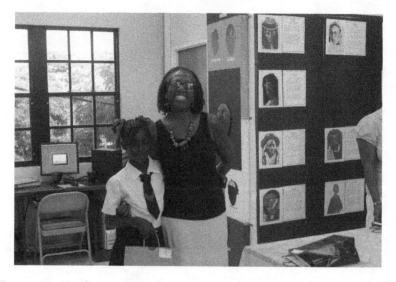

Figure 7.10. Handing over Reading Competition Prize to successful competitor (photo by LH staff).

Work and Making Progress in LH

This chapter presented a first-person perspective on my work in re-establishment of Liberty Hall: *The Legacy of Marcus Garvey* (LH) at 76 King Street, Kingston, Jamaica, as a cultural educational institution. The point of departure is acknowledgement that "museums have obligations as both educational and social institutions to participate in and contribute toward the restoration of wholeness in the communities of our country" (Gaither 1992: 58). In this chapter I documented how African-centred philosophy and history are employed as foundational tools in development of educational programmes aimed at positively affecting the self-esteem and self-identity of community members and all others who visit. LH's core educational programme is the MMGMM. It is the first museum in post-colonial Jamaica that represents Blackness in a manner that inspires, excites and educates; the first museum in the world dedicated to Garvey's life and work, and the first fully multimedia museum in the Caribbean. According to a 2013 internet search by the Museum Association of the Caribbean (MAC), The MMGMM was just one of its kind in the Caribbean as a fully multimedia museum.

LH has developed close relationships with the communities that surround it, which validates community experiences in that programmes are directly

resultant of community needs and requests (Gaither 1992: 60). Through this participatory relationship, inner-city children and adult community members are empowered and are now counted among museum audiences where previously they may have felt intimidated by and excluded from museums. The IOJ and the National Gallery, both located in Downtown Kingston, have expressed concern regarding their visitor numbers from surrounding communities and have attempted to launch more inclusive programmes to attract a wider community base.

Chapter 8

Representing Blackness

The MMGMM

Blackness and Jamaica's Self-Identity

Frantz Fanon, critic, psychoanalyst and revolutionary, writes that:

> As long as the black man is among his own, he will have no occasion, except in minor internal conflicts, to experience his being through others. [...] not only must the black man be black; he must be black in relation to the white man (Fanon 2002: 129).

People of African descent in Africa and its Diaspora have been the subject of shifting nomenclature used by whites and dominate societies to describe them in a negative light, to degrade, to oppress and to undermine their self-worth. In the early nineteenth century Cuvier's racist description of people of African origin, referenced by the classic scholar Martin Bernal, is but a sample of what was published by whites at the time as scholarship:

> The Negro race...is marked by black complexion, crisped or woolly hair, compressed cranium, and a flat nose. The projection of the lower parts of the face, and the thick lips, evidently approximate it to the monkey tribe: the hordes of which it consists have always remained in the most complete state of barbarism (Bernal 1987: 241).

The terms used interchangeably in Europe and the Americas over five centuries include Ethiopians (term used by the Portuguese to signify those with dark skins who lived far to the south) (Russell-Wood 2000: 21), blackamoor (black Muslims), African, negro or prêto (Spanish or Portuguese word for black), black, nigger, jigaboo, darky, spook, monkey, spade, aunt/uncle, boy, pichón (child of a vulture) (Moore 2008: 7–9) and many more.

There have been many responses by people of African origin to these terms. The terms "Negro" and "black" (with a capital "B") were transformed into terms of empowerment in the early twentieth century, and while still controversial, many youths believe that they have diffused the derogatory

connotation of "nigger" by popularizing it among themselves as a term of endearment. Black people in the twentieth century coined terms of their own choice, for example, the value-free descriptors "light-complected and dark-complected" coined in the 1930s by the influential black spiritual leader, Father Devine (Henry Louis Gates and West 2000: 125), black American, Afro-American, African American/Caribbean.

The process of naming, therefore, occupies the contested arena of identity where the question of "who am I?" is paramount to the life journey undertaken by individuals, families, communities and nations. In order to subvert the negative connotations historically attached to the term, scholars have employed "Blackness" "to unite diverse groups politically in a struggle for equality and social justice during the second half of the twentieth century" (Golding 2009: 40). In this way, Asians, Gypsies, African Caribbean women and those termed "others" are able to unite for the purpose of building a "socially conscious museum studies and museum learning".

The simple statement that "Black is beautiful" reputed to be first said by Marcus Garvey (Dennis and Willmarth 1984: 140) in the 1920s in America was at once cathartic for speakers looking back at themselves in the mirror on the one hand, and confrontational to whites who were uneasy with proclamations of black self-love on the other. This occurred just fifty-seven years after emancipation in the United States in 1865.

The need to declare the beauty of Blackness to black people in the United States and in the rest of the African Diaspora was important to counter centuries of imbibed propagandized self-hatred and to recall for them the existence of ancient African civilizations whose achievements are restorative of their dignity and confidence as a people. What is examined in this chapter shows how the declaration of Blackness in positive and reaffirming ways became the heart of the creation of the MMGMM. As a twenty-first century museum, the MMGMM is the site where Garvey's philosophy of providing educational opportunity for Jamaicans to learn about Africa, to embrace their self-identity as black people and to deliver programming to enhance their awareness of the power of Blackness as a positive attribute.

The Making of the MMGMM – Phase I

The one principal objective for establishment of the museum is echoed Amy Jacques Garvey's objective for compilation of his *Philosophy and Opinions*. The **MMGMM** is to represent Garvey by allowing him to speak

for himself about his life and work in development of the UNIA-ACL. Other objectives include that the museum should represent Garvey's systemic challenge, through the UNIA-ACL, to the subservient position ascribed to black people by whites, and his offer of a viable alternative that drove fear into a system that had thrived and developed on the oppression of black people for four hundred years. The museum would teach the nation that the UNIA-ACL represented the interests of black people the world over with pride and demonstrate its universal reach through the listing of its over 1,056 divisions on every continent in the world.

Garvey's knowledge of black history was the foundation of his quest for social justice. The focus on education for liberation is therefore integral to the development process. To these objectives I added that representation in the museum should be regarded as the institution's core educational programme and that the methodology for representation must have a multimedia focus to, among other things, attract and hold the attention of the youth.

As discussed earlier, the skeletal outlines of the museum were in place in time for the opening of LH on 20 October 2003. The museum was simply laid out with a space defined at one end by four benches to indicate a theatre for screening films, and a glass-enclosed stand with Garvey's cane surrounded by images and text under glass, at the other. Figure 8.1 below indicates the rudimentary outlines of the museum. Wall 1 is dominated at the centre with LH's logo consisting of the letters LH with a Black Star, the insignia of the UNIA-ACL's Black Star Shipping Line, in its centre. To the

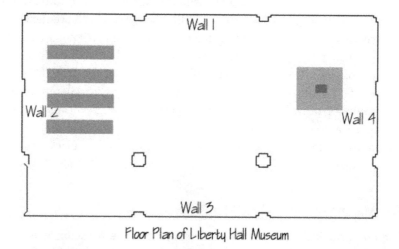

Floor Plan of Liberty Hall Museum

Figure 8.1. Floor plan and layout of Phase I of the museum – 2003.

right of wall 1 is the Garvey painting by Barrington Watson which remained in the museum for two months and was later replaced with a painting by artist Van Peterson of three images of Garvey in ceremonial dress, in academic robes, and in suit and hat. The painting had been restored and donated by the National Gallery of Jamaica.

Wall 2 has large, raised text panels that conceal windows and display the following Garvey statements:

Education: Education is the medium by which a people are prepared for the creation of their own particular civilization, and the advancement and glory of their own race.

Freedom: We meet at Liberty Hall not as cringing sycophants, but as men and women standing erect and demanding our rights from all quarters.

At the far left of wall 2 Garvey's words: *Up you mighty race. You can accomplish what you will* are written on the wall over a painting of Marcus Garvey in his wedding clothes on his marriage on 25 December 1919 to Amy Ashwood Garvey at LH in Harlem. The painting was donated to the IOJ in 1957 by the UNIA-ACL. The portrait was offered "to the Institute to [be] kept as *an inspiration to future generations*" (Ibid).

An extract from the minutes of meeting of the Board of Governors of the IOJ on 23 May 1957 which reports on the visit of Board members Messrs Roberts and Verity to Mr Campbell, President of the UNIA, St Andrew Division, is indicative of the IOJ Board's ambivalence towards Marcus Garvey:

Mr. Roberts said that the portrait was done probably after a photograph of Garvey as a young man. *It could not be considered of artistic merit*, but the frame was particularly remarkable. It was a very large and deep frame with the inner border about 3" in width of highly decorative confetti paper. There was no doubt that the portrait was of considerable historical interest in connection with the UNIA movement in Jamaica. It was agreed that the picture should be accepted by the Institute but that great care should be taken in phrasing the acceptance so that the Institute might have freedom of control of the picture. *Great care should also have to be taken so that the Board would not be expected to perpetuate a Garvey Shrine at the Institute!*[1] [my emphasis]

Mr C Bernard Lewis then wrote a letter (24 June 1957) to the President Mr John Campbell in which he thanked the UNIA for the portrait with the following statement:

Our Board of Governors at its last meeting was very pleased to accept your kind offer of the picture and I am directed to say that it will *ultimately find a prominent place in the extended Institute* which we hope will come about in the very near future. For the time being we hope to give it temporary exhibition as soon as it has been cleaned and tidied up a bit. I will let you know as soon as it has been put into its temporary place so that you and your associates can come down to see it[2] [my emphasis].

The Board of the IOJ understood the significance of the portrait to African Jamaican history but had no intention of adjusting its Eurocentric curatorial practice. No concerted effort was ever made in the 1950s and 1960s to collect objects specifically representational of Blackness as it was the IOJ's mandate, supported by the white and coloured ruling class, as well as by the British colonial office, to orient the whole of Jamaican society towards Europe (Moore and Johnson 2011). What Garvey stood for was in direct opposition to what the IOJ considered to be inspirational to future generations.

To the left of wall 3 in the museum, a Garvey storyboard highlights a timeline of important events in his life and adjacent to it are Garvey's words spoken at a conference in Nova Scotia in 1937 and made famous by reggae artist Robert "Bob" Nesta Marley: "*Emancipate yourself from mental slavery*". Directly next to that is another storyboard representing Garvey's New Jamaica, the tenets of the People's Political Party and the revolutionary plans he envisioned for Jamaica. This storyboard is followed by the words: "*A nation without knowledge of its past is like a tree without roots*". The entrance doors are also a feature of wall 3.

Wall 4 has three large text panels with the following messages:

History – Be as proud of your race today as our fathers were in the days of yore. We have a beautiful history, and we shall create another in the future that will astonish the world.

Africa – All of us may not live to see the higher accomplishment of an African Empire – so strong and powerful, as to compel the respect of mankind, but we in our life time can so work and act as to make the dream a possibility within another generation.

Confidence – If you have no confidence in self you are twice defeated in the race of life. With confidence you have won even before you have started.

Situated in front of wall 4 is the glass case holding Garvey's cane surrounded by images and text pertaining to his life. Even in its rudimentary stages, children enjoyed the museum immensely. They gathered around

the cane to get a closer look at the images and text under glass at the base of the cane and the most popular question asked was about the fact that both of Garvey's wives were named Amy.

Children recorded Garvey's words written on the walls and information from text panels in their exercise books in preparation for assignments back at school. While there was no sound or movies in the museum in the first month's operation, children and adults of all ages responded positively to the representation and were very willing to have their pictures taken in the museum.

The children's comments in the visitor's book demonstrated their interest:

> The place is interesting and exciting. The legacy of Marcus Garvey gave me a better understanding of his reason for being a national hero (Suzette; 12/23/2003).

> There's lots of things I didn't know about Marcus Garvey and his wives and by reading through I found out a lot of stuff and that ['s] the reason why I love this museum (Lide; 12/23/2003).

> I like the stick its in a frame. (Crystal, 6/2/04).

> To Garvey, thanks for daring to stand out (Shana-Kay; 2/12/2003)

The adults were equally interested and commented on their anticipation of the completed museum:

> A small but fitting tribute to a great man (Shawn; 12/30/2003).

> A hopeful inspiration for young people and an awakening for others (Carmen; 12/31/2003).

> I do hope this edifice to the memory of Marcus Garvey will be used to free our people from mental slavery before it is too late (D. Burnett; 2/29/2004).

> This visit reminds me of my school days in the 1930s when our ambitions were heightened by reading in the Daily Gleaner of a black Jamaican who inspired us to rise above slave mentality and be ambitious, and know we are no less than the greatest white man. Nice to see some of Marcus Garvey's dreams come true, and our generation look forward to the overflows to the benefit of the black race (C.G. Nembhard; 4/12/2005).

MMGMM – Phase II

The immediate challenge to creating the multimedia museum was funding. The Director of the Human Employment and Resource Training (HEART) Trust – Jamaica's national training agency, and the institution responsible for vocational training in Jamaica, attended the opening ceremonies of LH on 20 October 2003 and subsequently indicated that there was a possibility

for funding for the museum from HEART Established by the HEART Trust
Act of 1982, its mission and vision are as follows:

> Mission: Graduates using skills to increase productivity and competitiveness of
> Jamaican enterprises.
> Vision: A Jamaican workforce trained and certified to international standards
> stimulating employment – creating investment, contributing to improved
> productivity of individuals, and enterprises and the nation.

HEART's facilities include eighteen vocational training centres, throughout
the island in rural main towns, five academies, and four institutes. Included
in these are Garmex Academy – garment industry; Information technology;
Tool & Engineering Institute; Runaway Bay Hotel Training Institute; School
of Cosmetology; Jamaican German Automotive School; and the Vocational
Training Development Institute which trains teachers for the facilities.

While the functions of the Trust (www.heart- nta.org) do not include
funding museums, the Director believed that access to knowledge of
Garvey's philosophy would add the missing "cultural" variable to the
curriculum materials being used in all of HEART's facilities (Ibid). He
was cognizant of the fact that HEART Trust students were typically drawn
from all-age schools, as opposed to "traditional" high schools, which meant
that students had already imbibed a sense of "lack" from the overcrowded
conditions in which they were trained in schools deficient in resources. In
a study of all-age schools, Evans (2001) found that parents of all-age school
students had few expectations for the school other than to prepare their
children to pass the selection examinations for secondary school, that is,
the Common Entrance Examination, the Technical Examination, and the
Grade Nine Achievement Test. At the same time, these parents:

> mostly rural folk engaged in small farming or higglering were quite aware of
> the unlikelihood of their children gaining a place in a secondary school. So
> additionally, they wanted the all-age school to give their children *skills for earning
> a living*. Parents in other types of schools and from a different social class
> background have different expectations, and may be less likely to accept limited
> opportunities for their children [my emphasis] (Evans 2001: 6).

HEART's vocational training programmes positively provide what Evans
identified above as the desire of parents for their children – skills for
earning a living – and goes steps further by certifying graduates according
to international standards. HEART offers its students internships and
job placements as well as access to information on establishing small
businesses. However, schools and training facilities offer little opportunity

for students to learn about themselves or their history. Both secondary school scenarios (all-age and traditional high schools) place emphases on tests, grades and streaming of students for the job market. There is little "room in the school's timetable for topics that relate to students' self-knowledge or self-development, self-empowerment or about citizenship and human relationships" (Evans 2001: 71).

The grant proposal titled "Taking Garvey to HEART" was submitted in January 2004. Its rationale included the following:

> Technical and vocational training not with-standing, the quality of this workforce could be further enhanced through the introduction of enlightened knowledge of African/Caribbean history. Marcus Garvey's teachings about the importance of organization, striving for excellence, national and racial pride, to name a few, will strengthen the trainees' self-awareness, self-identity and will positively impact our goals for National development
>
> A skilled and semi-skilled workforce that is equipped to use the philosophy and teachings of Garvey to influence others to "do better than that" may be a critical part of the answer to Jamaica's ongoing challenges at the workplace and in communities. The link between skill attainment and positive self-identity is empowerment, which will encourage others to seek its attainment.

The Board of the HEART Trust/ (national training agency) agreed to fund the museum to the tune of ten million Jamaican Dollars (J$10M) per year including covering the cost of electricity for two years. This was an achievement. It was a first for a statutory body to fund the establishment of a museum and convinced of the beneficial role it could play in enhancing delivery of their core business. With acceptance of the proposal, I was able to embark on the design of the multimedia museum.

A contract was signed with Exhibit Media, a firm in Chicago, and the Council of the Institute of Jamaica on 1 July 2004 to produce the multimedia elements of the project. This included sourcing and purchase of film footage and photographs available in the United States, identification and specification of electronic equipment, creation of a script from material provided, and creation of the touchscreens.

LH's researcher Nicosia Shakes was the Chief Researcher on the project. She supervised the work of three graduates of Professor Rupert Lewis' class at the University of the West Indies, "Garvey and Garveyism" who were contracted to condense the vast life and work of Garvey into selected important segments, using available published materials. The Chief Researcher also prepared the segment of Garvey's return to Jamaica (1927–1935), his relocation of himself, family and the UNIA's international

headquarters to London, to his death (1935–1940). The work was divided as follows:

1. Marcus Garvey's Early Life in Jamaica (1887–1916)
2. Marcus Garvey Builds the UNIA-ACL in the United States (1916)
3. Marcus Garvey Stands up to his Enemies (1916–1940)
4. Marcus Garvey Continues the Work of the UNIA Outside the United States (1927–1940)
5. Marcus Garvey's Legacy Lives On

LH sought out, collected and gained permission for the use of selected film clips made by the Jamaica Information Service and the Creative Production and Training Centre, the photographic images from the National Library, Garvey related news published by the Gleaner Company in Jamaica, the tributes to Marcus Garvey by various musicians, the recorded speeches of Amy Jacques Garvey sourced from the Radio Education Unit, University of the West Indies, and a collection of elder women's reflections on Garvey recorded by the African Caribbean Institute of Jamaica/Jamaica Memory Bank. Original pages of the *Blackman* and the *Black Man Magazine* were also accessed in the National Library of Jamaica. Permission was obtained to use Garvey and UNIA-related images held in the archives of the Schomburg Center for Research in Black Culture a City of New York Library and the Garvey "Papers Project" at UCLA. Contracts were entered into with the producers of the WGBH/PBS documentary '...*Whirlwind*' for use of the interview footage. Important footage of Jamaica's pre- and early independence experience including the return of Garvey's body to Jamaica and his reburial in National Heroes Park were purchased from a source in the United Kingdom.

The physical museum space was designed with the assistance of the architectural firm of Patrick O Stanigar who addressed the challenge of the small size of the room by designing kiosks that towered over the space creating an illusion of space, and engendering curiosity in visitors to investigate whether there was more around the corners of the kiosks is evidenced in (figures 8.2 and 8.3).

The initial design above was altered to reflect relocation of Garvey's cane that had been a central focus in the skeletal outlines of the museum. An entrance wall was added to name and frame the initial view of the museum, as well as provide an additional screen upon which to project images. The design of the kiosks then determined their placement. With this change we were then able to put two kiosks back-to-back in that space, provide a seating area to view projected images and reposition the perimeter kiosks

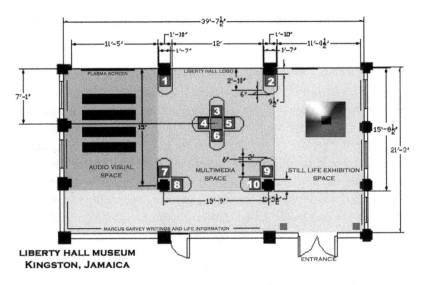

Figure 8.2. Initial design of museum space by Patrick O Stanigar, Architect.

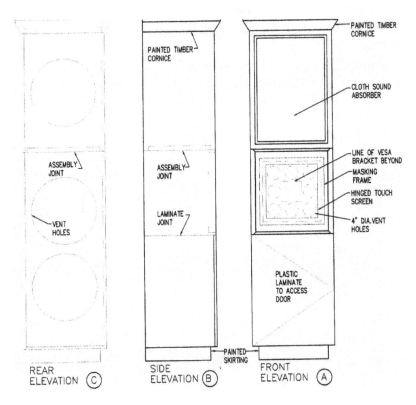

Figure 8.3. Kiosk design in multimedia museum.

while moving the four combined together somewhat on the border of the green and grey space pictured above. The final rendering showed the Sound Spots (see figure 8.3).

While the kiosks were being constructed, the carpet tiles in the colours of the UNIA-ACL (red, black and green) ordered, and the information, film, and other elements of the script for the touchscreens being sourced and compiled, making the "theatre space" fully functional was the next crucial step in development of the museum. It was an immediately doable project that would provide opportunities for LH staff to engage the public in conversations about Marcus Garvey, discuss the planned development of the multimedia aspects of the museum, and the opportunity to participate in creating LH into a cultural educational institution. Visitors would view the documentary produced for the opening outlining the multimedia plans for the museum. This documentary on Marcus Garvey was produced for the Friends of Liberty Hall by the Creative Production and Training Centre and Jamaica Information Service documentaries on Garvey produced to inform the nation of Jamaica's National Heroes. The first pieces of equipment purchased for the museum were: a 42" flat screen monitor and bracket; DVD/VCR player; amplifier; and surround sound speakers (see figures 8.4 and 8.5).

The theatre provided an opportunity for children to view the short film "Taking a bus ride through Dakar" and prompted a search for footage and

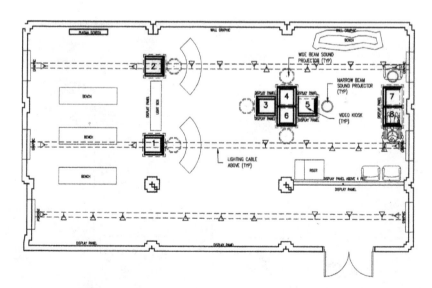

Figure 8.4. Final layout of the museum including lighting design.

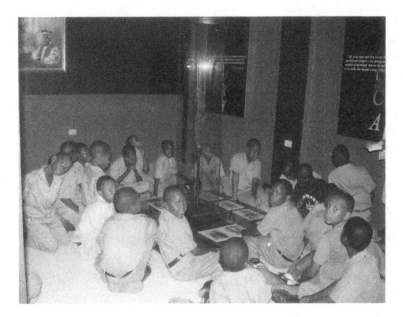

Figure 8.5. Children sitting on benches and on the floor enjoying the museum's theatre space (photo by author).

films about Garvey inside and outside of Jamaica. A bilingual film about the voyage of a ship of the UNIA's Black Star Line fleet to Port Limon, Costa Rica titled "The Promised Ship", produced by Mexican writer/filmmaker and resident of Costa Rica Ms Yazmin Ross came into our possession. Its theme is explored through the memories of elderly Costa Rican Garveyites and their descendants who still hold on to certificates of membership to the UNIA-ACL, their shares in the Black Star Line, and devotedly attend functions at LH which has been in consistent use by members of the UNIA-ACL since its establishment in 1919 (Hill 2011: Vol XI: clxxxvi; Evans 2001). Garvey's impact on banana plantation workers – Costa Rican natives and imported West Indian labour – in Central America is well documented in the film with references to the difficulties faced by the UNIA-ACL at the hands of colonial administrators and the major banana-producing multinational, United Fruit Company. LH received permission from Ms Ross not only to show the film in the museum but also to make an agreement regarding its sale in the future Museum Shop.

The multimedia aspects of the museum took two years to complete. While it was being created, I compiled a pictorial representation of Garvey's life for wall 3 (figure 8.1) that would illustrate the stories told on the touchscreens and offer another focal area in the museum. With the help of a graphic

design company, we determined that the information would be framed by two larger than life sized images of Garvey; one with him wearing a suit on the left and in academic robes on the right. Using the entire expanse of the wall, viewers are forced to raise their heads completely in order to view the images and to read the text, including powerful lines from a variety of speeches. The intent of this simple act was to foster a sense of pride and awe in viewers that drove home the intended point – that Marcus Garvey was a great man to be looked up to and deserving of respect.

On the left overlaying the bottom half of Garvey's image is representation of the 1,056 divisions of the UNIA formed worldwide between 1920 and the 1930s. The information is arranged by continent and region thus geographically presenting the fact that a division of the UNIA was on every continent in the world, and aptly demonstrating the wide reach of the Garvey Movement.

Images and descriptive text are arranged across the entire wall under the following headings:

- Jamaica at the Turn of the 20th Century (late 1800's to early 1900's)
- Marcus Garvey's Birth (1887) and Family Life
- Influences on Garvey: Edward Blyden (1832–1912); Robert Love (1839–1914); Booker T Washington (1856–1915); Ducé Mohammed Ali (1866–1945)
- The United States Years 1916–1927
- The Universal Negro Improvement Association and African Communities League in the World: with the following images: Black Star Line Delegation to Cuba 1920's; UNIA Delegation to Liberia 1924; Liberty Hall in Panama 1920's; and Garvey in Limon Costa Rica 1921
- The Jamaica Years 1927–1935
- The Final Journey – England 1935–1940
- The National Hero 1964
- Those Whom Garvey Influenced: Jomo Kenyatta (1889–1978); Queen Mother Audley Moore (1898–1997); Kwame Nkrumah (1909–1972); Malcolm X (1925–1965); Martin Luther King (1929–1968); Walter Rodney (1942–1980); Robert Nesta Marley (1945–1981); and Winston Rodney aka Burning Spear (1948–)

After much collaboration the agreed style of the touchscreen exhibit (see figure 8.6) is as follows:

The exhibition was enriched by the purchase of interview clips of: Garveyites and Garvey scholars, family members and others from the PBS/

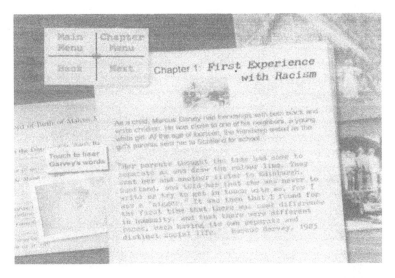

Figure 8.6. Style of interactive DVD.

WGBH film *Look for me in the Whirlwind*; clips of the official and historic visit of Emperor Haile Selassie I, King of Kings, Lord of Lords, Conquering Lion of the Tribe of Judah, Jah Rastafari to Jamaica 21 April 1966; (www .youtube.com/watch?v=enpFde5grmw) and the now no longer available Snagfilms.com images from the National Library that put in context life in Jamaica at selected periods; images from the *Daily Gleaner*, from the estate of James Van Der Zee, the official photographer of the UNIA-ACL in Harlem New York courtesy of Donna Mussenden Van Der Zee and the Schomburg Centre for Research in Black Culture; return of Garvey's remains to Jamaica and his designation as a National Hero; and narrations of Garvey's words by orator and radio personality Guyanese Ron Bobb Semple.

All of these elements together created an interesting, informative, and educational exhibition that could hold ones' interest for over three hours. The exhibition, named Marcus Garvey: The Movement and the Philosophy, is also available in text and photographs in the catalogue by the same name.

The official opening ceremony of the MMGMM took place on 13 October 2006 at 11:00AM in the Garvey Great Hall. It was attended by a large crowd of people and its special guests included: Dr Julius Garvey; Mr Robert Gregory, Executive Director of the HEART TRUST/NTA; Prof Rupert Lewis, Chairman of the Friends of Liberty Hall, and Prof Barry Chevannes, CD, Chairman of Council, Institute of Jamaica. The keynote speaker was the then Prime Minister, The Most Hon. Portia Simpson Miller, ON. (see figure 8.7).

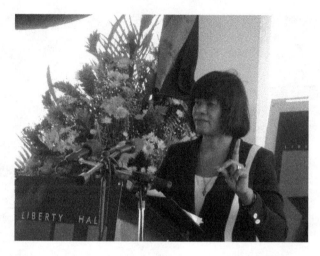

Figure 8.7. Prime Minister Simpson Miller delivering the address at the official opening of the MMGMM.

The MMGMM became the most sought-after experience of all the IOJ divisions. While we believed that it would cater mainly to children who had already mastered the art of reading, we found that small children ages 2–6 were very intrigued by the museum. With the assistance of film, and a very dedicated and inspiring museum guide, the children are engaged in meaningful dialogue.

The short film "Taking a bus ride through Dakar" to the music of the Kora is used to great effect with children who when asked "what do you think Africa looks like" invariably answered "jungle, starving children, people crying, mud huts..." After viewing the short film their perceptions change in that they can see scenes not far different from those in Jamaica. They were able to realize that their image of Africa is negatively influenced by news clips about famine or war and Tarzan movies that are still being shown in Jamaica. Some of the comments made in the visitor's book by teachers are as follows:

> Very informative and quite interesting display of info. Relating to Marcus Garvey (Glowell Preparatory School; 28/11/2006).

> We were fully informed of the life of the Right Hon. Marcus M. Garvey. We found it useful, and we intend to incorporate this information into our School's Curriculum to help the students to know and understand our rich culture & history (Suthermere Preparatory School; 26/10/2007).

> The presentation provided our children with well informed and relevant information that stimulated children's interest and learning needs. Teachers

were also educated on some cultural aspects of the African continent as well as the great Marcus Garvey. The presenter...did an excellent job (St. Anne's Infant School: 10/12/2010.

The tour guide...did a very good job with the children; he was able to engage them into little pep talks etc. We learnt a lot of new and interesting things about Marcus Garvey and Africa. We are very happy that we visited. It's great! We will come back (Miracle Pre-School: 11/11/2010).

The tour was very beneficial and informative. Teachers and students have been inspired, motivated, and empowered to acknowledge our culture and rich heritage. The tour guide gave a superb presentation of information (Franklyn Town Primary: 2/15/2011).[3]

The area on the back of the entrance wall of the MMGMM garnered considerable interest. Initially it was used to view amateur photos and film clips taken in Ethiopia of its cities, and its youth, and to introduce to visitors the only country in Africa that had never been colonized. Children had never been exposed to the wonders of Lalibella with its eleven churches carved out of solid rock from the ground down, with one, Bete Giorgis a monolith built in the shape of a cross; or of Gondar in the Church of Debra Berhan Selassie where winged black angels of Zion adorn the ceiling. They had never been told that Ethiopia had castles that rival those in Europe, or of Axum with its amazing carved granite obelisks, where Makeda, Queen of Sheba, ruled and from where she made her historic journey to meet King Solomon in Jerusalem (Garrick 1998: 93).

These images of contemporary photographs of various African countries were taken from the web. They revealed modern cities, ways of life, malls, and entertainment and vacation facilities that are comparable to those in Europe and America, were later added. Children and adults commented on the fact that they had never seen such images of Africa and that this representation changed their view of Africa.

Adults and children from Jamaica and around the world expressed their love for the museum and for Garvey. Many admitted that they knew nothing of him besides the fact that he is Jamaica's first national hero. Going through the kiosks and the museum provided them with a completely different perspective and they expressed their pleasure and surprise in the visitor's book:

Thank you for keeping Marcus Garvey alive in this museum. I hope that a day will come when not only blacks but all races will love themselves and then others, without judgement (E. Msengeti, Nairobi, Kenya: 1/5/2007).

Thank you for the inspiring quotes and pictures. Marcus Garvey is an inspiration to everyone regardless of race (M. Taurag, Bangalore, India: 1/5/2007).

My childhood dream about Garvey is fulfilled today (Hon Boafo (MP), Ghana: 3/27/2007).

This museum is what this country needs especially our students. A serious black awareness is vital. Spread the message (Pembroke Hall High School: 7/17/2007).

This place has so much information. It was so helpful! I'm glad that you guys are passing on Garvey's message and all the exhibits are very interesting (Chelsea: 9/25/2007).

Just being here is a small dream that has come true. I will surely return and it has been a wonderful experience getting information about my role model (Y. Francis: 10/16/2007).

Very informative, great museum and a pleasure to visit, makes me proud of my people knowing a man like this existed and done so much in so little [time] (Clunis; 10/26/2010).

Truly inspiring and uplifting. Visiting the Garvey Museum shows not only the quality of leadership Garvey gave us, but the lack of leadership we have today (3/17/11).

Students from Neptune Basic School, Russeau Primary and Triumph Early Childhood participated in numerous activities in the MMGMM (see figure 8.8). Secondary school students from St Elizabeth Technical (see figure 8.9) were frequent visitors as well as students from St. Joseph Teachers College (see figure 8.10).

The MMGMM – Phase III

Development of the Self-Identity Exhibit

In 2007 LH began collecting newspaper articles about skin bleaching, which was becoming an epidemic in Jamaica. Articles investigated the practice and raised important questions like why is skin colour important? Does practice relate to the devaluation of dark skin? Is this a result from the impact of enslavement? Other issues ask: why is skin lightening practised; what is the role of the media; the cosmetic and beauty care industry; is there a correlation between economic status and power that redefines the bleaching syndrome (Abel 2007)? The Ministry of Health launched an anti-bleaching campaign to discourage the practice, citing the various serious health risks, including skin cancer, and banned the sale of skin bleaching creams in the island. In 2009 an article indicated that "skin bleachers" were proud of their activities and that it had become a badge of honour in many communities (Reynolds 2009).

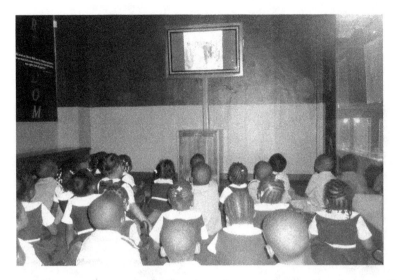

Figure 8.8. Triumphant Early Childhood Development Centre (photo by LH staff).

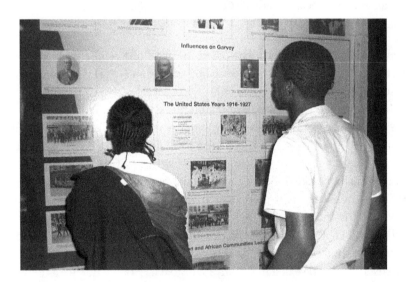

Figure 8.9. St Elizabeth Technical High School students (photo by author).

I purchased a film entitled *"A Girl Like Me"* Directed by Ms Keri Davis.[4] The film is described as "color is more than skin deep for young African American women struggling to define themselves", and interrogates issues of shades of skin colour, hair length and texture, body shape and other physical reasons persons use to discriminate. In the film Drs Kenneth

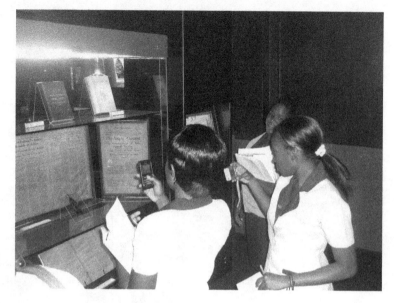

Figure 8.10. St. Joseph's Teacher's College students (photo by author).

and Mamie Clark's experiment called the "doll test" (1940s), used in the historic case of Brown versus Board of Education (1954), is re-conducted using children in 2005.

In order to facilitate a discussion, I invited selected students identified by their Guidance Counsellors from two inner-city schools in the community, along with a facilitator, to discuss the film and to hear their take on the issues presented. Teenage girls and boys ages 14–16 separately engaged in conversations about skin bleaching and found that while many had not indulged in the practice; their ideal of beauty began with light skin colour. Several girls indicated that they sought out boys whose complexion was "black and cool" rather than "black and shine". When probed this meant that the desired colouring of the skin was light brown rather than black. The discussions also revealed that many identified lack of confidence as a major problem with their peers. Further, they expressed a belief that natural black hair was not as beautiful as processed (or chemically straightened) hair. The boys revealed that they preferred girls with light-skinned complexions and long hair, although their mothers were of dark complexion. They were all a bit shocked by the Clark's "doll test" where the children's choice of white dolls in answer to questions such as which is the pretty doll; which is the good doll; and their choice of black dolls in answer to which is the bad doll; and which is the ugly doll were extremely telling. All the young people

noted the confusion on the child's face when asked the question of which doll looks like you and the reticence expressed in choosing the black doll. None craved to be white, but nearly all believed that a lighter shade of black was more desirable.

In 2011, I extended my questioning to school tour groups which garnered valuable information. I asked children to put their fingers on their lips, and without speaking raise their hands in answer to my questions. My questions were as follows:

1. How many of you are black?
 a. For those that did not raise their hands, what are you?
2. How many of you are African?
3. How many of you are Jamaican?
4. For the girls:
 a. How many have white dolls?
 b. How many have black dolls?
 c. Which of the dolls are the prettiest – white or black?
 d. Why?

The results of my informal questioning are outlined below. I found that among school tours, younger children expressed more ambivalence regarding their Blackness than older children. They wanted to be identified as brown, and although I asked that they do not speak while pondering the questions, invariable a child would admonish another for raising their hand in the affirmative to Blackness, indicating that the child was brown. In like manner, a child could be heard telling another that they were indeed black and should put up their hands.

Most children viewed themselves as Jamaicans and demonstrated great disinterest in initially being called African. I then challenged them to answer the question: If you cut down a tree in Africa and transport it to Jamaica and put it in the river and take it out four hundred years later, is it still a tree? Usually, younger children think that it is not. Then I ask, has it turned into a fish? They usually laugh and indicate no. I then ask them why is it that the descendants (I define the term) of their ancestors (I define the term) who were taken from Africa and brought to Jamaica for four hundred years are no longer African?

In answer to the incredulous looks on their faces I make the following pronouncements: When you say you are Jamaicans you give yourself approximately four hundred years of existence on earth. Is that a long time? Most say, "yes Miss". Then I ask how does four hundred compare with 195,000 years? They usually say, "a drop in the bucket, Miss". I then follow:

Table 8.1. Tabulated responses of students to selected questions on self-identity

DATE	SCHOOL/ ORGANIZATION	PARISH	# OF STUDENTS	# OF GIRLS	# OF BOYS	BLACK	BROWN	AFRICAN	JA'CAN	BLK D	WHT D	PRETTIEST WHT D	PRETTIEST BLK D
2/11/2011	St. Annies Primary	Kingston	42	20	22	21	20	2	40	6	20	20	
2/15/2011	Franklyn Town Primary	Kingston	40			30	3 + 6 abst	11	40		20	11	11
2/16/2011	Clifton Primary (ages 6-12)	E. Rural St. Andrew	17	11	6	13	3	3	16	2	5	6 because white	
2/16/2011	St. Hughs H.S. (ages 9-11)	Kingston	29	11	18	28	2+2wht/2mied	21	26				
2/18/2011	United Early Childhood Centre	Kingston	(ages 3-5) 41	22	19					3	11	22 because white	
2/18/2011	Trench Twn Reading Rm (5-13)	Kingston	22	11	11	11	8	5	22	4	7	11 because white	
2/18/2011	Salva. Army Schl for Visual Imp.	Kingston	(13-19) 37	17	20			15	16				
2/18/2011	Rollington Town Primary #1	Kingston	(6-8) 41			17	20	2	38	3	9	12 because white	
2/22/2011	Rollington Town Primary #2	Kingston	(6-8) 39	20	19	19	13	0	39	7	12	20 because white	
2/23/2011	Grove Primary (8-11)	Kingston	24	11	13	16	6	14	15	10	7		17 because Blk
	Ex Ed Community College 17-29	Kingston	19	15	4	19	0	10	19	11	14	6 because good hair	

2/23/2011	Guys Hill Primary	St. Mary	(8-11) 50	21	29	16	22+ undec.	0	50	5	21	ALL because white	
3/15/2011	Grove Primary (ages 7-8)	St. Mary	18	9	9	10	8	0	18	2	7	7 because white	
	Chandlers Pen (ages 12-15)	Clarendon	14	9	7	14	2	0	16	4	1		Black more beautiful
	Grange Hill (ages 16-17)	Kingston	65	41	24	63	2	3	60	9	20		Black more beautiful
5/4/2011	Duhany Park Primary (ages 6-7)	Kingston	52	23	28	22	30	7	52	17	20	ALL because white	
5/4/2011	Ocho Rios Primary (group 1)	St. Ann	33	16	17	20	11	0	33	7	10		Black more beautiful
5/4/2011	Ocho Rios Primary (group 2)	St. Ann	30	19	11	21	6	0	30	15	14	6 white most beautiful	More beautiful

When you say you are African, you are saying that you are the descendant of the first person who walked on the face of the earth; the first person to use language both written and spoken; the first doctor, musician, architect, engineer; did you know that? "No Miss". Didn't anyone tell you this? "No Miss". Well, Garvey learned these facts and it encouraged him to learn more about the ancient history of Africa and to create an organization that would spread Africa's rich history to Africans in Africa and in the Diaspora to inspire them to create more greatness in the future.

Younger children were also more likely to think that white dolls were the prettiest. I determined from looking into the stores in Downtown Kingston for black dolls that they were very scarce, and where available, were twice the price as white dolls.

In 2010 an animated short Sesame Street film titled, "I Love My Hair"[5] came to my attention as it focused on a child's love for her natural black hair. A black muppet in a pink dress sings about all the things that can be done with black hair. To provide younger children with positive self-identification we show this film in the museum and the children easily learned the song and, while touching their hair and singing along, reaffirm the beauty of black hair.

In pursuit of more materials for creation of the exhibition, we asked adults in the adult computer class to write (type) out their stories of self-identity that affected them when they were younger. This exercise revealed that adults had many encounters with issues of self-identity both as adults and during their childhood. Samples of their essays are as follows:

> My mother said to me one day that God has been good to me. I did not understand what she meant so I asked her. She replied "You have gotten a bit of colour; you are not as black as you were when you were born. I figure that it was because I drank a lot of Pepsi with you. I made sure for my second pregnancy I drank a lot of milk. You can see the difference—your brother is not as dark as you are." [Nicole: age 33]

> When I was much younger I went to look for a job at a garment factory. They needed machine operators. I did not know anything about machine operating; but I was desperate. On reaching there, I saw a lot of young girls who said that they were experienced operators. At first, I thought that I had no chance of getting the job but I decided to wait. The Chinese lady finally came and asked: "Are you all machine operators?" I answered: "Yes." (I had never used a machine from the day I was born). I was the third to last person in the line. There were a lot of ladies before me and the Chinese lady looked at me and said: "You first come for the test." I went in and didn't even know how to turn on the machine. I broke the needle and let the shuffle fall. The young ladies started to quarrel and said that it

was because I was brown and looked like the woman that she made me go first. I was surprised at the end of the day when I was selected for the job. My fat Black friend, who was a very good machine operator, was turned away. The Chinese lady said "Too fat and Black...you very lazy." [Joan: age 56]

These were shared among the students and garnered much discussion. Some of the students indicated that they had never revealed their experiences before and had kept them locked up as shameful. Pit against the teachings of Garvey, they realized how much they had internalized others' perceptions of them as lacking in beauty, and how much the society around them reinforced the binary code of shades.

With these stories I am in the process of developing an exhibition on self-identity for the museum that will allow everyone to navigate through the individual's feelings in the face of self-deprecating experiences and consider Garvey's response to the same. Parts of the exhibition, films and slide shows on contemporary Africa are already in force. However, the interactive touchscreen version, which we anticipate will generate change in people's perceptions of themselves, is not yet completed (at the time of this writing) due to availability of funds.

The MMGMM represents Blackness in post-colonial Jamaica in a positive, inspiring and educative light. Through the enlightened scholarship of Garvey scholars, his life and work are represented in a manner that allows Garvey to speak for himself, thereby inspiring and educating all who visit the museum. The MMGMM can be a paradigm for future museum development in Jamaica and marks the crossroads between Eurocentric modes and methods of representation of the history of people of African heritage and the future of representation from the perspectives of the people whose history is being exhibited.

Chapter 9

Representing Blackness in Jamaica's Post-Colonial Museums – The MMGMM

This book is based on the fact that I was given the opportunity in 2003 to design and create the MMGMM and to guide LH to its status of cultural educational institution. I am therefore intimately connected with its growth and development and am uniquely placed to recount its history and to plot its future. Driven by my own Pan-African perspective, I am able to implement programmes that are consistent with Garvey's published teachings and garner positive results with respect to self-identity. The latter will be tracked more closely when the self-identity exhibition is completed, and we are able to conduct more focus group discussions across a wider cross-section of the population and the nation to get at the deep-seated issues.

The museum's representation of the tenets of Garveyism, its inclusion of community members in the design of its programmes providing educational and economic opportunities, and its focus on addressing issues of self-identity among the youth provide a powerful example of a community museum that could eventually be a paradigm for Jamaica's museum development and have far-reaching impact on the development of the nation's youth.

In *Representing Blackness* I relied on the term "discursive" which is used to refer to any approach in which meaning, representation and culture are considered to be constitutive (Hall 2003). That is, it defines what factors impact on our formulation of ideas about things or places and what knowledge is considered "true" and useful. The book demonstrates that the legitimacy of persons speaking, and writing are determined, in part at least, by physical characteristics such as skin tone. Regarding representation, the discursive approach is concerned with its politics – the effects and consequences of how language and representation produce meaning; how knowledge that is taught from the perspective of a particular discourse arise out of, and effect power relations in society, conduct, constructs identities and determines social and cultural paradigms (Hall 2003: 15–64).

I explored the numerous discourses that influence exhibition design in one of Jamaica's museums. These include discourses of colonial education,

identity, race, shades of skin colour and class. Discourse is enmeshed with power (Hall 2003) which is intertwined with history, culture, and politics. Representational practices are governed by the socio-historical conditions of the moment. Epistemological concerns are not only with nature, origin, or the framing of knowledge but rather with whose knowledge counts; whose ways of knowing are widely taught and deemed acceptable to the academe (King 2005). My book therefore adds to discourse on museum education, affirms the development of a broader scope for museum educators, and supports its advocacy for a critical pedagogy within the realm of cultural politics (Hooper-Greenhill 1999).

LH holds positive promise for Jamaica's youth. The term "black" (to describe skin tone and ideological perspective) in Jamaica today is largely absent from the lexicon of Jamaica's journalists, media representatives and museum exhibition designers who promulgate a multicultural language and image for Jamaica. Connotative of negative binaries that have been incessantly challenged by black people including in the 1920s by the Garvey movement and again in the 1960s by the Black Power Movement. Through LH black will once again represent a positive assertion of self-identity and hopefully be a nail in the coffin of "shadism" that has determined Jamaica's social and economic reality for hundreds of years in the past and continues to wield influence in today's Jamaica.[1]

In the future, I hope that the Craft and Technology (Folk Museum) using CRT of museums would begin by acknowledging Africa's varied histories before the period of transatlantic enslavement and colonialism. These would include demonstrations of the manner in which disputes/ wars (among individuals, families and tribes) were handled, land for farming determined and allotted, how production of goods, markets and trade were established, sacred buildings and sculptures erected. In addition, there would an emphasis on the use and respect for the environment, advances in astronomy, medicine and engineering, to name a few and the importance of the gun in arresting critical areas of African development.

Examples of ancient African engineering feats like pyramids in Sudan and in Egypt, monolithic and semi-monolithic churches of Lalibella, and obelisks in Gondar in Ethiopia among other extraordinary sites on the continent would be presented as representative of Africa's accomplishments stimulating enquiry in the minds of all people and raise the self-esteem of people of African heritage in particular. The Horniman's "Africa Worlds" exhibition designed in 2000 is representative of such a radical shift in curatorial approach (Shelton 2000; Philips 2007; Golding 2009)

as it privileges the voices of Africans from Africa and its Diaspora in a collaborative exercise.

Foregrounding exhibitions of black life in Jamaica after emancipation with such historical narratives could remove the "history-lessness and context-lessness"(Morrison 1993: 53) that has been posited for blacks and which perhaps result in the children's reticence to being African tabulated in chapter 8. Establishing that, as in other cultures, many facets of life in Africa were and are rich and varied, and not dark and devoid of accomplishments as recorded in the fifteenth to twentieth centuries, the resilience of African retentions in agricultural and other economic and cultural systems employed away from plantations would be viewed in a different light. In summary, demonstration of African knowledge systems and accomplishments before enslavement in the People's Museum of Craft and Technology, would speak volumes to African resilience and retentions.

With respect to LH, as of this publication, several of the children who started out as members of the Youth Club in the early 2000s are now nineteen and over. The majority of the girls already have one child, have not completed their education, continue to live in challenging conditions, are under- or unemployed, and have widened the circle of poverty in which their parents are trapped. A handful of the boys have joined the police force and obtained jobs in the community without a high school diploma, but many are also under- or unemployed. Nonetheless, both boys and girls have remained close to the staff of LH. More time would have afforded me an opportunity to pay attention to the gender issues that are pertinent to development of community members and to speak to what interventions we have and could have made to the lives of girls. In the future, LH will invite all the youth who were members of the LH Youth Club to participate in a discussion about the years 2002 to present, their life choices, their experiences in educational institutions, their employability, their community experiences, and how LH can learn from their experiences and intervene on their behalf with provision of information and advice about the future.

Cultural theorist Sylvia Wynter refers to the Caribbean as a foundational "space of trans-culture" where three separate populations with varying cultural matrices, "each incommensurable with the other" were brought together to devastating effect for the non-Europeans (Wynter 2002: 7–8). After five hundred years of brutal enslavement and dehumanizing colonial rule, people of African heritage continue to be affected by racism in the social, political and economic sectors of Jamaican life.

Further, from the perspective of post-colonial theory, it is recognized that Jamaica's mainstream educational systems and structures serve to

perpetuate indoctrination of the majority black population by a historical narrative that privileges Europe and European culture while stigmatizing Africa, its people and culture. This is clear as the educational system-determined curricula and choice of textbooks show differential access to education by shades and classes of Jamaicans, the use of language and the position of Jamaican patois in didactic training. When children imbibe this negative binary in the classroom, I argue that it could have a deleterious effect on their self-esteem, self-confidence, identity and view of the world.

In the twenty-first century, African Jamaicans in positions of power are unconvinced that employing strategies of multiculturalism, antiracism and interculturalism to education and representation in museum is necessary, because they believe that with Independence these spheres have already been democratized. However, my research demonstrates that it is necessary to employ the tenets of CRT to expose racist hegemony and introduce African historical context in the classroom and the museum. Replacing existing historical narratives with the work of enlightened scholarship will attack systems of indoctrination, particularly of the youth, and address the traumatism that occurs during those years (Fanon 1967: 148).

During the first half of the twentieth century in Jamaica, black people yearned for a liberatory strategy to tackle racism by banks that denied loans to black businesses, public and private sector preference for employment of light-skinned persons, and the daily battle against "mental enslavement" promulgated by European narratives of inferiority. The purposefulness of indoctrination of black Jamaicans by colonial authorities through these narratives is underscored by political scientist and Garvey Scholar Rupert Lewis who sums up the relationship between politics and racism in Jamaica in the words of an English magistrate:

> in England films for the colonies should be censored so that whites should never appear ridiculous, because colonial rule depended on *nurturing...inferiority in the governed* (Lewis 2004: 15) [my emphasis].

Museums have proven to be integral components of educational offerings in the United States and in Europe and instrumental in shaping knowledge. Hooper-Greenhill links the democratization of museums in the twenty-first century with, among other things, a review of existing historical narratives that form the basis for museum representation. She states:

> A critical museum pedagogy is an educational approach that reviews and develops its methods, strategies, and provision with regard both to educational excellence and to working towards the democratization of the museum. Current emphases

> within museums on access, on public value and on audience consultation, offer opportunities to work to address long-established relations of advantage and disadvantage, to enable new voices to be heard, and critically to *review existing historical (and other) narratives*...a critical museum pedagogy that uses existing good practice for democratic purposes is a major task for museums and galleries in the twenty-first century (Hooper-Greenhill 1999: 4)[my emphasis]

The "uprisings" in Britain in the last two decades of the twentieth century, brought national focus to the need for practitioners in the educational sphere – classrooms and museums – to adapt strategies of multiculturalism, antiracism and inter-culturalism to teaching and representation. Inter-culturalism went beyond issues of access, recognition of and respect for difference in that it addresses the individuals' "sense of 'belonging' to a wider national community and sharing 'common values'" (Golding 2009: 141).

These approaches to attainment of intercultural harmony interrogate concepts of "similarity and difference" for the purpose of arriving at an accepted notion of being human that is translatable into positive day-to-day inter-personal encounters:

> The hope was that sympathetic teaching of other value systems will weaken the hold of prejudices' and 'act as a form of inoculation against the future development of racist attitudes'...to challenge bias and racism by facilitating human empathy and noting human similarities through differences (Golding 2009: 142).

My work indicates that many children in age groups 3–12 who visit the MMGMM prefer to be called brown rather than black and prefer white to black dolls solely because they are white. Questioning their preference revealed that the white dolls in addition to white skin colour have long soft hair that was determined to be more beautiful and desirable than "black" hair. Their responses signal that there are ongoing indicators within the society that reinforce colonial narratives of beauty that subtly undermine pride in Blackness. High incidences of skin bleaching and the popularity of hair weaving substantiate this point. One such indicator of colonial narrative is exampled below by a billboard in Barbican Square (see figure 9:1) one of Kingston's urban communities, erected early in 2012

The image is of a "Jamaica white"[2] girl flanked by two "brown" girls, all with long hair. The caption refers to them as "princesses". In the absence of a dark-skinned black child with natural hair, one may surmise that such a child would not be referred to as a princess. This advertisement is evocative of Golding's citation of Morrison's *The Bluest Eye* which "highlights a

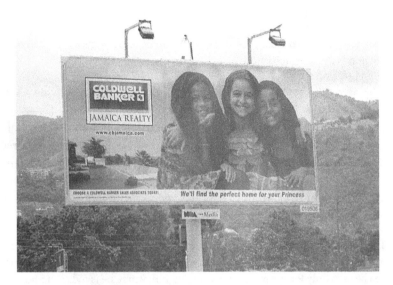

Figure 9.1. Billboard that subtly suggests the face of princesses (photo by permission of photographer C. Parchment).

subtle but pernicious racism, arising from the lived experience of daily life" (Golding 2009: 1).

The philosophy of Marcus Garvey and others before him like Edward Blyden (1832–1912) and Robert Love (1839–1914) put forward the notion that children of African heritage must be educated in African history as a necessary step toward their own redemption and that of the African continent. Garvey insisted that black people should "be as proud of your race today as our fathers were in the days of yore. We have a beautiful history, and we shall create another in the future that will astonish the world" (Garvey 1986: 7).

This principle, despite the utterings of Norman Manley, the founding father of Jamaica's nationalism, has not yet found its way into determining the course of the education system. At the height of the labour unrest in Jamaica in 1939, Manley called on teachers to help build a new Jamaica with a vision of the future that was based on history that honoured their own experiences. In essence he struck out against British hegemony specifically of Jamaican history and its construction of the cultural annihilation that occurs in schools which results in increased self-hatred and loathing against one's own race. He said:

In all countries the teaching of history is an opportunity to build up a basic nationalism and patriotism in the mind of the child ... have we ever in Jamaica

inculcated in the children in our schools a spirit which believes that the Jamaican is a fine person? That he is a laudable person? That the Jamaican has a great future before him? Now, unless the teacher believes these things – as a matter of deep and emotional feeling – the right atmosphere cannot live in the minds of the pupils (Nettleford 1978: 105)

Scholars, Arturo Schomburg 1874–1938; Blyden (1887); Cheikh Anta Diop (Diop 1974; 1987; Diop 1991); James (1989), Woodson (Woodson 1933/2005; 1945); Rodney (1972); Walker (2006) and others, have sought to compile bibliographies and write books that present an African-centred historical account of the character and achievements of African people, and the roles, past and future, played in development of Africa, Europe and the world. Writing in 1933 on the deleterious representation of black people in books and in society Woodson said:

> The Negro can be made proud of his past by [...]giving his own story to the world. What others have written about the Negro during the last three centuries has been mainly for the purpose of bringing him where he is today and holding him there (1933/2005: 194).

The liberatory potential of black education is to create a transformative education and research practice that not only raises the self-esteem of black people but also produces the "knowledge and understanding people need to rehumanize the world by dismantling hegemonic structures that impede such knowledge" (King 2005: 5). Representation in Jamaica's museums that is based on a transformative education and research practice could be the cathartic tool required to move the nation forward.

The MMGMM is a twenty-first-century museum that follows the prescription set forth by Greenhill and other noted museum scholars. The MMGMM represents Garvey's messages of self-upliftment, positive self-identity, education and preparedness. Garvey fostered public pride in Blackness and stood up against global racism and mental slavery by creating organizations that demonstrated that black people were just as capable, intelligent and beautiful as any other race. According to Sister Samaj, an elder Garveyite whose parents were emissaries of the UNIA-ACL to Jamaica, "Garvey made you stand tall and quiet"[3] The MMGMM instils pride, confidence and positively asserts the strength and beauty of Blackness.

The Future

Notes from Donna McFarlane, 9 May 2011, Kingston, Jamaica

Dr McFarlane wrote copious notes to herself, to those intended for staff and to whomever was the perspective recipient. These notes were written in countless numbers of notepads and journals in which the contents merged the personal and the professional. These notepads and journals identify the mechanisms by which how Donna McFarlane processed her thoughts and to whom she thought could actualize these ideas into action. Found among all these notes are a set written as the MMGMM was proving to be a stellar project. Clearly, the future ideas for the expansion of LH required the space next door. With this extra space, the mission of LH would continue to instil a sense of purpose, a site for conversation, reflection and education in service to Jamaica as well as to the African Diaspora.

Jottings in a spiral notepad 9 May 2011

1. Temporary Exhibition space (1st fl.)
2. Garvey Multi-Media Com. Centre (2nd fl.) & Training Rooms
3. Coffee shop/Bookstore
4. Garvey Research/Ref library- 2 floors
 a. Large reading/study room with carrels for individual readers
 b. Mezzanine to house the books/archives that looks down into the reading room in part
5. Multimedia rooms/small conference rooms
6. Administrative offices
7. 2 studio apartments to accommodate short-term overseas scholars
8. Buildings connected by outdoor elevators
9. Underground parking.

In addition

Research space for academics

venue for seminars

public events to engage with national and international policy makers, business, students, and general public

Caribbean scholars to address challenges in the Caribbean to move the Caribbean out of the colonial frame would move toward the 21st century that encourages research & debate.

These Include:

- Historical amnesia / diminished self-identity
- Poverty
- Lack of resources
- Lack of social infrastructure
- Ancient Contemporary
- Learn African History
- Learn history of African Diaspora
- Bring together academics, scientists, and practitioners from Africa & the African Diaspora to create collaboration needed for studying & tackling its challenges and opportunities for the 21st century.
- The decade for people of African descent is a crucial turning point for our people- Rapid scientific tech has returned Europe's gaze on Africa &The Caribbean as repository of important natural resources.
- But how do we prepare human resources of people of African descent to utilize the natural resources of our collective development?

Power of Ideas

Seize opportunities-
 Teams of people across disciplines to accelerate
 Provide incubation for ideas & transmission for implementation

Dr Donna McFarlane unedited personal notepad dated 9 May 2011 from personal archive.

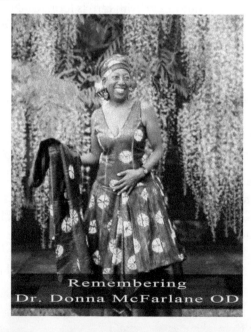

Remembering
Dr. Donna McFarlane OD

Epilogue

Donna McFarlane often spoke of how her thinking as a migrant Jamaican child living in Brooklyn in the 1960s was reshaped during the era of the Black Power and Civil Rights movement in the United States. She was determined to make her own contribution to change and prepared herself academically, studying Political Science at City University of New York and earning an MA in Economics from the New School for Social Research in New York in 1979. She lived near the Brooklyn Museum and Botanical Gardens and had benefitted a lot from its cultural holdings, its library and the opportunities it offered a young woman for self-development.

She returned to Jamaica to work as an economist during the late 1970s and committed herself to social transformation. Donna had a very productive career as an economist in the National Planning Agency under the leadership of the radical economist, Norman Girvan, helping to prepare a five-year development plan for Jamaica, and working with the World Bank on a project to involve women in rural development in Latin America and the Caribbean. She was responsible for co-ordinating the work in the Caribbean territories of Jamaica, Barbados, Suriname and Guyana. She also worked with the Inter-American Development Bank, the UNDP and with Jamaican government agencies and ministries as well as with the private sector. She did work in West Kingston on market women and their contribution to internal marketing of agricultural produce. She developed policies for sustainable tourism and worked on heritage tourism participating in the UNESCO/WTO Caribbean Slave Route Project. In her late forties she pursued an MA in Museum Studies at Leicester University in England and graduated in 2003. It was this preparation that led her in 2003 to eagerly accept the invitation of Ms Elaine Melbourne to take on the task of making something of an empty building in a poor community in downtown Kingston.

For decades followers of Marcus Garvey had been talking about the derelict building that had once housed the headquarters of the Kingston division of the UNIA and had called for its restoration. Elaine Melbourne, one of Jamaica's tireless and creative cultural administrators, took on the task of restoring LH, headquarters of the Kingston Division of the UNIA.

She had led the IOJ and the Jamaica Cultural Development Commission had worked with UNESCO and therefore brought considerable expertise and energy to the renovation of LH. In her capacity as executive director of the IOJ and with the approval of the Council of the IOJ she created a support group dubbed the Friends of Liberty Hall, of which I became the chairperson.

The IOJ obtained a grant from the government and set about the task of turning an abandoned building into a new structure. Ms Melbourne organized a group of theatre activists led by Carol Lawes to work in the community from 2002 to 2003. She also led the fundraising so that the Friends would have resources for equipment. LH functioned as a part of the African Caribbean Institute of Jamaica and Jamaica Memory Bank. For five years from 1998 to 2003 Elaine Melbourne ensured that LH would become a reality.

Donna McFarlane, at the time, was contemplating a career change from being an economist and when she was invited to apply for this job offer she enthusiastically embraced the opportunity to create a museum around the legacies of the Garvey movement. In 2003 when Donna was first employed by the IOJ she continued consultation with the community, the UNIA, Garvey activists, Dr Julius Garvey, son of Marcus Garvey, students, the business sector and as many stakeholders that she could identify. She appeared regularly in the media to discuss the project and get feedback. It was after this process that submissions were made to the Council of the IOJ. Among the programmes approved were the adult computer literacy class, the after-school programme, the summer arts programme where the students did murals that adorn the main hall in the building and the facade of the walls outside. Donna McFarlane created the Marcus Garvey Multimedia Museum, the Garvey Reference and Research Library, a library of children's books, the Garvey Multimedia Centre (Roper 2018). The annual Sankofa conference brought together students from Jamaica and other countries through online linkups to explore self-identity and to discuss the relevance of Garvey's philosophy to the twenty-first century.

Donna McFarlane brought to the project a philosophy about public spaces. She wrote:

> The accumulated experiences of my life have led me to the path of creation of public spaces in which people of African heritage can be engaged in recall and re-representation of their history from their perspective. Degrees in Museum Studies are signposts on that path, and creation of the **Marcus Mosiah Garvey Multimedia Museum (MMGMM)** the first major landmark. **MMGMM** is the first

entirely multimedia museum in the Caribbean, and the first museum in the world dedicated to the life and work Marcus Mosiah Garvey (McFarlane 2008: 1).

For fifteen years from 2003 until 2018 Donna McFarlane dedicated all her creative intellectual energies, mobilized her family, especially her husband Claude Nembhard, and their network of friends in Jamaica, Suriname, Dubai, New York, London, South Africa into supporting the LH project. Dr McFarlane's network of family and friends met for a Kwanzaa party at her home every New Year's eve for libation to the ancestors, excellent food, music and dancing. Donna pulled each person into giving support by way of money, skills, advice and she in turn stimulated their interest in knowledge about the legacies of the Garvey movement she was leading for the educational transformation of the next generation of young people.

Donna always discussed her ideas with those with whom she worked, welcoming feedback. Then she would revise and create a spreadsheet with budget, timelines, and steps towards implementation. She would build a team who would be responsible under her guidance for seeing the project through to completion. The team was drawn from wherever in the world the digital skills were that could be afforded. The IOJ provided the salaries for a small staff. Among the early staff were Ms Nicole Patrick Shaw, then of the African Caribbean Institute of Jamaica-Jamaica Memory Bank, who worked with Ms Melbourne from the start, Dr Nicosia Shakes who was in charge of research for the touchscreens, Constance Dunkley, Shanique Bailey, Netollia Fairweather Sims, Natalie Christian, Paul Morgan, Lois Brown and Shani Roper who during Donna's illness acted as Director/Curator.

Donna was critical of the history of the IOJ based on the persistence of colonial legacies in its curatorial practices. She had argued that the IOJ which had been created in 1879 by the island's Governor, Sir Anthony Musgrave, as a showcase for British imperial cultural power had not been sufficiently decolonized. The colonial mission and its racist assumptions were evident in a comment by Frank Cundall, who held the position of secretary and librarian of the IOJ from 1891 to 1936. In 1928, Cundall wrote:

> The negro race has at present gone but a short way on the path of civilization. The individuals are still as children, childlike in belief and faith...They too often lack pride in their work...Gratitude is, it is to be feared, not a strong point with many of them...As a race they are certainly not artistic (McFarlane 2015: 118).

She felt the IOJ's anti-black legacies had not been sufficiently confronted. Donna McFarlane wrote, "Up to 1961, collecting the material culture of black Jamaicans, and representing blackness in museums was never considered the responsibility or interest of the IOJ" (McFarlane 2015: 120). She had a high regard for the Jamaican novelist and intellectual, Neville Dawes (1926–1984), who was appointed the first black executive director of the IOJ and "ushered in a marked change in the IOJ, as he declared his mission to use culture as a catalyst for development of all Jamaicans, particularly underprivileged children, whom he observed were being left out of the 'national' feeling of being a Jamaican" (McFarlane 2015: 121). McFarlane embraced this vision and spent much of her time nurturing children from the inner-city communities. She knew the children by name, knew their parents and raised money to enable some of them to have scholarships to further their education. So many of them thought they were black and ugly. This was one of the issues that led her to establish the self-identity touchscreen where the issues of self-hate and low self-esteem were challenged. The children also had very negative views about Africa and this led to another touchscreen display about the continent and its modernity.

For those who have replaced Donna McFarlane in leading LH they can do well to follow her guidance when she summarized her work of 15 years to:

- Develop LH into a cultural/educational institution that offers the following: The Garvey Multimedia Computer Centre that teaches computer skills to adults and children while imparting information about Marcus Garvey; the GRRL that offers the public information on Marcus Garvey, Pan Africans, the history of Africa and its Diaspora; the Garvey Outreach Programme that serves the needs of children between the ages of 7 and 17 in the inner-city communities that surround LH; and any other services required by the community to build its social and economic wealth.
- Seek funding from national and international agencies, the private and public sectors, the philanthropic community, and individuals for the development and sustainability of LH as a cultural/educational institution.
- Design and implement a multimedia museum for dissemination of information on the life and work of Marcus Mosiah Garvey.
- Collaborate and make linkages with like institutions and organizations in Africa and the African Diaspora.

- Direct the work of LH's staff — administrator, researcher, librarian, computer teachers, primary school teacher, office attendant, three security personnel and a cadre of volunteers (McFarlane 2008: 2).

Donna was always thinking about developing Jamaica's public spaces. She had prodded the IOJ into acquiring an adjoining property to 76 King Street which now provides parking for visitors to LH. She knew that LH had outgrown the building on 76 King Street and there was need for more space for the library, conference facilities, and the gift and coffee shop. Her dream was to develop the Amy Jacques Garvey Centre and for this she was determined to seek funding. Donna desperately wanted to see more public spaces dedicated to the memorials to enslavement, more public parks, for a wide range of cultural activities, recreation and reflection. Donna's curatorial work is of relevance not only to LH in Kingston but is a guide to the memorialization of spaces throughout the world that affirm our humanity and our ongoing struggles to overcome the long history of enslavement, plantations, racism and colonialism.

I am grateful to Professor Lynn Bolles for continuing the labours of the late Donna McFarlane in reshaping her doctoral thesis into this book.

Notes

Prologue

1. Donna McFarlane 2003 Masters of Arts in Museum Studies University of Leicester UK.

2. Donna McFarlane 2011 The Diaspora Gives Back: How International Funding led to the Restoration and Re-Opening of Liberty Hall: *The Legacy of Marcus Garvey*. Presentation to JAMPACT.
Tony Martin, *Marcus Garvey, Hero: A First Biography*, 137.

3. www nmaahc.si.edu/aboutmuseum (accessed 11 March 2019).

4. www.huffingtonpost.co.uk/2017/03/9-powerful-things-ngugi-said-at-his-public-lecture

5. Bolles (2013).

6. www.americananthropologist.org/wp-content/uploads/2019/03/Decolonizing_museums_inpractice (accessed 19 March 2019).

7. *Jamaican Observer*, 5 February 2018 (accessed 14 January 2019).

Chapter 1. Introduction – Museums at the Crossroads – The Making of the Marcus Mosiah Garvey Multimedia Museum

1. www.jamaica-gleaner.com/gleaner/20120203/lead/lead91.html

Chapter 2. Museums in Jamaica: Injecting a Good Dose of English Culture; Restoring Blackness at the Core

1. Nettleford (1978: 3).

2. The Royal Society of Arts with the Royal Agricultural Society of Jamaica.

3. The Institute of Jamaica (1913: 4).

4. Bryan (1998: 116–32).

5. Moore and Johnson (2011: 111–12).

6. *The Rules of the Institute of Jamaica* (1913: 5–10).

7. See www.nlj.gov.jm/bios-a-h#cundall

8. See http://openlibrary.org/authors/OL115048A/Frank_Cundall.

9. Cundall (1928: 61).

10. Cundall and Anderson (1927: 11).

11. *Jamaica Gleaner* (16 October 1999).

12. Ibid., 345.

13. Hinsley (1991).

14. Ibid., 346.

15. Booth (1972: 42).

16. *Jamaica Exhibition Bulletin* (28 June 1892: 2).

17. Booth (1972).

18. Ibid.

19. Moors – the original Moors/Berbers/Libyans – were black-skinned people from North Africa. They are racially akin to the Ethiopians, Kushites and Nubians. Their architectural legacy in Spain (from the ninth to thirteenth century) is prized and was widely copied in Europe and the United States, while the racial characteristics of the Moors were erased.

20. These three were Ernest Verley, a noted horse breeder; George Stiebel, a Jewish mulatto millionaire who was the Custos of the parish of St Andrew; and Col. Charles Ward, the Custos of Kingston.

21. Booth (1972: 40).

22. Ibid.

23. *Colonial Standard* (4 March and 15 April 1891).

24. Moore and Johnson (2011: 246).

25. Sherlock and Bennett (1998).

26. Nettleford (1971: 102–07).

27. *Daily Gleaner* (27 October 1961).

28. Ibid., 83.

29. Hamilton (1976: 9).

30. Dawes (1977: 52).

31. Dawes (1979: 7).

32. Ibid., 53.

33. Wynter (1991: 4–8).

Chapter 4. Setting the Colonial Identity Stage

1. The transatlantic trade in Africans or the "triangular trade" that describes the starting port in Europe, collection of Africans in Africa, transporting them to the Americas, and returning to Europe to settle with investors and outfit ships.

2. www.jdfmil.org/JamaicaLegion/vet_extral.php

Chapter 6. The Friends of Liberty Hall (Marcus Garvey) Foundation – 2002

1. Mrs Elaine Melbourne, Ms Donna Scott-Motley, Prof. Rupert Lewis, Mr Frank Gordon (UNIA-ACL), Ms Beverly Hamilton, Deacon Wolde Mehdin (UNIA-ACL), Ms Nicole Patrick-Shaw, Mr Anthony Laing, Mr Herbert Repole, Ms Marjorie Scott-Anderson.

2. The walking stick, with Garvey's name etched in the silver handle, came into the collection of the IOJ in the 1970s when it was given to a

member of the Bob Marley and the Wailers band in England by Mr Benjamin Cunningham who then worked with Island Records. He tells the story that the cane was secured by his Irish Grandfather in 1935 during the deconstruction of Garvey's last home at 53 Talgarth Road, entrusted it to his father and told him that it belonged to Marcus Garvey. Mr Cunningham believed that the cane should be in Jamaica and received permission from his father to release it. The cane was brought to Jamaica and handed over to the Minister of Culture who entrusted it to the IOJ.

Chapter 7. Building a Cultural Educational Institution that Serves Members of the Surrounding Inner-City Communities First

1. A coin bearing Garvey's image.

Chapter 8. Representing Blackness: The MMGMM

1. Ibid.
2. Ibid.
3. For the period 2006–2011, 22,821 visitors have viewed the museum, filling five books with comments.
4. www.snagfilms.com
5. www.youtube.com/watch?v=enpFde5rgmw

Chapter 9. Representing Blackness in Jamaica's Post-Colonial Museums – The MMGMM

1. See front page of The Sunday Gleaner, September 11, 2011 'Brownings Please': Several Local Businesses asking state-owned employment agency for light-skinned trainees.
2. "Jamaica" white refers to white people who are born in Jamaica and may have some African heritage although not immediately visible and certainly is unclaimed.
3. Section 3 of exhibition Garvey: The Man and the Philosophy; MMGMM.

Bibliography

1996. *Allsopp's Dictionary of Caribbean English Usage*. Kingston: UWI Press.

1999. "The Concise Oxford Dictionary". In *The Concise Oxford Dictionary*, edited by J. Pearsall. Oxford: Oxford University Press.

Abel, W. 2007. "'Mirror, Mirror On The Wall, Who's The Fairest of Us All?' Bleached, Brown, Beautiful?" *The Gleaner*. Kingston: Gleaner Company.

Achebe, C. 2009. *The Education of a British-Protected Child*. New York: Alfred A. Knopf.

Allen, J., H. Als, et al., eds. 2004. *Without Sanctuary: Lynching Photography in America*. Santa Fe: Twin Palms Publishers.

Ames, P.J. 1994. "A Challenge to Modern Museum Management: Meshing Mission and Market". In *Museum Management*, edited by K. Moore, 15–21. London and New York: Routledge.

Appleton, J. 2001. "Museums for 'The People'?" In *Museums and their Communities*, edited by S. Watson, 114–26. London: Routledge.

Araújo, M. and S.R. Maeso. 2011. "History Textbooks, Racism and the Critique of Eurocentrism: Beyond Rectification or Compensation". *Ethnic and Racial Studies* 35, no. 12: 1266–86 (online version August 2011).

Arbell, M. 2000. *The Portuguese Jews of Jamaica*. Jamaica: Canoe Press.

Archer-Straw, P. 2000. *Negrophilia: Avant-Garde Paris and Black Culture in the 1920's*. London: Thames & Hudson.

Armstrong, P.B., ed. 2006. *Joseph Conrad: Heart of Darkness*. New York: W. W. Norton & Company.

Asante, M.K. 1987. *The Afrocentric Idea*. Philadelphia: Temple University Press.

Back, L., and J. Solomos, eds. 2000. *Theories of Race and Racism: A Reader*. New York: Routledge.

Bailey, A.C. 2005. *African Voices of the Atlantic Slave Trade*. Boston, MA: Beacon Press Books.

Banks, J.A. 1993. "Multicultural Education: Historical Development, Dimensions, and Practice". In *Review of Research in Education*, edited by L. Darling-Hammond, vol. 19, 3. Washington, DC: American Educational Research Association.

Banton, M. 1967. *Race Relations*. New York: Basic Books.

Barthes, R. 1972. *Mythologies*. London: Cape.

Baxter, P., and B. Sansom, eds. 1972. *Race and Social Difference*. Middlesex: Penguin Books.

Beckles, H., and V. Shepherd, eds. 1996. *Caribbean Freedom: Economy and Society from Emancipaion to the Present*. Kingston: Ian Randle Publishers.

Beckwith, C., and A. Fisher. 2000. *Passages*. New York: H.N. Abrams Publisher.

Beer, V. 1994. "The Problem and Promise of Museum Goals". In *Museum Management*, edited by K. Moore, 31–40. London and New York: Routledge.

Bell, D. 1979. "Bakke, Minority Admissions, and the Usual Price of Racial Remedies". *California Law Review* 76: 3–19.

———. 1980. "Brown v. Board of Education and the Interest-Convergence Dilemma". *Harvard Law Review* 93: 518–33.

———. 1987. *And We Are not Saved: The Elusive Quest for Racial Justice*. New York: Basic Books.

Bell, D.A. 1992. *Race, Racism, and American Law*. Boston: Little, Brown.

Ben-Jochannan, Y. 1970. *Black Man of the Nile*. New York: Alkebu-Lan Books.

Bernal, M. 1987. *Black Athena: The Afroasiatic Roots of Classical Civilization*. New Brunswick: Rutgers University Press.

Bhabha, H.K. 1996. "Culture's In-Between". In *Questions of Cultural Identity*, edited by S. Hall and P.d. Gay. London: Sage Publications.

Blyden, E.W. 1887. *Christianity, Islam and the Negro Race*. Edinburg: University of Edinburgh Press.

Bohannan, P. et al. 1976. "Africa". In *The World Book Encylopedia*, vol. 1, 88–126. Chicago: Field Enterprises Educational Corporation.

Bolles, A.L. 2013. "Telling the Story Straight: Black Feminist Intellectual Thought in Anthropology". *Transforming Anthropology* 1: 57–71.

Booth, K. 1972. "When Jamaica Welcomed the World: The Great Exhibition of 1891". *Jamaica Journal* 6, no. 2: 39–51.

Brodber, E. 1975. *A Study of Yards in the City of Kingston*. Kingston: Institute of Social and Economic Research - University of the West Indies, Jamaica.

Bryan, P. 1991. *The Jamaican People 1880-1902: Race, Class and Social Control*. Kingston: The University of the West Indies Press.

———. 1998. "The White Minority in Jamaica at the End of the Nineteenth Century". In *The White Minority in the Caribbean*, edited by H. Johnson and K. Watson, 116–32. Kingston: Ian Randle Publishers.

Burnard, T. 2004. *Mastery, Tyranny, and Desire: Thomas Thistlewood and His Slaves in the Anglo-Jamaican World*. Chapel Hill and London: The University of North Carolina Press.

Burns, K. 2001. *Mansa Musa: The Lion of Mali*. San Diego: Gulliver Books Harcourt.

Butler, S.R. 1999. *Contested Representations: Revisiting Into the Heart of Africa*. Australia: Gordon and Breach Publishers.

Candelario, G.E.B. 2007. *Black Behind the Ears: Dominican Racial Identity From Museums to Beauty Shops*. Durham and London: Duke University Press.

Carby, H. 1992. "The Multicultural Wars". In *Black Popular Culture*, edited by M. Wallace and G. Dent. Seattle: Bay Press.

Cesaire, A. 1972. *Discourse on Colonialism*. New York and London: Monthly Review Press.

Chafe, W.H., R. Gavins, et al., eds. 2001. *Remembering Jim Crow: African Americans Tell About Life in the Segregated South*. New York: The New Press.

Chinweizu. 2010. *What "Slave Trade"? (Toward an Afrocentric Rectification of Terms)*, 1–31. Lagos.

Clarke, A., J. Dodd, et al., eds. 2001. *Learning Through Culture: The DfES Museums and Galleries Education Programme: A Guide to Good Practice*. Leicester: Research Centre for Museums and Galleries.

Clarke, C.G. 2006. *Kingston Jamaica: Urban Development and Social Change, 1692-2002*. Kingston: Ian Randle Publishers.

Clarke, J.H., and A.J. Garvey, eds. 1974. *Marcus Garvey and the Vision of Africa*. New York: Vintage Books.

Collins, P.H. 2000. *Black Feminist Thought: Knowledge, Consciousness, and the Politics of Empowerment*. New York and London: Routledge.

Collins, R.O. 1977. "Africa or Africa Propria". *New Age Encyclopedia*. Lexicon Publications. 1: 111–12.

Correspondent, G. 1989. "Teaching Garveyism in Schools". *The Daily Gleaner*. Kingston: Gleaner Company.

Crew, S.R. 1996. "African Americans, History and Museums: Preserving African American History in the Public Arena". In *Making Histories in Museums*, edited by G. Kavanagh, 80–91. London: Leicester University Press.

Cundall, F. 1895. *Handbook of Information for Intending Settlers and Others*. Kingston: Institute of Jamaica, Date Tree Hall.

———. 1907. *The Journal of Lady Nugent*. London: Institute of Jamaica, A and C Black Publishers.

———. 1928. *Jamaica 1928: A Handbook of Information for Visitors and Intending Residents with some Account of the Colony's History*. London: West India Committee.

Cundall, F., and I. Anderson. 1927. *Jamaica Negro Proverbs and Sayings: Collected and Classified According to Subjects*. London: West India Committee.

Curtin, P.D. 1970. *Two Jamaicas: The Role of Ideas in a Tropical Colony 1830-1863*. New York: Atheneum.

Daily Gleaner, 23 March 1933, p. 18.

Dalby, J. 2000. *Crime and Punishment in Jamaica: 1756 - 1856*. Kingston: The University of the West Indies, Mona.

Davidson, B. 1992. *Africa in History*. London: Phoenix Press.

Dawes, N. 1977. "Cultural Policy in Jamaica: A Study Prepared by the Institute of Jamaica". In *Cultural Policy*, 53. Paris: UNESCO.

Dawes, N. 1979. *The Presence of African Negro Culture in the African Diaspora*. Kingston: Institute of Jamaica.

Dayan, J. 1998. *Haiti, History, and the Gods*. Berkeley: University of California Press.

Dennis, D., and S. Willmarth. 1984. *Black History For Beginners*. London: Writers and Readers Publishing Cooperative Society Limited.

deQuatrefagas, A. 1905. *The Human Species*. New York: Appleton and Co.

Deren, M. 1970. *Divine Horseman: The Living Gods of Haiti*. New York: Documentext McPherson & Company.

Diop, C.A. 1974. *The African Origin of Civilization, Myth or Reality*. Chicago: Lawrence Hill Books.

———. 1987. *PRECOLONIAL BLACK AFRICA: A Comparative Study of the Political and Social Systems of Europe and Black Africa, from Antiquity to the Formation of Modern States*. Brooklyn: Lawrence Hill Books.

———. 1991. *Civilization or Barbarism: An Authentic Anthropology*. New York: Lawrence Hill Books.

Dixon, A.D., and C.K. Rousseau, eds. 2006. *Critical Race Theory in Education*. New York and London: Routledge.

Dodson, H. 1999. *The Black New Yorkers: The Schomburg Illustrated Chronology*. New York: Wiley Publisher.

Donnell, A., and S.L. Welsh, eds. 1996. *The Routledge Reader in Caribbean Literature*. London and New York: Routledge.

Dunn, H.S., and L.L. Dunn. 2002. *People and Tourism: Issues and Attitudes in the Jamaican Hospitality Industry*. Kingston: Arawak Publications.

Eoe, S.M. 1995. "Creating a National Unity: The Role of Museums". *Museums and Communities, ICOM* 4: 14–15.

Evans, H. 2001. *Inside Jamaican Schools*. Kingston: University of the West Indies Press.

Fanon, F. 1963. *The Wretched of the Earth*. New York: Grove Press.

———. 1967. *Black Skin White Masks*. New York: Grove Press.

———. 2002. "The Fact of Blackness". In *The Visual Culture Reader*, edited by N. Mirzoeff, 129–31. London and New York: Routledge.

Foucault, M. 1970. *The Order of Things: An Archaeology of the Human Sciences*. London: Routledge.

Francis, O.C. 1963. *The People of Modern Jamaica*. Kingston: Department of Statistics.

Freeman, K. 2005. "Black Populations Globally: The Costs of the Underutilization of Blacks in Education". In *Black Education: A Transformative Research and Action Agenda for the New Century*, edited by J.E. King, 135–58. Mahwah: Lawrence Erlbaum Associates.

Freire, P. 1973. *Pedagogy of the Oppressed*. New York: The Seabury Press.

———. [1974] 2008. *Education for Critical Consciousness*. London and New York: Continuum.

Gable, E. 1996. "Maintaining Boundaries, or 'mainstreaming' Black History in a White Museum". In *Theorizing Museums: Representing Identity and Diversity in a Changing World*, edited by S. Macdonald and G. Fyfe, 177–202. Oxford: Blackwell Publishers/The Sociological Review.

Gaither, E.B. 1992. "'Hey! That's Mine': Thoughts on Pluralism and American Museums". In *Museums and Communities: The Politics of Public Culture*, edited by I. Karp, C.M. Kreamer and S.D. Levine, 56–64. Washington, DC and London: Smithsonian Institution Press.

Gantz, C.R. 2008. *The 1933 Chicago World's Fair: A Century of Progress*. Urbana and Chicago: University of Illinois Press.

Garrick, N. 1998. *A Rasta's Pilgrimage: Ethiopian Faces and Places*. San Francisco: Pomegranate.

Garvey, A.J. 1986. *The Philosophy & Opinions of Marcus Garvey*. Dover: The Majority Press.

Gilroy, P. 2004. *After Empire: Melancholia or Convivial Culture?* London: Routledge.

Giroux, H. 1993. *Boder-Crossings: Cultural Workers and the Politics of Education*. London: Routledge.

Girvan, N. 1987. "The Political Economy of Race in the Americas: The Historical Context of Garveyism". In *Garvey: His Work and Impact*, edited by R. Lewis and P. Bryan, 11–22. Mona: Institute of Social and Economic Research & Department of Extra-Mural Studies, University of the West Indies, Mona.

Golding, V. 2009. *Learning at The Museum Frontiers: Identity, Race, and Power*. Surrey: Ashgate Publishing Limited.

Gordon, B. 1997. "Intimacy and Objects: A proxemic Analysis of Gender-Based Response to the Material World". In *The Material Culture of Gender: The Gender of Material Culture*, edited by K. Martinez and K.L. Ames, 237–52. Winterthur, Delaware: Henry Francis du Pont Winterthur Museum.

"Governor to Open Folk Museum". *Daily Gleaner*, 27 October 1961.

Grant, C. 2008. *Negro with a Hate: The Rise and Fall of Marcus Garvey*. New York: Oxford University Press.

Grossberg, L. 1996. "Identity and Cultural Studies: Is That All There Is?" In *Questions of Cultural Identity*, edited by S. Hall and P. du Gay, 87–107. London: Sage Publications.

Hall, A. 2010. "The Battle - Blood Flows as Security Forces Go after Dudus on May 24, 2010". *The Gleaner*. Kingston: Gleaner Company.

Hall, C. 2000. "William Knibb and the Constitution of the New Black Subject". *Small Axe: A Caribbean Journal of Criticism* 8: 31–55.

Hall, D. 1999. *In Miserable Slavery: Thomas Thistlewood in Jamaica 1750-86*. Kingston: The University of the West Indies Press.

Hall, E.T. 1966. *The Hidden Dimension*. New York: Anchor Books, Doubleday.

Hall, S. 1996. "Introduction: Who Needs 'Identity'?" In *Questions of Cultural Identity*, edited by S. Hall and P.d. Gay, 1–17. London: Sage Publications.

———. 2000. "The Multicultural Question". In *Un/settled Multiculturalisms*, edited by B. Hesse, 209–41. London: Zed.

———, ed. 2003. *Representation: Cultural Representations and Signifying Practices*. London, Thousand Oaks and New Delhi: Sage Publications.

Hamilton, B.S.J. 1976. "Neville Dawes: Institute's treasures belong to all Jamaica". *Sunday Gleaner*, November 14, p. 9. Kingston: The Gleaner Company.

Harris, C.I. 1993. "Whiteness as Property". *Harvard Law Review* 106: 1707–91.

Hart, R. 1985. *Slaves who Abolished Slavery: Blacks in Rebellion*. Institute of Social and Economic Research, University of the West Indies, Jamaica.

Hein, G.E. 1998. *Learning in the Museum*. New York: Routledge.

Henry Louis Gates, J., and C. West. 2000. *The African-American Century: How Black Americans Have Shaped Our Country*. New York: The Free Press.

Higman, B.W. 1995. *Slave Population and Economy in Jamaica 1807-1834*. Kingston: The Press University of the West Indies.

———. 1998. *Montpelier Jamaica: A Plantation Community in Slavery and Freedom 1739-1912*. Jamaica: The Press University of the West Indies.

Hill, R. 1994. "Making Noise: Marcus Garvey Dada, August 1922". In *Picturing Us: African American Identity*, edited by D. Willis. New York: The New Press.

Hill, R.A., ed. 1983. *The Marcus Garvey and Universal Negro Improvement Association Papers Vol. II*. Berkeley and Los Angeles: University of California Press.

———, ed. 1984. *The Marcus Garvey and Universal Negro Improvement Association Papers Vol. III*. Berkely and Los Angeles: University of California Press.

———, ed. 1987. *Marcus Garvey Life and Lessons: A Centennial Companion to the Marcus Garvey Universal Negro Improvement Association Papers*. Berkeley: University of California Press.

———, ed. 1990. *The Marcus Garvey and Universal Negro Improvement Association Papers Vol. VII*. Berkely and Los Angeles: University of California Press.

Hinsley, C.M. 1991. "The World as Marketplace: Commodification of the Exotic at the World's Columbian Exposition, Chicago, 1893". In *Exhibiting Cultures: The Poetics and Politics of Museum Display*, edited by I. Karp and S. Lavine, 344–63. Washington: Smithsonian Institution Press.

Hochschild, A. 1999. *King Leopold's Ghost*. Boston and New York: First Mariner Books.

Hooper-Greenhill, E., ed. 1989. *Initiatives in Museum Education*. Leicester: University of Leicester.

———. 1992. *Museums and the Shaping of Knowledge*. London and New York: Routledge.

———. 1999a. "Education, Communication and Interpretation: Towards a Critical Pedagogy in Museums". In *The Educational Role of the Museum*, edited by E. Hooper-Greenhill, 3–26. London and New York: Routledge.

———, ed. 1999b. *The Educational Role of the Museum*. London and New York: Routledge.

———. 2007. *Museums and Education: Purpose, Pedagogy, Performance*. London and New York: Routledge.

Hord, F.L., and J.S. Lee. 1995. "'I am because we are': An Introduction to Black Philosophy". In *I AM BECAUSE WE ARE: Readings in Black Philosophy*, edited by F.L. Hord and J.S. Lee. Amherst: University of Massachusetts Press.

Hudson, W., and V.W. Wesley. 1997. *Afro-Bets: Book of Black Heroes From A to Z*. East Orange: Just Us Books; Afro-Bets.

Inikori, J.E. 2002. *Africans And The Industrial Revolution in England*. Cambridge: Cambridge University Press.

Institute of Jamaica. 1913. *The Rules of the Institute of Jamaica for the Encouragement of Literature, Science and Art*. London: H. Sotheran & Co.

Jamaica, o. 2001. *Population Census. S. I. o. Jamaica*. Kingston: Government Printing Office.

Jamaica Exhibition Bulletin. Kingston: National Library of Jamaica, 28 June 1892.

James, G.G.M. 1989. *Stolen Legacy*. Newport News: United Brothers Communications Systems.

Johnson, H., and K. Watson, eds. 1998. *The White Minority in the Caribbean*. Kingston: Ian Randle Publishers.

Jones, K., ed. 2002. *Marcus Garvey Said...* Kingston: Ken S. Jones.

King, J.E., ed. 2005a. *Black Education: A Transformative Research and Action Agenda for the New Century*. Mahwah and London: Lawrence Erlbaum Associates.

———. 2005b. "A Declaration of Intellectual Independence for Human Freedom". In *Black Education: A Transformative Research and Action Agenda for the New Century*, edited by J.E. King, 19–42. Washington, DC: American Educational Research Association.

———. 2005c. "A Transformative Vision of Black Education for Human Freedom". In *Black Education: A Transformative Research and Action Agenda for the New Century*, edited by J.E. King. Mahwah: Lawerence Erlbaum Associates.

Knight, F. 2000. "Imperialism and Slavery". In *Caribbean Slavery in the Atlantic World: A Student Reader*, edited by V. Shepherd and H.M. Beckles, 153–65. Kingston: Ian Randle Publishers.

Knight, J. 1742. *The Natural Moral and Political History of Jamaica...to the year 1742*. British Museum.

Ladson-Billings, G., and W.F. Tate. 2006. "Toward a Critical Race Theory of Education". In *Critical Race Theory in Education*, edited by A.D. Dixson and C.K. Rousseau, 1–22. New York and London: Routledge.

Landers, J. 2000. "Cimarron Ethnicity and Cultural Adaptation in the Spanish Domains of the Circum-Caribbean, 1503-1763". In *Identity in the Shadow of Slavery*, edited by P.E. Lovejoy, 30–54. London and New York: Continuum.

Lee, C.D. 2005. "The State of Knowledge about the Education of African Americans". In *Black 22 Education: A Transformative Research and Action Agenda for the New Century*, edited by J.E. King, 45–71. Washington, DC: American Educational Research Association.

Levy, H. 2009. *Killing Streets & Community Revival*. Kingston: Arawak Publications.

Lewis, R. 1988. *Marcus Garvey: Anti-Colonial Champion*. Trenton: Africa World Press.

———. 2004. *The Intellectual and Political Legacy of Marcus Garvey and Philip Lightbody*, 15. Kingston: University of the West Indies, Mona.

Lidchi, H. 1997. "The Poetics and the Politics of Exhibiting Other Cultures". In *Representation: Cultural Representations and Signifying Practices*, edited by S. Hall, 151–208. London: Sage Publications.

Livingstone, W.P. 1899. *Black Jamaica: A Study in Evolution*. London: Sampson Low, Marston, and Company Limited.

Long, E. 1658–1774. *The Long Papers*, vols. 1–3. London: British Museum.

Long, E. 1774. *History of Jamaica*. London.

Lovejoy, P.E., ed. 2000. *Identity in the Shadow of Slavery*. London and New York: Continuum.

Luton, D. 2010. "Dogs Ate My Sister". *The Gleaner*. Kingston: Gleaner Company.

Lynch, H.R., ed. 1971. *Black Spokesman: Selected Published Writings of Edward Wilmot Blyden*. London: Frank Cass & Co.

Mansingh, A., and L. Mansingh. 1989. "The Impact of East Indians on Jamaican Religious Thoughts and Expressions". *Caribbean Journal of Religious Studies* 10, no. 2: 36–52.

Marshall, W.K. 1996. "'We be wise to many more tings': Blacks' Hope and Expectations of Emancipation". In *Caribbean Freedom, Economy and Society from Emancipation to the Present*, edited by H. Beckles and V. Shepherd. Kingston: Ian Randle Publishers.

Martin, F., and C. Anstey 2007. "Crime, Violence, and Development: Trends, Costs, and Policy Options in the Caribbean". United Nations Office on Drugs and Crime and the Latin America and the Caribbean Region of the World Bank.

Martin, T., ed. 1991. *African Fundamentalism: A Literal and Cultural Anthology of Garvey's Harlem Renaissance*. Dover: The Majority Press.

———. 1993. *The Jewish Onslaught: Despatches from the Wellesley Battlefront*. Dover: The Majority Press.

Mason, J. 2002. *Qualitative Researching*. Sage Publications.

Matsuda, M.J., C.R. Lawrence, et al., eds. 1993. *Words that Wound: Critical Race Theory, Assaultive Speech, and the First Amendment*. Boulder: Westview Press.

McFarlane, D. December 2015. "The Institute of Jamaica Representation of Whose Culture?" *Jamaica Journal* 36, no. 1–2.

McFarlane, D. 2008. Curriculum Vitae (personal papers Donna McFarlane).

Mills, C.W. 1997. *The Racial Contract*. Ithaca and London: Cornell University Press.

Mintz, S.W. 1985. *Sweetness and Power*. New York: Penguin Books.

Modest, W. 2019. *Matters of Belonging: Ethnographic Museums in Changing Europe*. South Holland Netherlands: Sidestone Publishers.

Moore, B.L., and M.A. Johnson, eds. 2000. *"Squalid Kingston" 1890-1920: How The Poor Lived, Moved and Had Their Being*. Kingston: The University of the West Indies, Mona.

———. 2004. *Neither Led nor Driven: Contesting British Cultural Imperialism in Jamaica, 1865-1920*. Kingston: University of the West Indies Press.

———. 2011. *"They Do as They Please": The Jamaican Struggle for Cultural Freedom after Morant Bay*. Jamaica: University of the West Indies Press.

Moore, C. 2008. *Pichon A Memoir: Race and Revolution in Castro's Cuba*. Chicago: Lawrence Hill Books.

Morrison, T. 1993. *Playing in the Dark: Whiteness and the Literary Imagination*. New York: Vintage Books.

Moughtin, J.C., ed. 1988. *The Work of Z.R. Dmochowski: Nigerian Traditional Architecture*. London: Ethnographica.

National Library of Jamaica. 2016. "The Kingston Earthquake of 1907". Pg. 4 Nlj.gov.jm.

Nettleford, R., ed. 1971. *Norman Washington Manley and the New Jamaica: Selected Speeches and Writings 1938-68*. Trinidad and Jamaica: Longman Caribbean.

Nettleford, R.M. 1972. *Identity Race and Protest in Jamaica*. New York: Wiliam Morrow & Company.

———. 1978. *Caribbean Cultural Identity: The Case of Jamaica*. Kingston: Institute of Jamaica.

———. 1998. *Mirror Mirror: Identity Race and Protest in Jamaica*. Kingston: LMH Publishing Limited.

Omi, M., and H. Winant 1994. *Racial Formation in the United States: From the 1960s to the 1990s*. New York: Routledge.

Otha Richard Sullivan, E.D., ed. 1998. *Black Stars: African American Inventors*. New York: John Wiley & Sons.

Ottenberg, P. 1977. "African Peoples". *New Age Encyclopedia, Encyclopedia International* 1: 137–44.

Patterson, O. 1973. *The Sociology of Slavery: An Analysis of the Origins, Development and Structure of Negro Slave Society in Jamaica*. Kingston: Sangsters Book Granada Publishing.

Pattullo, P. 1996. *Last Resorts: The Cost of Tourism in the Caribbean*. London: Cassell.

Pearsall, J., ed. 1999. *The Concise Oxford Dictionary*. Oxford: Oxford University Press.

Philips, R.B. 2007. "Exhibiting Africa after Modernism: Globalization, Pluralism, and the {Ersistent Paradigms of Art and Artifact". In *Museums After Modernism: Strategies of Engagement*, edited by G. Pollock and J. Zemans, 80–103. Oxford: Blackwell Publishing.

Reid, S. 1977. "An Introductory Approach to the Concentration of Power in Jamaican Corporate Economy and Notes on Its Origin". In *Essays on Power and Change in Jamaica*, edited by D.C. Stone and D.A. Brown. Kingston: Jamaica Publishing House.

Reynolds, A. 2009. "Proud a mi Bleaching". *The Sunday Gleaner*. Kingston: Gleaner Company.

Robinson, R. 2000. *The Debt: What America Owes to Blacks*. New York: Dutton.

Robotham, D. 1987. "The Development of a Black Ethnicity in Jamaica". In *Garvey: His Work and Impact*, edited by R. Lewis and P. Bryan, 23–38. Kingston: Institute of Social and Economic Research & Department of Extra-Mural Studies, University of the West Indies,Mona.

Rodney, W. 1972. *How Europe Underdeveloped Africa*. London: Bogle-L'Ouverture.

———. 2000. "How Europe Became the Dominant Section of a World-wide Trade System". In *Caribbean Slavery in the Atlantic World: A Student Reader*, edited by V. Shepherd and H.M. Beckles, 2–10. Kingston: Ian Randle Publishers.

Roper, S. May 2018. "Donna McFarlane, OD First Director/Curator of Liberty Hall: The Legacy of Marcus Garvey". *Jamaica Journal* 37, no. 1–2.

The Rules of the Institute of Jamaica. Kingston: Institute of Jamaica, 1913.

Russell, K., M. Wilson, et al. 1992. *The Color Complex: The Politics of Skin Color Among African Americans*. New York, London, Toronto, Sydney and Auckland: Anchor Books Doubleday.

Russell-Wood, A.J.R. 2000. "Before Columbus: Portugal's African Prelude to the Middle Passage and Contribution to Discourse on Race and Slavery". In *Caribbean Slavery in the Atlantic World*, edited by V. Shepherd and H.M. Beckles, 11–31. Kingston: Ian Randle Publishers.

Rustin, M. 2007. "'Working from the Symptom': Stuart Hall's Political Writing". In *Culture, Politics, Race and Diaspora: The Thought of Stuart Hall*, edited by B. Meeks. Kingston: Ian Randle Publishers.

Schuler, M. 1980. *"Alas, Alas, Kongo": A Social History of Indentured African Immigration in Jamaica, 1841-1865*. Baltimore and London: Johns Hopkins Press.

Scott, D. 2000. "The Re-Enchantment of Humanism: An Interview with Sylvia Wynter". *Small Axe: A Journal of Criticism* 4, no. 2: 119–79.

Scott, E. 2008. "The Origin of the word 'Black'". from www.languagestudy .suite101.com/article.cfm/the_origin_of_the_word_black.

Senior, O. 2003. "Encyclopedia of Jamaican Heritage". In *Encyclopedia of Jamaican Heritage*, edited by St. Andrew, 348, 349. Jamaica: Twin Guinep Publishers.

Shelton, A. 2000. "Curating African Worlds". *Journal of Museum Ethnography* 12: 5–20.

Shepherd, V.A. 2002. *Maharani's Misery: Narratives of a Passage from India to the Caribbean*. Kingston: The University of the West Indies Press.

Sherlock, P., and H. Bennett 1998. *The Story of the Jamaican People*. Kingston: Ian Randle Publishers.

Smith, R.T. 1996. *The Matrifocal Family: Power, Pluralism, and Politics*. New York: Routledge.

Spillers, H.J. 1991. *Comparative American Identities: Race, Sex and Nationality in the Modern Text*. New York and London: Routledge.

Steptoe, J. 1987. *Mufaro's Beautiful Daughters: An African Tale*. New York: Lothorp, Lee & Shepard Books.

Stone, C. 1988. "Jan' 88 Carl Stone Poll: Majority Supports Teaching About Garvey in Schools". *The Gleaner*. Kingston: Gleaner Company.

Suina, J.H. 1999. "Museum Multicultural Education for Young Learners". In *The Educational Role of the Museum*, edited by E. Hooper-Greenhill, 105–09. London and New York: Routledge.

Tanna, L. 1983. "African Retentions: Yoruba and Kikongo Songs in Jamaica". *Jamaica Journal* 16, no. 3: 47–52.

Tate, W.F. 1997. "Critical Race Theory and Education: History, Theory, and Implications". *Review of Research in Education* 22: 195–247.

Thompson, E.P. 1963. *The Making of the English Working Class*. New York: Vintage Books.

Thompson, R.F. 1993. *Face of the Gods: Art and Alters of Africa and the African Americas*. New York: The Museum for African Art.

Trouillot, M.-R. 1995. *Silencing the Past: Power and the Production of History*. Boston: Beacon Press.

VanSertima, I. 1976. *They Came Before Columbus*. New York: Random House.

————, ed. 1986. *African Presence in Early Europe*. New Brunswick: Transaction Books.

————, ed. 1989. *Egypt Revisited: Journal of African Civilization*. New Brunswick: Transaction Publishers.

Vergo, P., ed. 1989. *The New Museology*. London: Reakton Books Ltd.

Volney, C.F. 1890. *The Ruins of Empire*. US: Peter Eckler.

Walker, R. 2006. *When We Ruled: The Ancient and Medieval History of Black Civilisations*. London: Every Generation Media.

Warner-Lewis, M. 1996. "African Continuities in the Linguistic Heritage of Jamaica". *African Caribbean Institute of Jamaica Research Review* 3.

Watson, B. 1999. *The Pan-Africanists*. Kingston: Ian Randle Publishers.

Williams, E. 1970. *From Columbus to Castro: The History of the Caribbean 1492-1969*. London: Andre Deutsch.

Willis, W.B. 1998. *The Adinkra Dictionary: A Visual Primer on The Language of ADINKRA*. Washington, DC: The Pyramid Complex.

Wilson, A.N. 1978. *The Developmental Psychology of The Black Child*. New York: Africana Research Publications.

Witter, J.H. 1990. "Remember Our Forefathers' Works". *The Daily Gleaner*. Kingston: Gleaner Company.

Woodson, C.G. 1933/2005. *The Mis-Education of the Negro*. Drewryville: Khalifah's Booksellers & Associates.

————. 1945. *The Negro In Our History*. Washington, DC: The Associated Publishers.

————. 2005. *The Mis-Education of the Negro*. Drewryville: Khalifah's Booksellers & Associates.

"The Work of Frank Cundall and K.E. Ingram". *Jamaica Gleaner*, 16 October 1999.

www.fbi.gov./stories-of-our-history-our-service-event-mark-100-years-since-first-african- american-special-agent, James Wormely Jones.

Wynter, S. "Lady Nugent's Journal". from www.dloc.com.

Wynter, S. 1984a. "New Seville and the Conversion Experience of Bartolome de las Casas, Part Two". *Jamaica Journal* 17, no. 3: 46–55.

————. 1984b. "New Seville and the Conversion Experience of Bartolone de Las Casas, Part One". *Jamaica Journal* 17, no. 2: 25–32.

————. 1991a. "1492: A 'New World' View". *The New World* 2 (Spring/Summer): 4–8.

————. 1991b. "1492: A 'New World' View". *The New World* 2 (Spring/Summer): 4–8.

————. 1995. "The Pope Must Have Been Drunk, the King of Castile a Madman: Culture as Actuality, and the Caribbean Rethinking Modernity". In *The Reordering of Culture: Latin America, The Caribbean and Canada in the Hood*, edited by A. Ruprecht and C. Taiana, 17–41. Ottawa: Carleton University Press.

————. 2002. "On the Relativity, Nature-Culture Hybridity, and Auto-Institutedness of Our Genre (s) of *Being-Human*: Towards the Transculturality of a Caribbean/ New World Matrix". In *Distinguished Lecture*, Caribbean Cultural Studies Institute, Faculty of Humanities, The University of the West Indies, 1–13.

Yin, R.K. 1989. *Case Study Research: Design and Methods*. London: Sage Publications.

CPSIA information can be obtained
at www.ICGtesting.com
Printed in the USA
LVHW071524230623
750604LV00002B/207